BetterPhoto Guide to Photographing

Light

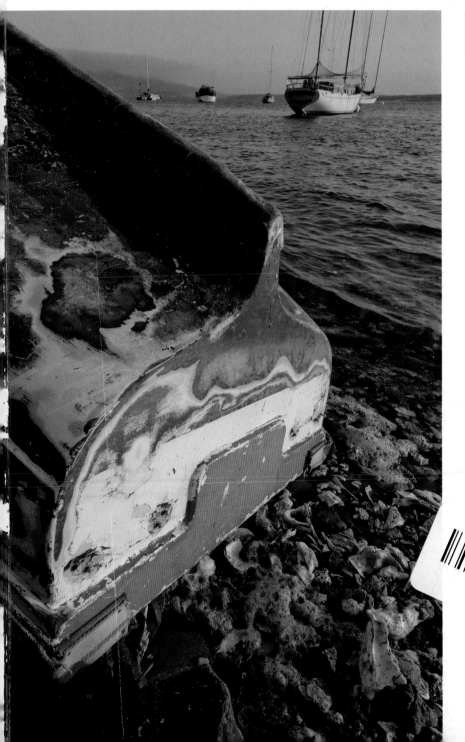

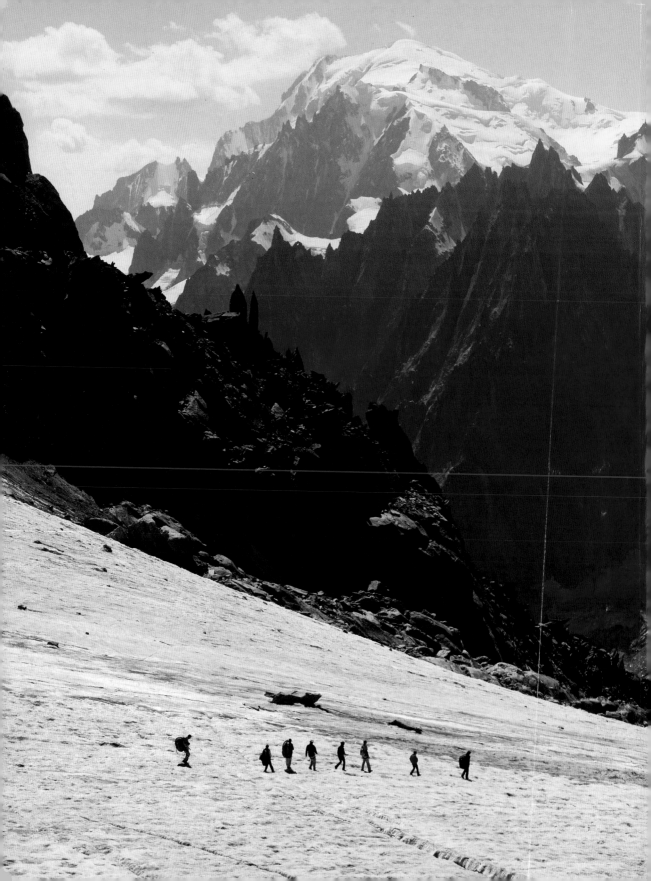

THE BetterPhoto Guide to
PHOTOGRAPHING
Light

JIM MIOTKE AND KERRY DRAGER

AMPHOTO BOOKS

an imprint of the Crown Publishing Group
New York

Published in the United States by Amphoto Books, an imprint
of the Crown Publishing Group, a division of Random House, Inc.,
New York.
www.crownpublishing.com
www.amphotobooks.com

Amphoto Books and the Amphoto Books logo are trademarks
of Random House, Inc.

Library of Congress Cataloging-in-Publication Data
Miotke, Jim.
 The BetterPhoto guide to photographing light / Jim Miotke and Kerry
Drager.
 p. cm.
 Includes index.
1. Photography—Lighting. I. Drager, Kerry. II. Betterphoto.com. III.
Title. IV. Title: Guide to light.
 TR590.M56 2011
 778.7'6—dc23
 2011020988

Printed in China

Design by veést design

Front cover photographs by Kerry Drager (top); Jim Miotke (center
left); Donna Pagakis (center middle); Anne McKinnell (center right);
Tony Sweet (bottom)

Back cover photographs by Kerry Drager (left)
and Deborah Lewinson (Right)

10 9 8 7 6 5 4 3 2 1
First Edition

p. 1 Late-day sunlight is always special, and that was certainly
the case one evening along California's Morro Bay. Thanks to a
wide-angle lens and a very low and close camera position, this old
multicolored boat dominates the foreground and adds a slice of
storytelling to the surroundings.
Photo © Kerry Drager. 1/60 sec. at *f*/19, ISO 200, 20mm lens

pp. 2–3 Mont Blanc, at 15,782 feet, is the highest mountain in the
Alps. It straddles the border between France and Italy. Photogra-
pher Stefania Barbier shot this scene from a cable car that crosses
over the glaciers between the mountain's summits. Note how light
helped to shape things, with the late-afternoon sun catching the
distant peak. This grand scene almost seems to engulf the hikers
below, but while pictured small in the photo, they stand out due to
the dark-against-white contrast.
**Photo © Stefania Barbier. 1/640 sec. at *f*/10, ISO 100, 24–70mm
lens at 54mm**

p. 5 This close wildlife encounter was captured in Namibia,
Africa—close-up, with a wide-angle lens. The subject was behind
a fence (which made the close camera position possible) and was
snarling at another male leopard, recalls Jim Zuckerman. Also,
the low-angled sunlight of late afternoon resulted in a beautiful
warm-vs.-cool color contrast.
**Photo © Jim Zuckerman. 1/1250 sec. at *f*/16, ISO 1000, 24–105mm
lens at 24mm**

pp. 6-7 An old truck and a metal sculpture came together for
a fun country scene in the beautiful light just before sunset. I
particularly liked the color contrast between the bold, warm
tones of the truck and the sky's cool blue. With my wide-angle
lens, I moved physically close to the subjects in order to leave out
surrounding distractions. I then tilted the camera to get a diagonal
composition for additional visual vitality.
**Photo © Kerry Drager. 1/8 sec. at *f*/22, ISO 100, 12–24mm lens at
22mm**

pp. 8–9 (left to right)
Seattle, Washington, is a great place to photograph, with a wealth
of subjects! One early morning at Olympic Sculpture Park, the
low-angled sunlight was bright and sharp, ideal for shooting
shadows. For this scene, the row of chairs caught my eye, not
only because of the shadows created by sidelighting but also due
to the red-versus-green color contrast. I decided to include the
concrete landscaping feature as a secondary design element.
**Photo © Kerry Drager. 1/90 sec. at *f*/16, ISO 200, 70–300mm lens
at 70mm**

Late one afternoon at home, I zeroed in on the pattern of this
colorful serape. Diffused indirect window light was the primary
source of illumination. To retain brightness throughout the
photo, I used a small reflector—just outside the field of vision—to
emphasize the designs, lines, and textures. While not quite in
extreme close-up range, I moved in really tight with my telephoto
macro lens to fill up the picture frame with this pattern.
Photo © Kerry Drager. 1/10 sec. at *f*/16, ISO 200, 105mm lens

I don't normally do much photographing at midday, when the
overhead sunlight "flattens" out scenes and puts shadows in all
the wrong places (think harsh facial shadows in portraits). For this
scene, however, I was attracted by all the great contrast: the stark
white railings set against the red brick wall and the contrasting
shadow under the stairway that helped the white areas stand out
in contrast.
**Photo © Jim Miotke. 1/600 sec. at *f*/5, ISO 200, 24–70mm lens at
70mm**

Photographer Donna Pagakis went out to this beach, along the
Southern California coast, in hopes of capturing a stunning sunset.
Things were looking especially good with the eye-catching cloud
formations. "I set up my tripod in the sand," she recalls. "Then
I saw this jogger coming into frame and pressed the shutter. I
had my camera set on the 2-second timer, so I had to time it just
right." With the exposure set for the background, the shadowed
runner was rendered as a silhouette. To retain the colors pretty
much as she saw them, Pagakis used a daylight white balance
(covered in more detail in chapter 3).
**Photo © Donna Pagakis. 1/500 sec. at *f*/7.1, ISO 100, 18–55mm
lens at 18mm**

Armed with a macro lens, photographer Rob Sheppard caught this
little grasshopper at a native-plants garden in Los Angeles. While
the bright green subject leaps out against the dark background,
Sheppard emphasizes that there was no flash involved. "This is
actually sunlight," he says, "but the light from the sun is intense
next to a very dark shadow from an outbuilding in the garden."
Photo © Rob Sheppard. 1/125 sec. at *f*/11, ISO 400, 50mm lens

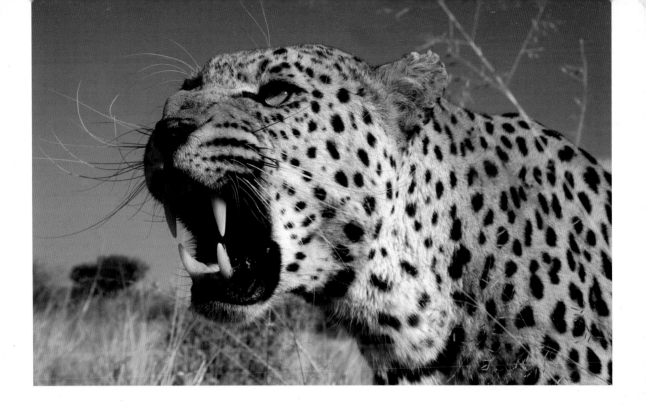

ACKNOWLEDGMENTS

We are very grateful to the many people who have helped us produce this book.

First, we would not be anywhere without Team BetterPhoto—thank you all for your incredible support.

Next, Jim would like to thank his family—wife, business partner, and best friend, Denise, and children Julian, Alex, and Alina—for their loving support. He is also very grateful to Brian and Marti Hauf for their prayerful and practical support.

Kerry would like to thank his family—wife and best friend, Mary, and his stepchildren, Dan and Kristin—for their great love and never-ending support.

A special thanks goes to the great team at Amphoto—Victoria Craven, Julie Mazur, Autumn Kindelspire, and Stephen Brewer.

We feel deeply honored to work with the amazing photographers who teach at BetterPhoto.com, including Tony Sweet, Jim Zuckerman, Vik Orenstein, Lewis Kemper, George Schaub, Kathleen T. Carr, Susan and Neil Silverman, Deborah Sandidge, Peter K. Burian, William Neill, G.

Newman Lowrance, Paul Gero, Rob Sheppard, Jim White, John Siskin, Charlotte Lowrie, Simon Stafford, Ibarionex Perello, Jenni Bidner, Doug Johnson, Kevin Moss, Lynne Eodice, and Doug Steakley. You all rock! On page 219, there is a list of websites of all the BetterPhoto members and instructors who shared their wonderful images. We would like to say "thank you" to each of you.

We also would like to thank Art Wolfe, Dewitt Jones, Jack Hollingsworth, Dane Sanders, Rick Sammon, Bob Krist, Jack Warren, Ben Willmore, and Colin Smith; Kevin La Rue and Laurie Shupp at Nik Software; Gabriel Biderman, Tana Thomson, Jonathan Yudin, and Hershel Waldner at B&H Photo; Sam Perdue at Lensbaby; Neal Gold and Chris Washko at Photographer's Edge; Gary Farber at Hunt's Photo in Boston; Kathleen Davis at Popular Photography; the team at Singh-Ray Filters; and the team behind Adobe Lightroom and Photoshop.

Last, we extend our thanks to the dedicated members of BetterPhoto, who have helped make this enterprise such an awesome and joyful photographic community. Keep it up!

We dedicate this book to all photographers
who dream of following their own creative vision
and who strive to follow the light.

CONTENTS

 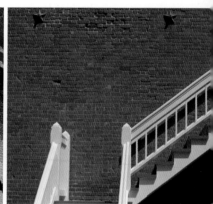

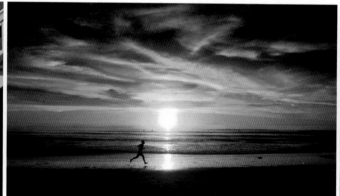
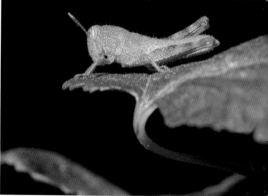

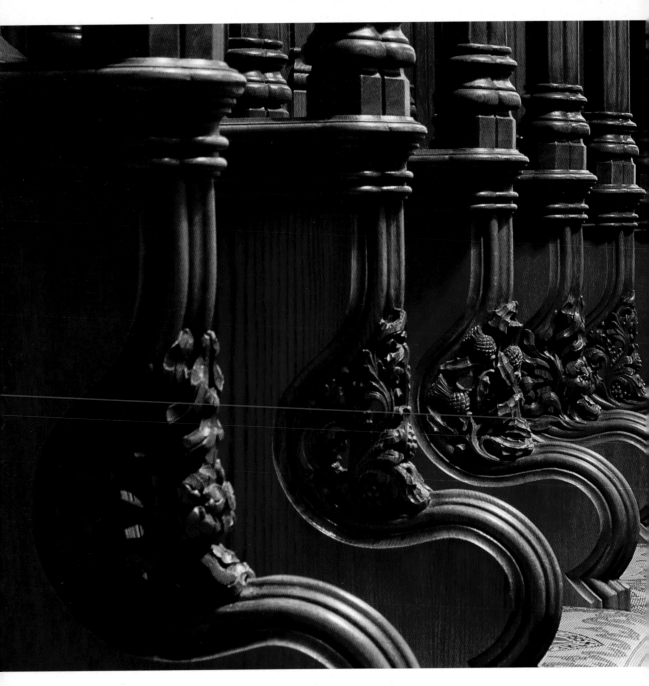

Photographer Christopher J. Budny says he has "always been drawn to repeating and receding design elements." This series of long bench-style seats—a "massive carved-oak beauty," as Budny calls it—graces the Great Choir of the Washington National Cathedral. These seats are lit by a collection of electric chandeliers high above, as well as ambient light from the many stained glass windows.

↑ Photo © Christopher J. Budny. 1 2/3 seconds at f/10, ISO 800, 17–85mm lens at 35mm

INTRODUCTION

Light can define a scene, enhance a mood, and make the image. Quite simply, if there's no light, there's no picture—a plain fact that should automatically place light at the top of any photographer's priority list. More than that, great light can help you create a great image. After all, photography is often defined as "writing with light." As acclaimed photographer Galen Rowell (1940–2002) says in his classic book, *Mountain Light,* "When the light is right, my camera is out long before I know what I want to photograph."

In *The BetterPhoto Guide to Photographing Light,* we discuss—in words and images—such topics as the direction of light, sunrise and sunset, the color of light, moody and dramatic light, and so much more. We cover such techniques for fixing lighting problems as fill flash, reflectors, and High Dynamic Range (HDR). Exposure receives its share of our time, too, and we cover potentially tricky situations like photographing in the snow and in low light. We discuss the time of day, from mid-morning to mid-afternoon, and show you how to make successful photos at high noon on a blue-sky day (rarely a prime time) and how to appreciate the light of an overcast day.

You'll learn new approaches that you can start to use immediately—techniques that are guaranteed to help breathe new life into your photography. The advice and insights we share on these pages have worked not only for us, but they have also proved to be effective for the many hundreds of students who have taken our classes and attended our workshops. These photographers have dramatically expanded their vision and discovered how light can magically take their photography to higher levels. As a result, they have started to make satisfying images consistently.

Of course, we realize that sometimes we have no choice regarding the light in which we must shoot. Parades, festivals, sporting events, and other special activities routinely occur in less-than-inspiring light. But nonetheless, a good understanding of natural light will help you photograph in not-so-stellar conditions. One of the underlying themes of this book is to help you make the most of whatever light you have.

If you're a beginner, the techniques and exercises we share are designed to take you beyond the snapshot stage and into the realm of creative photography. If you're an advanced shooter, you'll find insights and motivation for fine-tuning your knowledge of light and for taking your photography to the next artistic level.

Thinking outside the photographic box and experimenting with innovative ideas are overriding topics that come up throughout the book. Likewise, we can't overemphasize the fact that you don't need exotic locales to make exciting photographs. Possibilities for dynamic images exist anywhere, wherever you happen to be. And to really give your skills and creativity a boost, you need to shoot regularly.

This book is for all photographers, including enthusiasts who have jobs, are busy with families or school, and who may have limited financial resources. What's really required is a desire to learn, and since you are reading this book, you already have what you need to start taking your photography to new artistic heights.

CAMERA CONCERNS

Even though photography is amazingly gear oriented, you don't have to own the best equipment to make the best photos. Really. Over the years, we've critiqued thousands of student images. For the pictures that have fallen short, we have rarely pointed out the camera as the culprit. Rather, the reasons almost always involve shortcomings in light, composition, viewpoint, overall vision, subject selection, or creative technique.

You can accomplish most of the techniques in this book with any camera. Today's high-end digital compacts (also known as "point-and-shoots") are quite sophisticated, but we both choose DSLR (digital single-lens reflex) cameras for our pro work. Although relatively big and awkward as compared to the sleek compact models, DSLRs offer the ultimate in image quality while providing features and options that are easy to use. They also allow you to use a variety of lenses.

If you think you need to buy a new camera, our best advice is to wait and make the most of what you already have—until you can no longer stand the limitations of your current model and are ready to upgrade. You'll then know the precise bells, whistles, modes, and functions that you want, and as a result, you will be better able to make the informed choice that's right for you.

DIGITAL DARKROOM

All digital images require at least some optimizing—particularly if you're shooting in raw (see page 36). But the goal of this book is to help you capture images so well that you'll move beyond the "I'll fix it later in Photoshop" mentality. That attitude can lead to sloppy practices. Image-editing software can't always successfully salvage major exposure or composition problems, and no amount of fix can salvage images that fall short of a sparkling vision.

Of course, we realize you may wish to apply special digital filters to an image, make photo composites, or employ other digital art techniques. But even then, coming up with the best picture possible—right out of the camera—will make the entire process more enjoyable and more efficient and help ensure that you'll be happy with the final result.

It's easier than you might think to sharpen your skills, develop your creative eye, and become a master of light. The tips and techniques outlined in these pages will get you started on a very exciting path in your photographic journey. You're in for a fast, fun, and exhilarating ride. Paying attention to the quality of light is a time-tested way to start capturing more images that elicit an extended gaze, rather than a fleeting glance.

At a marina one cloudy day, this brightly colored rope caught my attention. I moved in tight with my macro lens and filled the frame with the yellow-and-blue pattern. A very small aperture resulted in a good depth of field, providing sharpness throughout the picture. → Photo © Kerry Drager. 1/3 sec. at *f*/22, ISO 100, 105mm lens

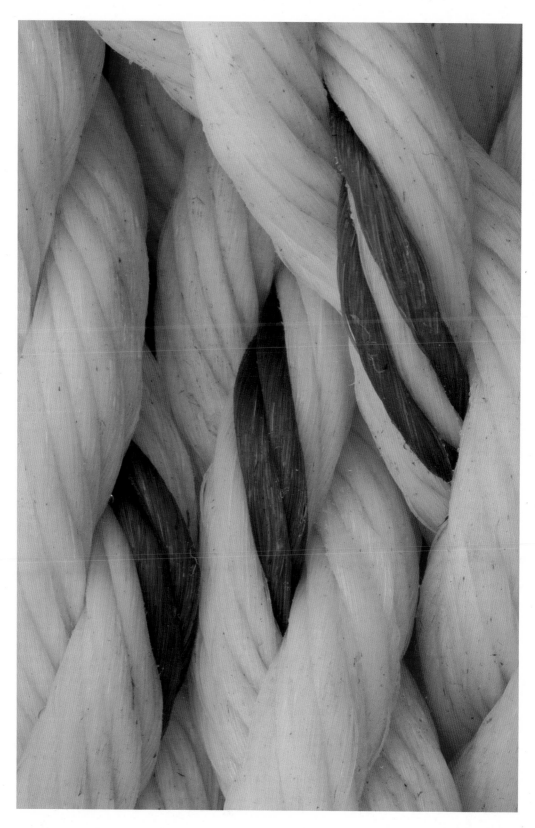

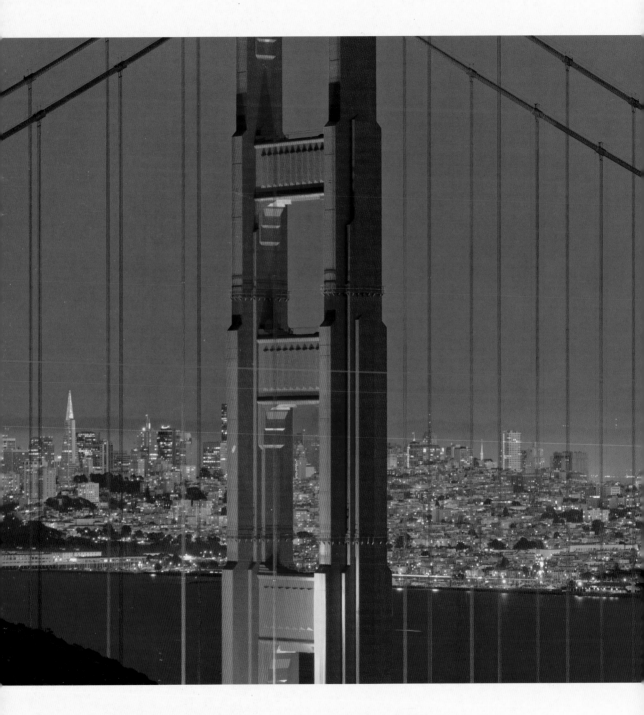

From high in the hills of Marin County, the views overlooking the Golden Gate Bridge—with San Francisco as a backdrop—are wonderful at any time. But at twilight, the scene is downright magical. This telephoto image, with the lights of the city twinkling against a beautiful blue sky, shows why many scenes look their best during the period between sunset and nighttime.

↑ Photo © Kerry Drager. 8 seconds at *f*/6.7, ISO 400, 70–300mm lens at 155mm

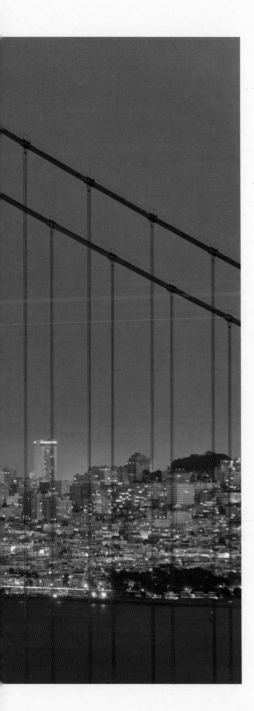

↗

CHAPTER 1

UNDERSTANDING NATURAL LIGHT

It really is as simple as it sounds: Start paying more attention to the quality of natural light and your photographs will more consistently match your hopes—and your vision.

The importance of the quality of light came to the fore in the earliest days of photography. "Light makes photography," wrote Eastman Kodak founder George Eastman (1854–1932). "Embrace light. Admire it. Love it. But above all, know light. Know it for all you are worth, and you will know the key to photography."

While photography rules are made to be broken, here are two that come close to being untouchable:

- An uninspiring subject in wonderful light almost always looks better than a wonderful subject in uninspiring light.
- Unless you are willing to regularly take advantage of beautiful light, your photography will never live up to its potential.

You already know light's potential to create some remarkable sights. Just think of the last sunset you saw. But it's not always easy to grasp the intricacies of natural light. This first chapter is all about helping you more fully understand light and how your camera records it. This not only requires that you analyze light's impact on your subject at a given moment but that you also imagine how light might transform a scene at another time. Now, let's get started!

THINKING ABOUT LIGHT

Successful outdoor shooters understand and pay attention to the quality of light. By quality we mean the direction, intensity, and color of light. When clouds are moving and the sunlight is shifting, light becomes a minute-by-minute adventure, turning from routine to dramatic in an instant.

Experienced photographers use natural light to inject drama, enhance tones, and create mood. Learning to recognize good light and how to work with it will help you expand your photography. A good way to start is by asking questions: Is the light gentle, harsh, or glaring? Which way are the shadows falling? What direction is the light hitting your subject or scene? Is the sunlight coming toward you, from behind you, or from the left or right?

Whenever possible with our own photography, we prefer to let the light dictate what we shoot. The sun throws long shadows and warm tones when it is low in the sky, and this light is ideal for shooting sweeping landscapes, seascapes, or city skylines. An overcast day, when the light is diffused, even, and soothing and casts no shadows, is just right for capturing the colors and details of intimate scenes and for shooting close-ups.

As this book progresses, you will expand your awareness of light's infinite range of characteristics and subtleties and how light impacts subjects. You'll come to understand how the fleeting nature of natural light lets you capture unique photos of places that have been shot hundreds of times. You'll be pleasantly surprised how much your photography improves once you start thinking—*really* thinking—about light.

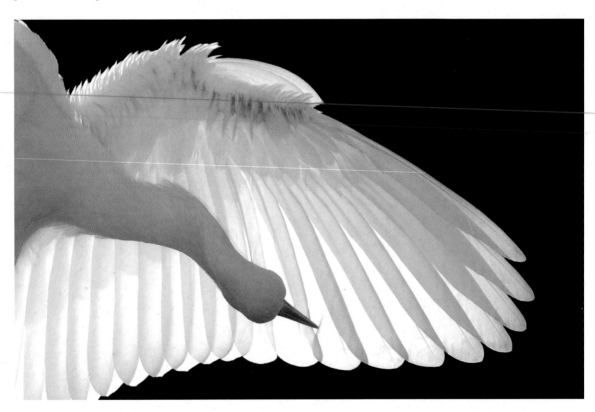

Especially in early spring, the Alligator Farm in St. Augustine, Florida, is the place to be for bird photography. Photographer Deborah Sandidge noticed this young egret preening her feathers in the light of early morning. "There was something very elegant in the gesture of extending her wing," recalls Sandidge. "She seemed to be counting her feathers one by one. I set up my tripod and camera, waiting for just the right moment to take the photo that would tell my story." A fast shutter speed froze the moment.
↑ Photo © Deborah Sandidge. 1/640 sec. at *f*/5.6, ISO 200, 200–400mm lens at 270mm

Steel storage buildings are a common sight in the California countryside. These two images show how light transformed a routine wall into a graphic-design pattern of light, shadow, and color. I shot the image at left in midafternoon. In the image below, the setting sun turned the reflective wall into a golden glow.

← Photo © Kerry Drager. 1/80 sec. at f/18, ISO 100, 105mm lens

↓ Photo © Kerry Drager. 1/10 sec. at f/22, ISO 100, 105mm lens

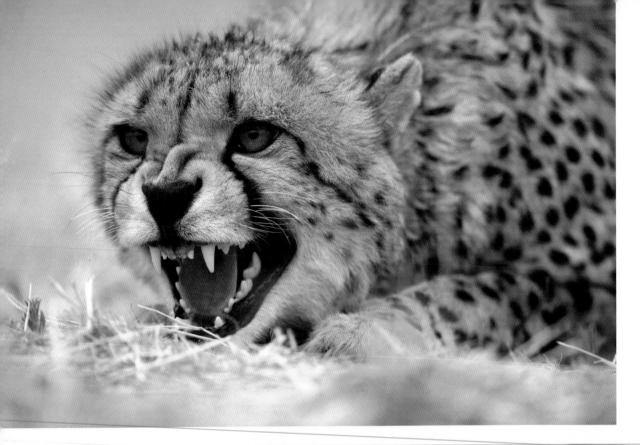

This close encounter with a young cheetah in Namibia, Africa, via long telephoto, demonstrates how effective soft overcast light can be when photographing animals—or humans, for that matter.
↑ **Photo** © Jim Zuckerman. 1/320 sec. at *f*/4.5, ISO 200, 500mm lens

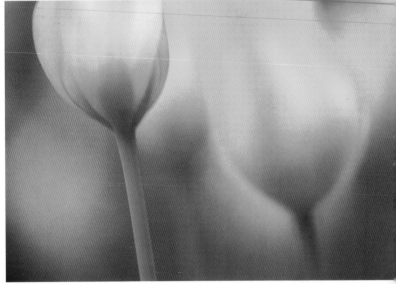

In this close-up image, light is just as important as the subject. The pleasant lighting—no harsh bright-versus-shadow contrast—highlights the colors of this grouping of flowers. In addition, the wide aperture, long telephoto lens, and close focusing create a narrow depth of field with very little sharpness from front to back, enhancing the soft look of this image.
↑ **Photo** © Tony Sweet. 1/125 sec. at *f*/4, ISO 50, 300mm lens

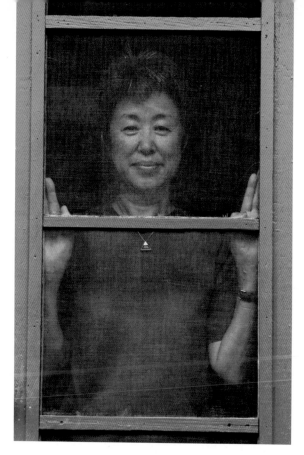

Diffused sunlight and window screening help create an unusual portrait. The vertical format not only captures the symmetry of the subject's upraised arms but also catches the color contrast between the red frame and the blue clothing.
← **Photo** © Kathleen T. Carr. 1/60 sec. at *f*/9, ISO 200, 18–55mm lens at 55mm

Not everyone appreciates a solid overcast sky. Yet working in cloudy conditions can be a major photographic benefit when you narrow your view and choose colorful subjects. Nature's great white canopy cast gentle lighting that was ideal for an abstract rendition of the bottom of an old, multicolor rowboat. Additionally, I used a polarizing filter to reduce the amount of glare on the boat's surface while boosting the colors. (See chapter 3 for more on polarizers.)
→ **Photo** © Kerry Drager. 1/4 sec. at *f*/22, ISO 200, 12–24mm lens at 24mm

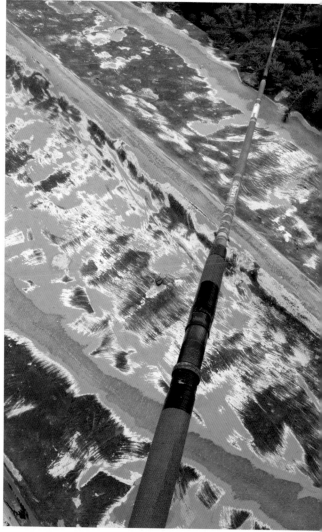

BECOME AN OBSERVER OF LIGHT

Make a habit of becoming an observer of light. Begin with a little exploring in and around your home. Take an hour here, an hour there, and give your creative eye a workout. Instead of thinking specifically about the subjects—furniture, windows, plants, etc.—start watching for the light. See how the light from your kitchen window strikes dishes or silverware on the counter. Discover how sunlight reflects off a wall or illuminates flowers or other plants. Find out how light can add texture or color. You'll soon discover that light transforms every object it touches.

Accept this challenge: Always strive to look around you and consider shooting a scene in a unique way. Altering your camera position can put your subject in a totally different and maybe better light. Spend the time to make the most of a situation. Change your camera angle in relation to the sun. Vary the compositions. Zoom in tighter, move in physically closer, step to the side.

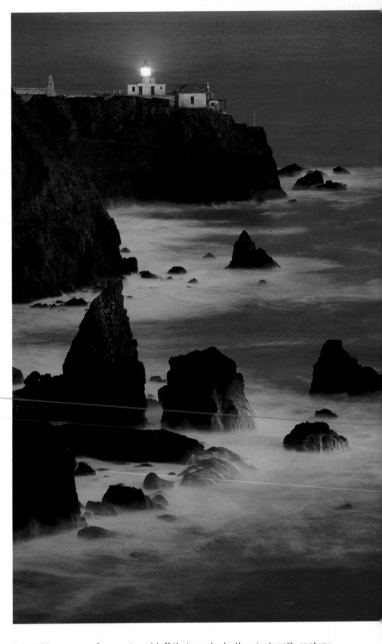

I shot this seascape from a steep bluff that overlooks the nineteenth-century Point Bonita Lighthouse just across San Francisco's Golden Gate Bridge in Marin County. Besides a high vantage point, I chose a special time of day: dusk (late twilight), which cast the scene in a magical blue. In addition, the light was low and the shutter speed was slow—ideal for capturing the almost-surreal appearance of the surf. Incidentally, here's a good tip that I put to use for this scene: Don't stop too soon. Right before nighttime kicks in, things may appear too dim for shooting, but if you detect even a hint of color left in the sky, go for it. The camera's ability to accumulate light over time can make the resulting image brighter and more colorful than what you see. Twilight has been called the "blue hour," and this scene shows why!
↑ Photo © Kerry Drager. 10 seconds at *f*/8, ISO 200, 70–300mm lens at 155mm

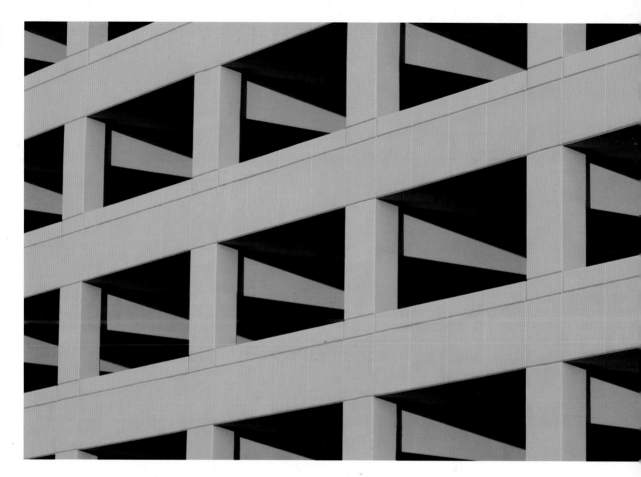

I enjoy heading out and looking for photos even when I don't have a specific project or assignment in mind. These excursions are thought- and creativity-provoking workouts. On one photo quest shortly before sunset I discovered this multistory parking structure. I used my telephoto lens to zoom in for a very tight composition that spotlighted the graphic light-and-shadow patterns. Getting out in fine light is a terrific way to escape the creativity doldrums. After all, just about everything looks better in eye-grabbing light, even parking garages!

↑ Photo © Kerry Drager. 1/45 sec. at *f*/22, ISO 200, 80–200mm lens at 170mm

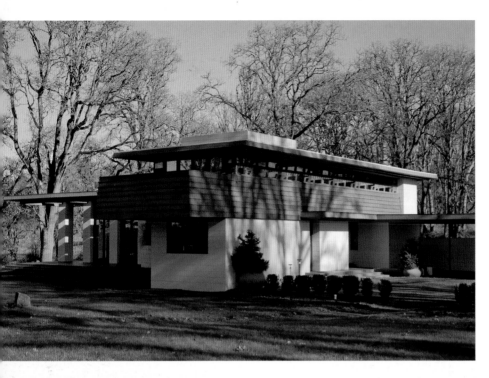

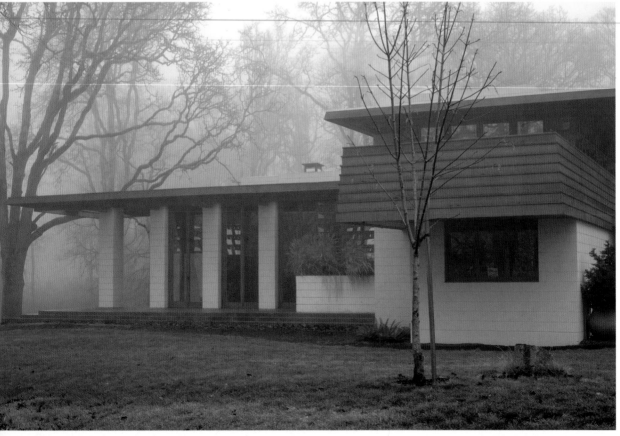

On my first visit to Gordon House in Silverton, Oregon, designed by Frank Lloyd Wright in 1957, I encountered an unattractive mixture of bright sunlight and deep shadow; see the image top left. But I recognized the subject's potential, and when moody fog swept the area the next day, I returned for an overall view and for a more intimate composition.

↖ Photo © Kerry Drager. 1/10 sec. at f/9, ISO 200, 50mm lens

← Photo © Kerry Drager. 1/45 sec. at f/11, ISO 200, 50mm lens

↑ Photo © Kerry Drager. 1/15 sec. at f/13, ISO 200, 105mm lens

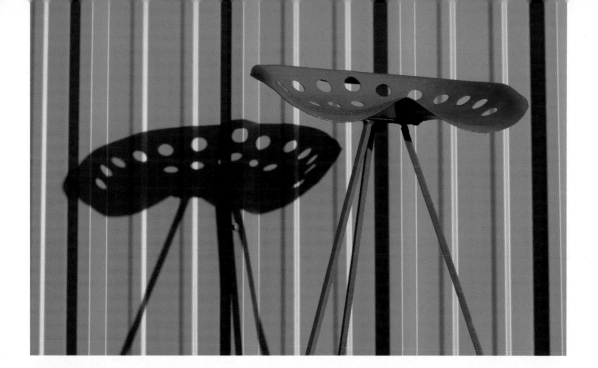

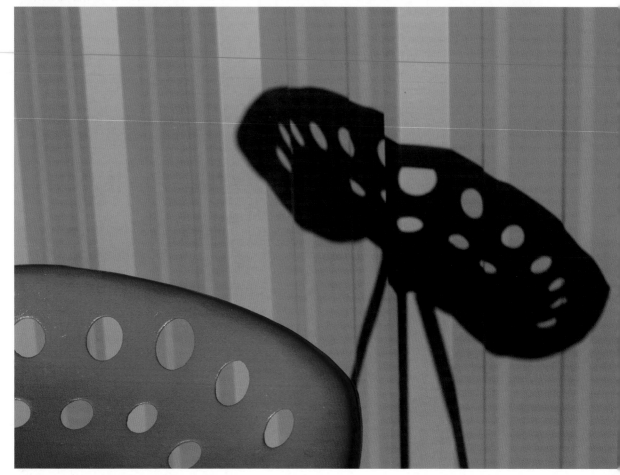

This tractor-seat stool next to a steel storage building caught my attention late one sunny day in wintertime. The fresh coat of red paint particularly stood out, as did the outstanding shadow. I liked my first attempt (top left), but I thought I could do better. I returned a short while later (minutes before sunset) and simplified the composition to spotlight just the shadow and a section of the bright red seat. Around sunset the light changes fast and furious: Although these two photos were taken just fifteen minutes apart, you can see a noticeable difference with the light warming up further in the later (close-up) shot.

← Photo © Kerry Drager. 1/45 sec. at *f*/19, ISO 200, 105mm lens
↓ Photo © Kerry Drager. 1/15 sec. at *f*/22, ISO 200, 105mm lens

 TIP: COME BACK FOR SECONDS

Explore any scene you wish to photograph for different compositions and viewpoints, and ask, Is this the best light? A sensible way to answer that question is to come back at another time and see for yourself! All you need to do is find an interesting and easily accessible scene that you can visit again and again at different times and in varying weather. This act of recording a subject, inspecting the results on another day (after your initial excitement about the scene has cooled down), and returning for a reshoot or two is a valuable way to develop your self-critiquing abilities while also improving your photographic vision. You'll discover how rewarding and enjoyable it is to become a student of light!

SEEING LIKE THE CAMERA SEES

Let's be blunt. You and your camera don't always see eye to eye. While we have an incredible ability to recognize tonal extremes, digital sensors can only detect a fairly limited dynamic range of light. As a result, the camera simply can't record a high-contrast scene of deep shadows and bright highlights in a single image. When you shoot a scene that has a range of sunlight to shadow, the subject will likely look either washed out or too dark. This human-versus-camera disparity explains why we often remember the lighting in a scene as being so much better than what appears in the pictures.

Photographing based on the way our cameras view the world, rather than the way we do, can be a challenge. The good news is that it doesn't take years of experience to start making a connection between what you're seeing and how the camera is recording it. This subject will come up throughout the book—it's that important!—in different contexts.

Once you really grasp this whole concept, you'll no longer wonder why your photos don't always match what you saw. You'll be able to recognize lighting contrast and how it helps—or hurts—your interpretation of a scene.

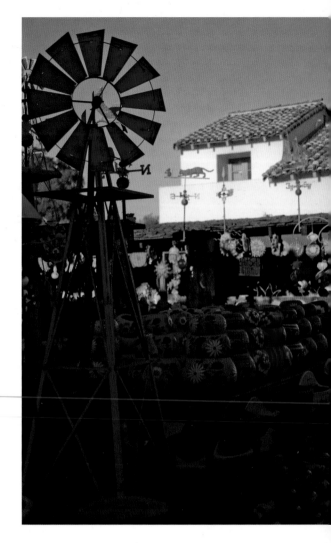

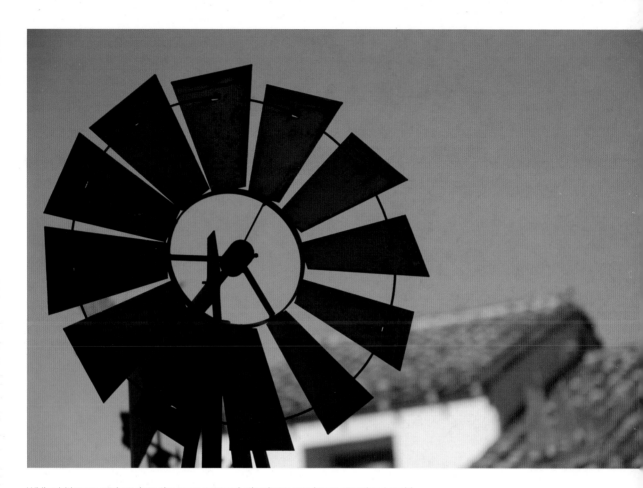

While visiting an outdoor shop, the many pots and other items caught my attention. I could easily detect good detail throughout the scene—that's the nature of the human eye—but the camera simply can't record such an extreme range of bright to dark: While the sunlit building and sky appeared good and colorful, the shadowed part of the scene was very dark. By zooming in tight with a telephoto, I was able to leave out the shaded area while showing the silhouetted windmill against the bright blue background, with a slice of the red-tile roofs adding visual interest. What if I wanted to capture the foreground, too? I could have made a second photo while leaving out the sky, shot multiple exposures and combined them later (see High Dynamic Range in chapter 5), or returned when the entire scene was in sunlight.

↖ Photo © Jim Miotke. 1/1000 sec. at *f*/5, ISO 200, 28–135mm lens at 56mm

↑ Photo © Jim Miotke. 1/800 sec. at *f*/5, ISO 200, 28–135mm lens at 135mm

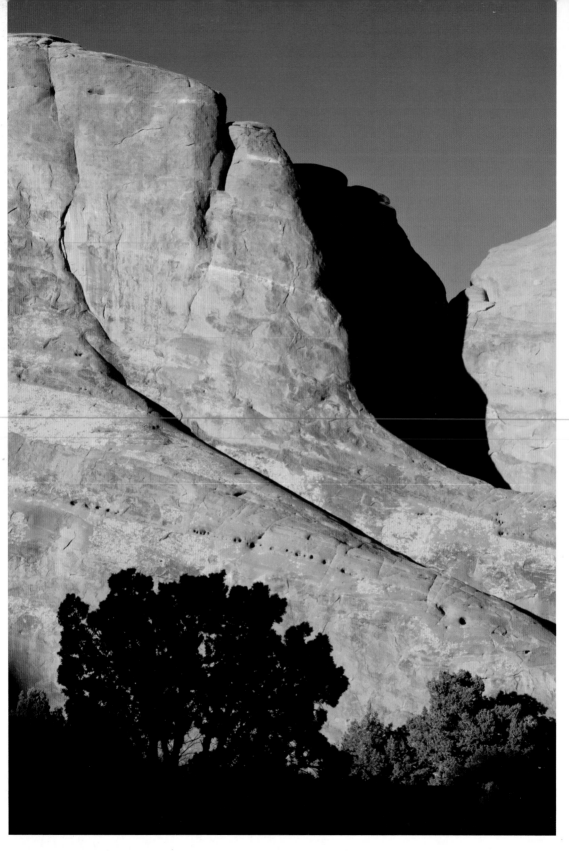

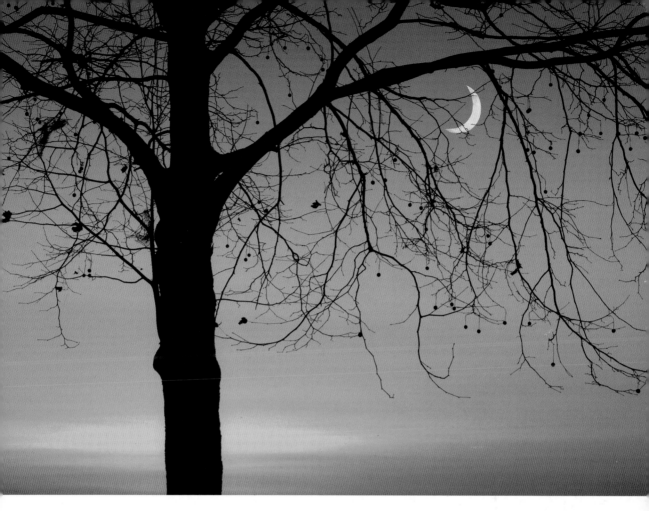

The contrast of a bright rock wall and a shaded juniper in Arches National Park, Utah, caught the attention of photographer Rob Sheppard late one afternoon. Although he could easily see a great deal of detail throughout the scene, he knew that the camera records a narrow range of lighting values. Setting the exposure for the bright wall rendered the shadows in black, creating a striking interplay of light, color, and shadow.

← Photo © Rob Sheppard. 1/60 sec. at *f*/13, ISO 100, 28–135mm lens at 53mm

The outstretched branch of a silhouetted tree frames an outstanding crescent moon in a bright, colorful twilight sky. The photographer achieved the effect by setting an exposure reading directly off the sky, locking in those settings, recomposing, and firing away.

↑ Photo © Deborah Sandidge. 1/80 sec. at *f*/11, ISO 400, 24–70mm lens at 70mm

EXPECT THE UNEXPECTED

Being ready to let go of your preconceived ideas can be a winning formula for creativity with light. While a well-thought-out plan of attack helps you make the most of a shoot, an open mind is just as important. At times the elements just won't fall into place according to design. Construction might derail your city shoot. Low-angled sunlight may never hit the meadow that's high on your photo list. A grand landscape may look downright dull under a gray sky.

But photographers who expect the unexpected and make the most of a situation are often the recipients of happy surprises. Accept the challenge.

Experienced photographers usually have a Plan B—a backup strategy—just in case. They have a secondary location in mind, one they can shoot in any light, just in case the main objective falls short.

On a winter weekend visit to the California coast, my plan was to capture sweeping seascapes in the late-day sunlight. But Mother Nature had different plans, in the form of heavy overcast skies. I knew that Point Lobos State Reserve was renowned for its incredible rock formations, and since the soft light of a white or gray sky is ideal for recording colors and details, I switched my attention to working on a smaller palette. I then zeroed in tight on the designs.
↑ Photo © Kerry Drager. 1/15 sec. at f/16, ISO 200, 20mm lens
→ Photo © Kerry Drager. 1/8 sec. at f/16, ISO 200, 20mm lens

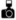 ASSIGNMENT: SHOOT, THEN STUDY

For this exercise, first photograph the same scene or subject at various times throughout the day. You can do this over a series of days. The idea is to see how natural light accents a scene in various lighting conditions, so be sure to find a location where nothing blocks low-angled sunlight. Photograph your subject in early morning, midday, and late day.

Study your results. A key factor in improving your lighting visual power is to analyze your digital files carefully after each photo session. Don't just delete the misses and admire the hits. Instead, review the images to see why some work and some fall short. By spending quality time with your photos, you'll really see, and even feel, the difference that light can make.

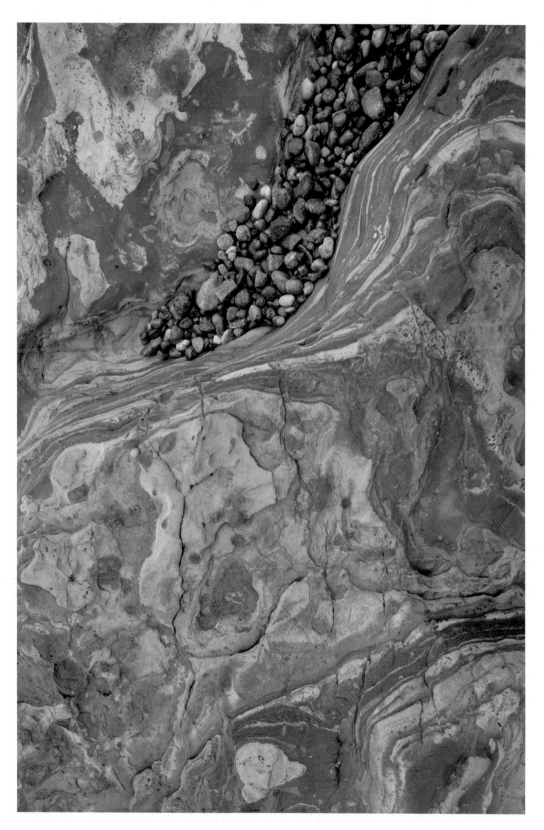

USING A TRIPOD: WHY AND WHEN

It's time to talk tripods (and we can hear the moans and groans about the so-called accessory that photographers love to hate). Using a tripod can be a hassle at best and, when photographing action or shooting in busy places, is often just not practical. Some museums and other locations may even prohibit the use of a tripod.

But using a tripod will boost your photography in terms of image quality and in terms of composition, too. A tripod allows you to be more deliberate in framing the picture, and, just as important, it opens up a dramatic world of low light without flash—at daybreak or sundown, during twilight, in deep shade, and even indoors. With a tripod, you won't need to rack up the ISO to high levels that can produce noise (see more on ISO on page 34). And a tripod allows you to achieve some cool special effects, such as turning moving water into a silky flow via a super-slow shutter speed.

Avoid going the cheap route, however. Our students often tell us they don't use their tripods because they're too flimsy and too difficult to operate. A quality tripod, with good support and with quick-and-easy controls, is a pleasure to use and a worthwhile investment in your photographic hobby.

A few buying tips:

- Make sure the tripod is sturdy enough to hold your gear. A lightweight model may be wonderful to carry, but if it can't adequately hold your hefty DSLR and telephoto-zoom lens, then it will be of little value. When shopping, take your heaviest camera/lens combination and see how the tripod performs. Online, confirm the maximum weight that both legs and head can carry. The precise weight can vary wildly, depending on your gear—ranging from less than two pounds for a lightweight DSLR with a small zoom lens to six pounds (or more!) for a hefty pro DSLR with a big telephoto zoom.
- A quick-release system is an absolute must—this makes it a snap to take the camera on and off the tripod head.
- A cable shutter release allows you to keep your hands off the camera, so you record the image without inadvertently jiggling the tripod.
- Height matters too. If you do a lot of ground level close-up work, you'll want a tripod that goes low. You also want a tripod that you can raise to eye level without compromising rigidity by having to raise the center column to a high position, especially when it's windy.

TIP: CHECK BEFORE STABILIZING

Image stabilization—often called VR (vibration reduction) or IS (image stabilization)—reduces blurriness caused by camera shake or vibration. But, in some cases, stabilization can actually increase blurriness when using a tripod. That's because there can be a "tension" between the stabilization technology trying to detect camera movement and the tripod keeping the camera steady. So here's the *standard* advice: When in doubt, it's usually best to turn off built-into-the-camera stabilization or lens stabilization when using a tripod. However, some newer lens VR/IS systems work just fine in conjunction with a tripod, so the *best* advice is to check your instruction manual for the definitive course of action for your gear.

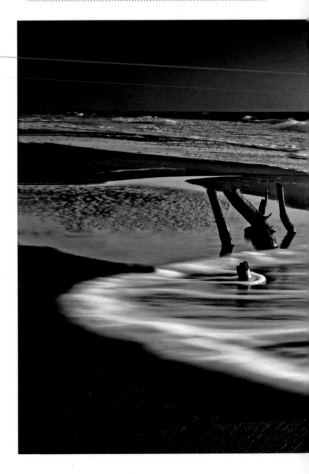

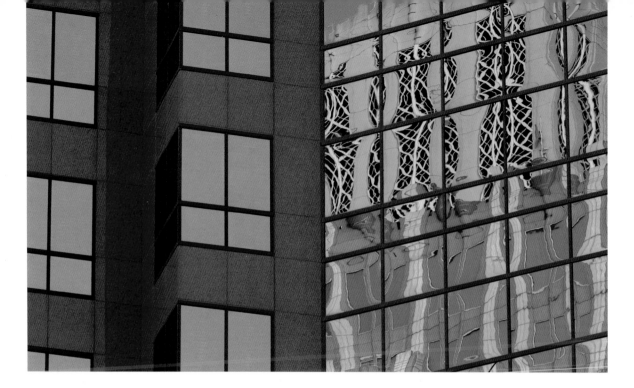

Good things seem to happen when photographers venture out late in the day. This building was in shadow, while the late-day sunlight lit up a nearby building (shown in the reflection) with warm light. A long telephoto zoom lens, combined with a small aperture to capture a good depth of field (to ensure sharpness in the main building and the reflection), meant a very slow shutter speed—definitely a time for a sturdy tripod.

↑ Photo © Kerry Drager. 1/8 sec. at *f*/16, ISO 200, 70–300mm lens at 280mm

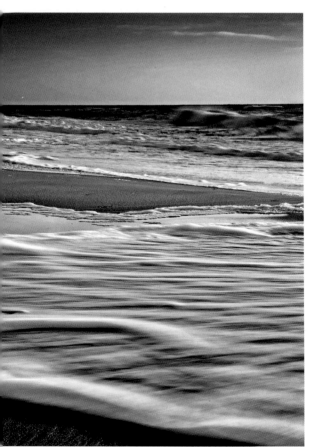

A tripod was a necessity when photographer Deborah Lewinson set out to capture this coastal scene at sunrise. It enabled her to use a slow shutter speed to blur the water and show the pattern of the retreating wave. "I was most concerned with the light and wanted to show night changing to day," Lewinson says. She chose to convert the photo to black and white to emphasize the scene's great tonal contrast.

← Photo © Deborah Lewinson. 1/6 sec. at *f*/27, ISO 100, 28–300mm lens at 45mm

REVIEW OF EXPOSURE BASICS

Throughout this book, we discuss specific ways to get the right exposure in difficult lighting situations—from low light to bright snow, and from backlight to twilight. But if you feel a need for a quick refresher course on the basics, read on.

Three factors work together to control how much light reaches the camera's sensor—that is, provide the right exposure. However, setting exposure can be a balancing act: When you change one of these three elements, another must be changed to keep everything in perfect balance. Even though the camera does much of this automatically—unless you're in manual mode—it's important to know how these settings interrelate and affect your photo. Here's a quick rundown:

APERTURE (OR *f*-STOP)

This is the size of the lens opening, which lets light pass through the camera. You adjust the size of the aperture to change the amount of light entering the camera and exposing the digital sensor. The higher the *f*-stop number, the smaller the lens aperture (less light will enter the lens). The lower the *f*-stop number, the larger the lens opening (more light being let in).

The *f*-stop is a major factor in controlling the depth of field (the range of front-to-back sharpness in a scene with depth). Wider lens openings give less depth of field but also contribute to faster shutter speeds. Smaller apertures mean a greater depth of field but a slower shutter speed.

The traditional DSLR *f*-stop settings include *f*/2, *f*/2.8, *f*/4, *f*/5.6, *f*/8, *f*/11, *f*/16, and *f*/22. Each *f*-stop lets in twice as much light as the next setting and half as much as the previous setting. The largest aperture (lowest *f*-stop number) varies from lens to lens. A "full stop" (or simply a "stop") refers to each doubling or halving of the light. In addition, many cameras also allow you to set apertures by one-third stops (so between *f*/8 and *f*/11, for example, there are the third stops of *f*/9 and *f*/10) or by one-half stops (i.e., *f*/9.5 between *f*/8 and *f*/11).

SHUTTER SPEED

This controls the length of time the shutter remains open to allow light to pass through the lens aperture to the sensor. The shutter button opens the shutter for a set amount of time, specified by the shutter speed. In addition, shutter speeds let you freeze the action with a fast speed or blur subject motion with a slow speed.

Standard shutter speeds include 1 second and 1/2, 1/4, 1/8, 1/15, 1/30, 1/60, 1/125, 1/250, 1/500, and 1/1000 of a second. Of these basic speeds, each is half as fast as the next setting and twice as fast as the previous one. Most cameras now offer speeds in either one-third intervals (so between 1/125 and 1/60, for instance, you may find 1/100 and 1/80) or one-half increments (i.e., 1/90 between 1/125 and 1/60).

ISO

This measures the sensor's sensitivity to light. A less sensitive ISO (lower number) means the sensor must receive more light (via a wider aperture, a longer shutter speed, or both) to get the same exposure you'll achieve with a very sensitive ISO setting (higher number). While a high ISO setting can mean faster shutter speeds, the downside is that higher ISOs can cause "noise," an effect in which the image looks grainy or mushy with color blotches. Camera manufacturers, by the way, have made ISO a priority in recent years, and newer DSLRs are able to handle higher ISOs while still maintaining acceptable image quality. Still, the precise ISO at which noise kicks in at a detectable level varies from camera to camera.

Here's our guideline: Use a high ISO only when necessary. Unless your subject is moving or the light is very low and you can't use a tripod, then go with your camera's lowest ISO setting (usually 100 or 200), since that will produce the least amount of noise. But if a high ISO is necessary, go for it. A sharp, noisy picture is always preferable to a blurry, non-noisy one.

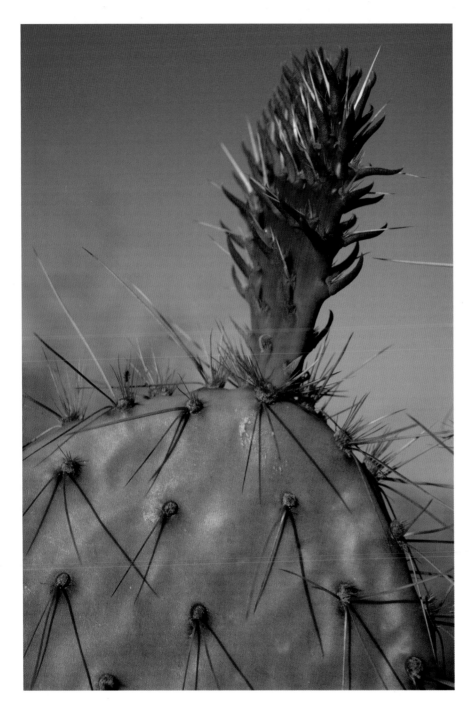

Morning light and some lingering fog created a mood I liked and seemed to go perfectly with this cactus. I took a low camera position so I could place the subject against the beautiful blue sky. A slight slant to the cactus added extra visual energy to the photo. Exposure was easy—pretty much a point-and-shoot situation, in fact—because of the middle tones and the even illumination (no harsh mix of light and shadow).

↑ Photo © Jim Miotke. 1/200 sec. at f/10, ISO 100, 24–70mm lens at 70mm

OTHER CONSIDERATIONS

For the best images, also take these exposure-related considerations into account.

Manual or Auto?

You may think that all-manual exposure is recommended for serious shooters, but that's not necessarily the case! While some serious shooters do operate in manual much or all of the time, many pros actually use one of the semi-autoexposure modes—such as Aperture Priority or Shutter Priority. Either way, it's important to know a little bit about the basics of exposure, so that you know what you—and your camera—are doing in whichever metering mode you choose to use.

Which Metering Mode?

Here's a question that comes up a lot, and no wonder, since digital cameras provide multiple metering options, usually including the following:

- Multipattern (also known as multizone or multisegment), which reads and analyzes different parts of the scene to compute the exposure. Camera makers have different names for this mode, such as Evaluative or Matrix.
- Center weighted, which, as the name implies, emphasizes the middle area shown in the viewfinder.
- Spot, which measures a tiny part of the scene.

The multipattern mode (i.e., Evaluative or Matrix) is the "default" for many photographers, since it handles most lighting situations successfully. That's what we both use routinely. When darks or brights dominate much of the frame, we might choose another mode to get an accurate reading: center-weighted or, more frequently, spot metering, since it really zeroes in tight on a distant subject. Keep in mind, though, that spot metering is a specialty mode for limited situations that require you to interpret the scene accurately and then choose the correct spot in the scene to meter. If in doubt, stick to multipattern, plus our suggestions (which we share throughout the book) for handling tricky exposure situations.

Exposure Compensation

This is a major go-to feature when you're in challenging lighting conditions, such as when you encounter a high contrast of brights and shadows or are shooting a scene that is primarily light-toned or very dark-toned. Photograph the scene as you normally would, then study the image on the back of your camera using the histogram or the highlight warning (for more on these functions, see page 60). If the photo seems too dark (underexposed), you can reshoot to lighten it via an exposure compensation adjustment; if it seems too light (overexposed), you can darken it.

Exposure compensation can be made in one-third or one-half stop increments, depending on your DSLR's settings. Note: Some cameras use the term "EV" (Exposure Value) when referring to increasing or decreasing the exposure.

Raw or JPEG?

If you aren't already shooting in Camera Raw, we urge you to start doing so. Raw files contain much more tonal and color information than JPEGs do, so they are much more forgiving. The additional file data offer much greater flexibility in working with images in the digital darkroom. For instance, if you make a mistake with exposure or white balance (see chapter 3), you have many more options for fixing your errors in the digital darkroom and for adjusting other aspects of the photo. That's why the raw file is aptly compared to a film negative.

While you must process raw files with specialized software before you work on them in the digital darkroom, once you nail down some workflow skills the extra work is easy and you'll be glad you have raw versions of your images available. If you are wedded to JPEGs, you don't necessarily have to give them up—many cameras have a Raw+JPEG option in which the two files are simultaneously recorded. Then you have a JPEG for your instant gratification, while a raw version is available if you feel an image requires more intense processing sometime in the future. Note, though, that raw shooting takes up more memory card space—and more storage space in your computer—but we think it's worth it!

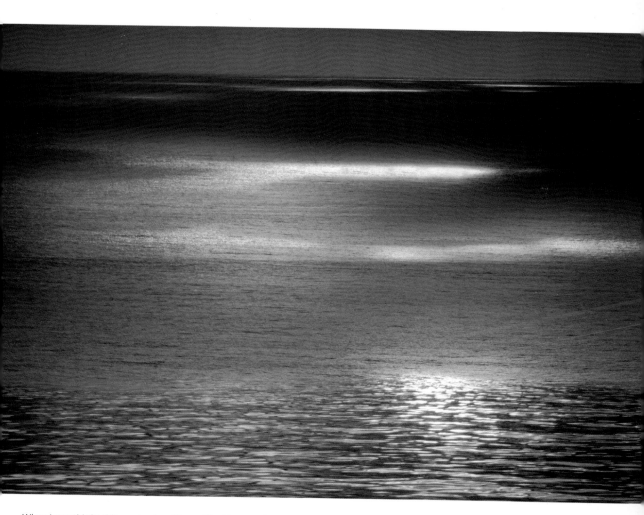

When I saw this backlit ocean view, I knew I had to record it. As always, exposure can be an issue with scenes like this, which have both bright areas and dark areas. I know that camera-metering systems are programmed for middle tones, including medium gray, so I simply switched to spot-metering mode and pointed to one of the many parts of the scene that are mid-gray (not light, not dark). Then, with exposure lock, I recomposed and shot the scene with those settings. Here's another solution: Photograph things as you normally would and then study the image on the back of your camera. Use exposure compensation if you think an adjustment is necessary.

↑ Photo © Jim Miotke. 1/2000 sec. at f/5.6, ISO 100, 70–300mm lens at 300mm

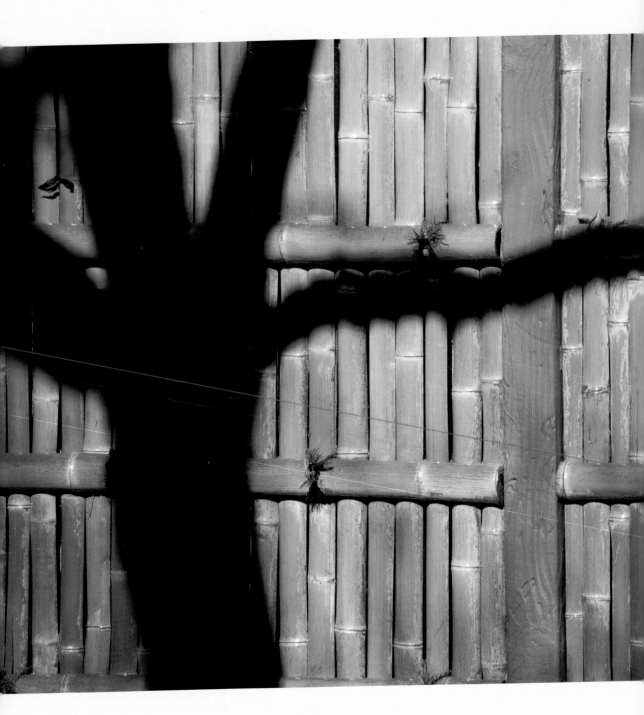

One of the benefits of shooting in low-angled light early or late on a sunny day is just what you see on this bamboo fence in San Diego: a dynamic shadow with accompanying warm light. This distinctive tree, with a simple yet strong form, made a great subject for a light-and-shadow photo. A long telephoto helped me zoom in on just the important parts.

↑ Photo © Jim Miotke. 1/800 sec. at *f*/8, ISO 400, 70–300mm lens at 300mm

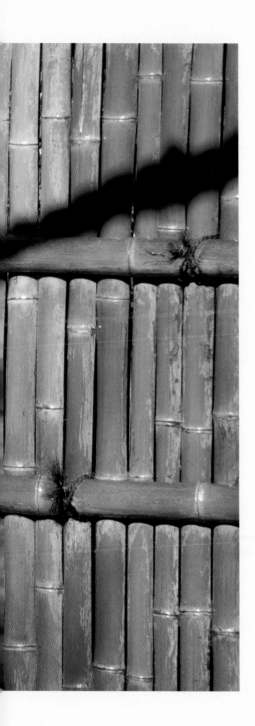

CHAPTER 2

DIRECTION
OF LIGHT

Want the best light for your subject? The solution may be as simple as changing your camera position in relation to the sun. Paying attention to the direction of light, and exploiting the various possibilities, can offer high visual impact.

For example, when the sun is low in the sky, you have several options for lighting your subject or scene—from the front, side, and back. Each can offer a dramatically unique effect, and there are lots of variations in between.

Midday "toplight" has potential as well, even though this is frequently the least interesting light a photographer will encounter. For portraits, the midday sun's bright harshness puts shadows in all the wrong places, and for landscapes, the overhead sunlight tends to "flatten" the scenery. However, you might be pleasantly surprised at the results you get from the techniques we share for working productively in midday.

Be forewarned, though, that experimenting with light's direction can be an unnervingly easy way to create exposure challenges, particularly with backlighting. In any case, your photo success hangs on understanding what light does and how it impacts your scene. So read on: In this chapter, we cover all the ins and outs of the direction of light.

FRONTLIGHT

Frontlight occurs when the photographer is situated between the subject and the sun, and it is generally the easiest type of lighting in which to photograph. In other words, the sun is at your back and hits the front of your scene. Frontlight is straight-on and straightforward and often is just right for what you want to photograph.

Frontlight, however, has long been called "flat lighting," since a scene is illuminated uniformly from the front. As a result, objects lose much of their form, texture, depth, and perspective.

While frontlighting may lack sidelight's dimension and backlight's drama, it has virtues, too—namely in regard to exposure and color. First, frontlight is convenient and easy to work with, since all sections of the scene fall within the same brightness range. This lack of contrast generally translates into simple exposure circumstances—just set your camera on autopilot and fire away. Second, direct illumination can be just right for capturing rich colors, and tones are especially vibrant in the low-angled sunlight of early and late day. When visual drama unfolds as the sun rises and sets at the ends of the day, look around you to see captivating subjects illuminated by warm, glowing light.

For portraits, low-angled sunlight can reduce unwanted shadows on your subject's face. For the proper exposure, just point your camera at the scene, select the combination of exposure settings to fit your subject, and click away to get a good image.

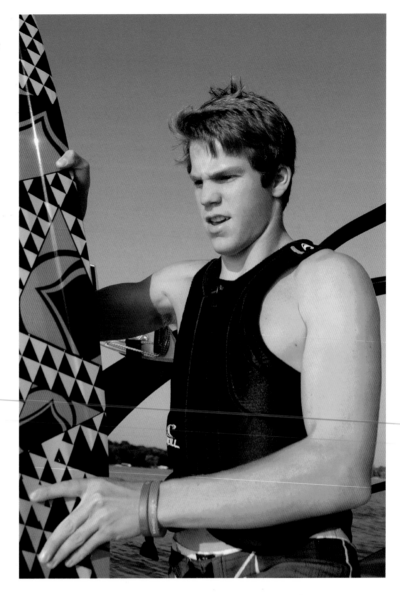

People can look great in warm and low-angled sunlight, and subjects in direct sunlight can often best be captured when the sun hits them at a slight angle rather than strictly straight on. Photographer Vik Orenstein caught this wake boarder in late afternoon, with the sun hitting him at a slight angle—mostly frontlight but slightly to the side.
↑ Photo © Vik Orenstein/Kidcapers Portraits. 1/3200 sec. at f/3.5, ISO 400, 18mm lens

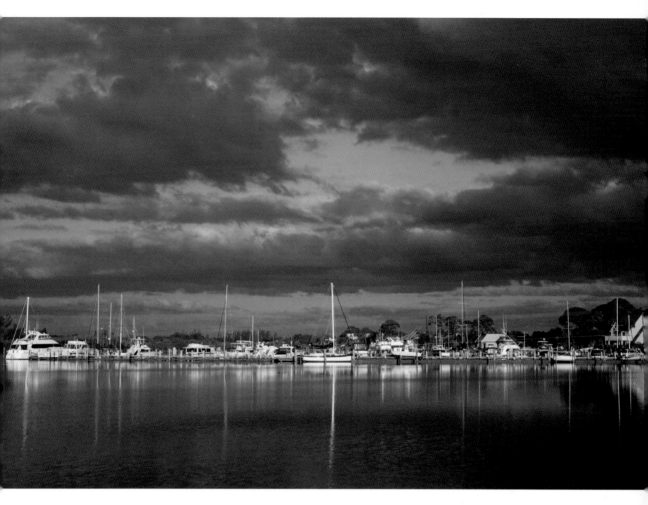

A blend of clouds and sky almost always pumps up landscapes and seascapes. Photographing in early-morning light is extra-special, as shown in this marina scene just after sunrise. With frontlighting (sun behind me), the white boats jump out in contrast to the richly colored sky and water.

↑ Photo © Jim Miotke. 1/3200 sec. at *f*/3.5, ISO 400, 18mm lens

Shooting shadow shots in warm, low-angled sunlight is a great way to have fun with the camera, as I did late one day on a beach in Fiji. These two images also prove the versatility of the wide-angle lens. I shot both with the same 24mm focal length, but by changing the camera position, I transformed the entire perspective. One image shows the tree filling the frame. Then, simply by moving back, I was able to include more of the sandy beach and, of course, my shadow, which helped to conceal my camera.
↑ Photo © Jim Miotke. 1/100 sec. at *f*/8, ISO 100, 24–70mm lens at 24mm
↗ Photo © Jim Miotke. 1/160 sec. at *f*/8, ISO 100, 24–70mm lens at 24mm

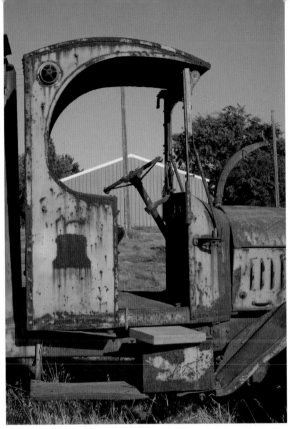

This old truck looked great in the frontlight of late afternoon. Thanks to a normal 50mm focal length, the vertical shot shows the truck in the context of its environment. However, I found the background a bit busy, with distant features competing with the foreground. So I returned in early evening to catch even warmer, late-day sunlight. I switched to a long telephoto (300mm) to zero in tight on the truck. Note the telephoto perspective, which seems to compress the foreground and background.

← Photo © Kerry Drager. 1/125 sec. at *f*/9, ISO 100, 50mm lens
↓ Photo © Kerry Drager. 1/15 sec. at *f*/11, ISO 100, 300mm lens

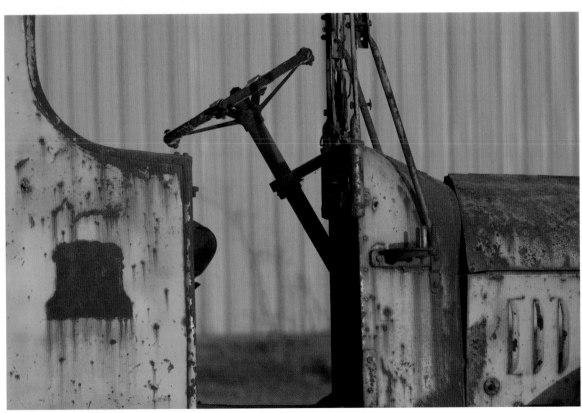

SIDELIGHT

When sunlight starts hitting subjects from an angle, things start to heat up visually. Sidelight occurs when the rays of a low-in-the-sky sun rake across your scene from the left or from the right. The result is often a striking tension between brights and shadows. Sidelight adds texture and form and can create a three-dimensional look of depth.

For landscapes, the sidelight that occurs during the early or late day creates long and striking shadows that can become a key feature of your composition. Sidelight illuminates one side of your subject more than the other and for portraits can accentuate the shape and curves of the face. Strong directional sidelight will brighten only one side of the face, which can be a very artsy effect.

But sidelighting may create too much contrast for a particular scene. This is especially true with portrait subjects, but it applies to other subjects, too. Your photo could suffer from highlights that are way too glaring or shadows that are way too dark. But you can reduce the problem, while still maintaining the form and texture that sidelight provides, by bouncing or reflecting light onto the shaded side of your subject using a reflector. See chapter 5 for more details on reflectors and also the fill-flash alternative.

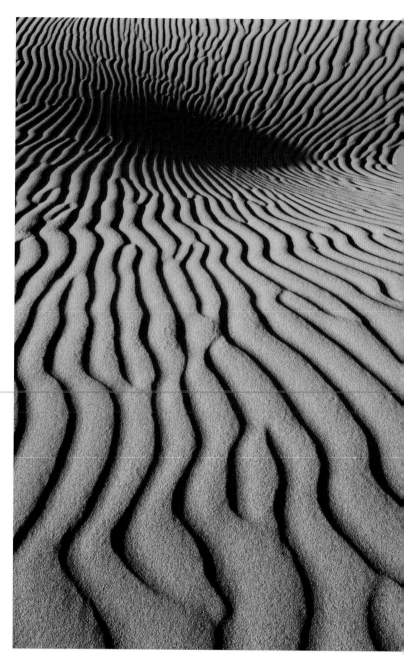

The textures, designs, and lines of sand dunes really come alive when the sun is low in the sky and illuminates the scene from the side. For this view along California's central coast, pro photographer Doug Steakley used a wide-angle focal length to produce front-to-back depth. The use of a small aperture ensured a deep depth of field, with everything sharp from close foreground to distant background.
↑ Photo © Doug Steakley. 1/90 sec. at f/19, ISO 200, 17–35mm lens at 35mm

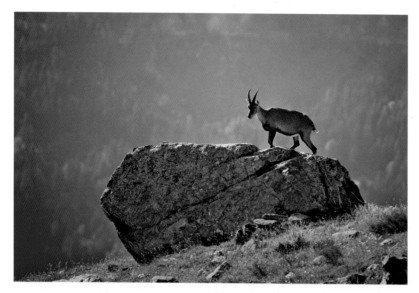

Photographer Stefania Barbier captured this scene high in the Alps, on the French side of Mont Blanc. It was late afternoon, and she loved how the sunlight was catching this scene mostly from the side. The dark and rim-lighted wild ibex is well separated from the blue-tinted background. Also note the composition: Stefania placed the ibex to the right of center so it faces the center of the image.

← Photo © Stefania Barbier. 1/320 sec. at f/6.3, ISO 100, 100–400mm lens at 400mm

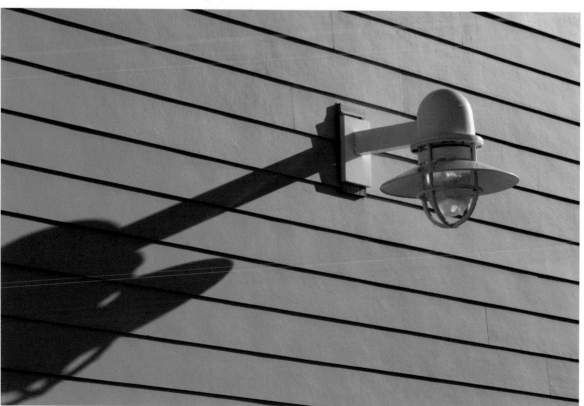

Lamps on the sides of buildings often make great photo subjects, but lighting is the key to success. With the sunlight hitting the scene from the side, a nice shadow extends from the lamp. A horizontal format, with the subject placed to the far right, allows the shadow to extend through the scene. I positioned the camera so it was angled to the wall (as opposed to straight on) and used a telephoto focal length, resulting in a repetition of diagonal lines that also added to the overall look of the scene.

↑ Photo © Kerry Drager. 1/20 sec. at f/16, ISO 105, 105mm lens

Strong directional light can be used quite effectively to saturate colors and emphasize shape and line, as shown in this image by Ibarionex Perello.
↑ Photo © Ibarionex Perello. 1/80 sec. at *f*/13, ISO 100, 12–60mm lens at 54mm

The subject—a close-up section of a wheelchair ramp—was all about shadow and repetition, thanks to the directional sunlight. That's what caught the eye of photographer Ibarionex Perello. "The awareness of shadows helped guide me to the best camera position," he says, "which allowed me to emphasize the round shapes."
→ Photo © Ibarionex Perello. 1/200 sec. at *f*/9, ISO 200, 12–60mm lens at 49mm

WINDOW LIGHT

Just because you're indoors doesn't mean you can't take advantage of the great outdoors. The light streaming through a window can be a wonderful source of natural light and very flattering for shooting people, pets, still-life scenes, art objects, patterns of kitchen utensils, etc.

Window-light photography isn't limited to a make-do-when-it's-raining or a better-than-nothing situation. The great indoors can be the place to be even on a beautiful day—provided the subject is right next to a window.

But window light isn't all alike. For example:

- With direct window light, the sun shines directly through the window and strikes your subject. Because the light is coming from mostly a single direction, you must take care in dealing with the shadows on the side of the subject that's away from the window. When used to creative advantage, the contrast can be eye-catching as a light-and-shadow shot. Otherwise, you might need to use a reflector or fill flash (both covered in chapter 5) to brighten up the shadows.

- With indirect (or diffused) window light, the sun does not shine directly through the window and as a result is softer and more diffused than direct sunlight. You can get indirect light on an overcast day, or on a sunny day when the window is not hit by the direct sun.

A rainy day doesn't mean doing without natural light. In this case, beautifully diffused light flowing through the main window (from the left) was ideal for photographing my model, Kim. With window lighting, the light is often very directional, and the rest of the room is very dark in comparison. But not in this case. A smaller window (at the right) provided a "secondary" light source, so no fill flash or reflector was necessary.

↑ Photo © Kerry Drager. 1/10 sec. at *f*/16, ISO 200, 105mm lens

The color and character of this awesome old chair caught my eye. I liked the way it was spotlighted by the low-angled sunlight streaming through an adjacent window. There was no need for supplemental lighting (such as flash) or a reflector. All of the main features show up perfectly, with the interplay between light and shadow adding nice visual interest.
← Photo © Jim Miotke. 1/20 sec. at *f*/5, ISO 1600, 28–135mm lens at 28mm

Creative poses and compositions can occur spontaneously. Photographer Susana Heide recalls: "My daughter and I were having a fun little photo shoot and were just goofing around. She was wearing this pink bracelet to accent her mostly gray outfit. During the shoot, I remembered that I had a Circle Theme Day coming up in a photo group of which I am a member. Suddenly it clicked that having her look through the circular bracelet could be my entry for that theme. So I ended up with some really unconventional and fun portraits of my daughter." Heide caught this indoor scene next to three large windows with the natural light diffused by blinds.
↓ Photo © Susana Heide. 1/60 sec. at *f*/2.5, ISO 400, 50mm lens

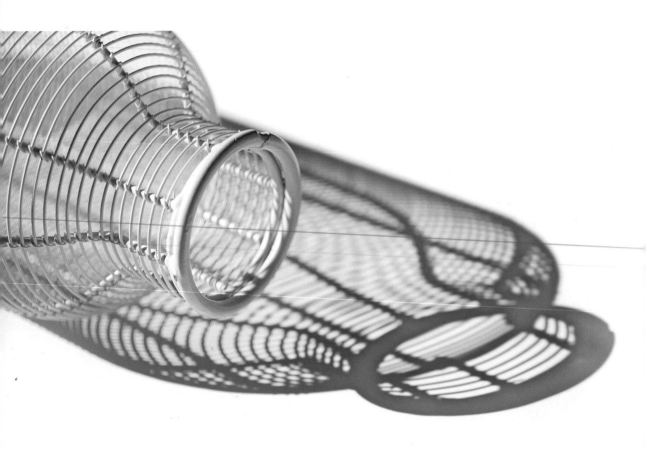

Photographer Susana Heide has "a fascination with shadows in photography, especially in still-life images. Usually my subjects for shadows will be colorful glass objects that will cast a colorful shadow, but on this occasion I opted for a colorless subject to create this high-key image." She shot this scene indoors next to windows with direct sunlight.
↑ Photo © Susana Heide. 1/2000 sec. at f/2.5, ISO 100, 50mm lens

Photographer Deb Harder didn't have to travel far to catch this still-life scene. She took this photo in her house, with the sunlight streaming in to create wonderful light and shadows.
→ Photo © Deb Harder/DRH Images LLC. 1/8 sec. at f/11, ISO 200, 24mm lens

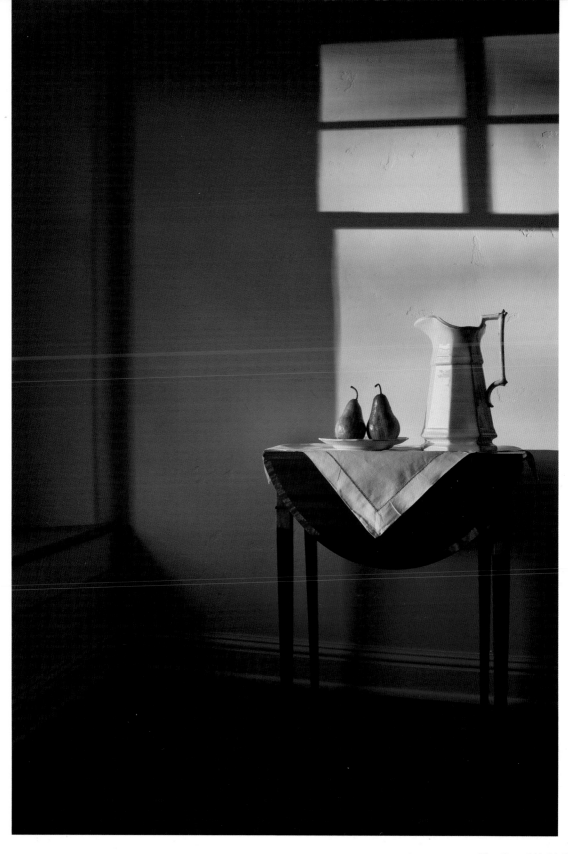

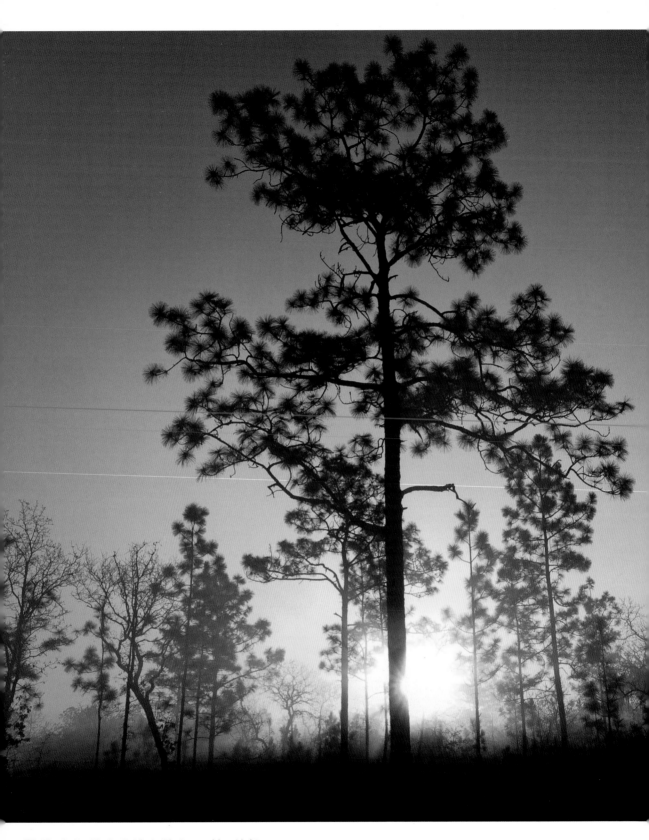

BACKLIGHT

Yes, it's true: You really can shoot toward the sun, despite what you may have been taught. And you can do so successfully, regardless of any failed attempts you may have experienced in the past. Backlight occurs when you face toward the sun, so the subject is between you and the sun.

Backlight can be a challenge from an exposure point of view, due to the extreme contrast of highlights and shadows. That's probably why many people simply avoid pointing their cameras toward the sun and why old camera manuals used to encourage photographers always to keep the sun at their backs. But backlit scenes are simply too thrilling to shun, especially when shooting in the golden light of early morning and late day.

With backlight, look for dynamic silhouettes—stark and dark forms that pop right out of the picture—and many special effects. Rim lighting occurs when the outline of a subject catches the rays of sunlight. This illuminates the edges of people (who take on a halo), rocks, tree trunks, and plants, separating them from the background and creating extended shadows that stretch toward the camera. Translucent objects—such as balloons, feathers, flowers, and fabric—stand out with bold colors and intricate details. If you shoot when the sun is overhead, use backlight to silhouette the branches of trees and make the colors of leaves pop (point the camera upward and keep the sun out of the frame or obscure it with a big branch). Combine backlighting with fog or mist, and the scene can be mesmerizing. We show you how to create some eye-catching backlit fog scenes in chapter 4.

Pro photographer Rob Sheppard recalls how wonderful the early light sifting through a low mist was at sunup one day in northern Florida. Note how Sheppard selected a tree to serve as the star of the show and placed the sun slightly behind the tree. That position helped reduce the size of the bright area while also showing a partial sunburst effect.
← Photo © Rob Sheppard. 1/180 sec. at f/11, ISO 100, 12–60mm lens at 16mm

Early one cold morning, I discovered a great macro scene—dew drops against the rising sun, which was bathing everything in a warm glow. Since things change so rapidly at sunup (sundown, too), the scene was ideal for multiple macro shots. Not only does the sun change position, but the photographer can change camera positions, too, just as I did. These are two of my favorites from this early-morning shoot—taken within a few moments of each other. Macro notes: In extreme close-up photography, or macro, a specialized DSLR lens or accessory (such as an extension tube) lets you focus much closer to a subject than you can with non-macro gear. Notice that I shot these images with a wide aperture (*f*/4.8). When shooting a macro scene with the sun right at the horizon, the wider aperture keeps the sun large in the frame—which I liked. A small aperture created a greater depth of field (more things in sharp focus), but the stopping-down of the lens made the sun much smaller in the frame—not the effect I wanted. The advice: When possible, experiment with depth of field as well as composition and viewpoint.

↑ (top) Photo © Kerry Drager. 1/30 sec. at *f*/4.8, ISO 200, 105mm lens
↑ (bottom) Photo © Kerry Drager. 1/180 sec. at *f*/4.8, ISO 200, 105mm lens

A barrier—with great graphic-design potential—caught the eye of photographer Ibarionex Perello as he walked along a city street. Backlight allowed him to capture the saturated color and intricate details.

↑ Photo © Ibarionex Perello. 1/400 sec. at f/4, ISO 100, 130mm lens

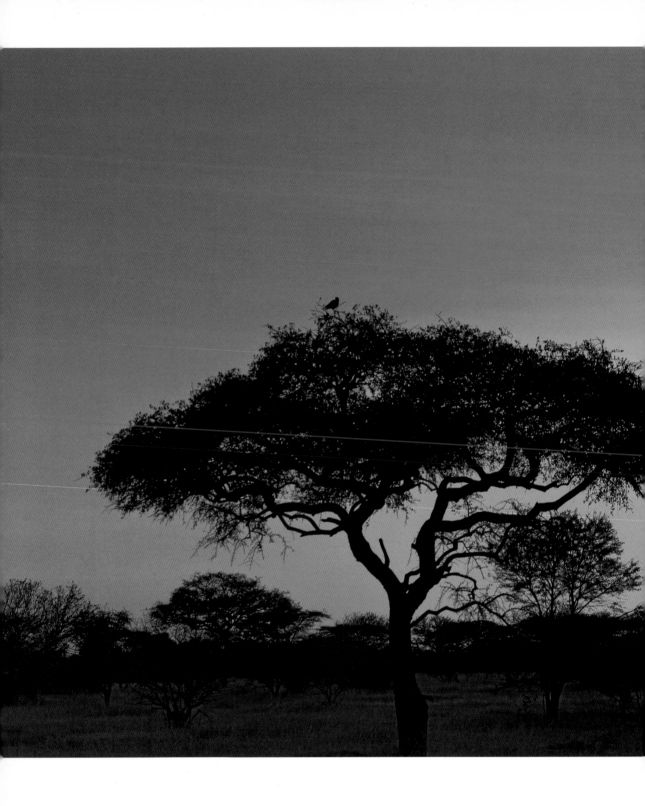

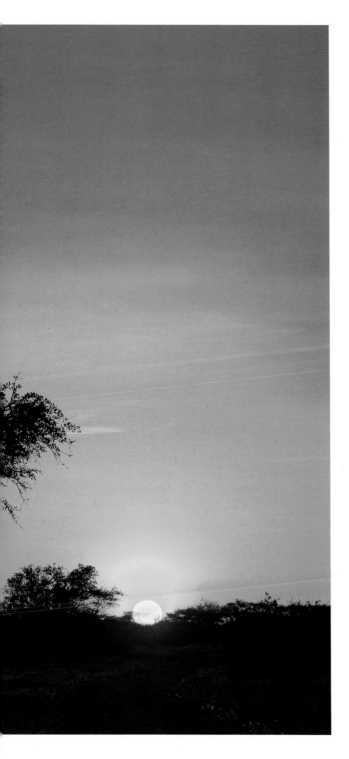

STRIKING SILHOUETTES

Working the dramatic interplay of light and shadow helps produce a great visual showstopper: the silhouette. Silhouettes show off a subject's outline but otherwise create an aura of mystery by leaving details to the viewer's imagination. The best silhouette subjects are pure, simple shapes that appear startling and dark with little or no detail.

These artistic images just don't happen, however. You need a backlit or shaded subject that's set against a sunlit, uncluttered background—that is, a subject surrounded by brightness. A low-on-the-horizon sun—just after sunrise or just before sunset—always provides great silhouette potential. Actually, any bright background (such as a shimmering beach or snow scene, a bright lake, or a sunlit building) can be used to create beautiful silhouettes, assuming your subject is in shadow. Good subjects should be sharply outlined and, usually, easily identifiable—such as people, towers, jagged peaks, trees, natural arches, railings, fences, statues, bridges, architectural elements, and animals.

When shooting silhouettes, aim to catch moments when the main subject is set apart from any other dark surroundings. For example, an important subject that is too close to or actually touches other objects will appear to merge and create a large mass of darkness. That can be very unappealing, and even confusing, to your viewers. Be sure to keep empty space around your silhouetted object so the viewer can easily recognize the shape. Double-check your work on the back of your camera. Adjust your camera angle or composition when necessary, assuming your subject is stationary.

For this sunrise scene over the Serengeti in Tanzania, Africa, photographer Doug Steakley caught two primary subjects—the silhouette of the tree and the sun just appearing above the horizon. The silhouetted bird atop the tree was a bonus. By getting an exposure reading off the middle tone of the sky—away from the sun—all the tonal values fell perfectly into place, with the shadowed subjects showing up silhouetted and the brighter areas showing good color.
← Photo © Doug Steakley. 1/80 sec. at f/5.6, ISO 100, 28–70mm lens at 70mm

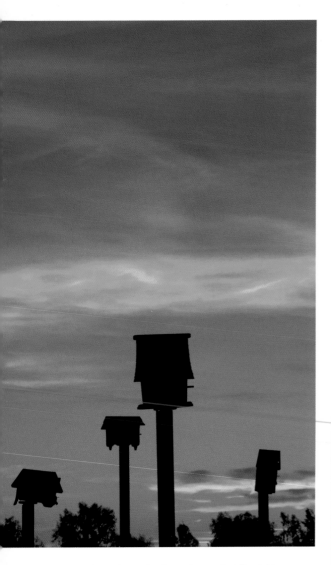

With their distinctive forms, these birdhouses are ideal subjects for a silhouette treatment. For this scene, I ventured out at sunset. I chose a vertical format, with the subjects low in the frame, since the cloud formation above was so interesting. For many scenes with a broad mix of light (dark to bright), overall multipattern metering (such as Evaluative or Matrix) can work fine, and that's what I used here. I took advantage of digital technology by double-checking my camera's LCD monitor to make sure the photo wasn't too bright (blown-out highlights) or too dark.
← Photo © Kerry Drager. 1/13 sec. at *f*/13, ISO 100, 80–200mm lens at 80mm

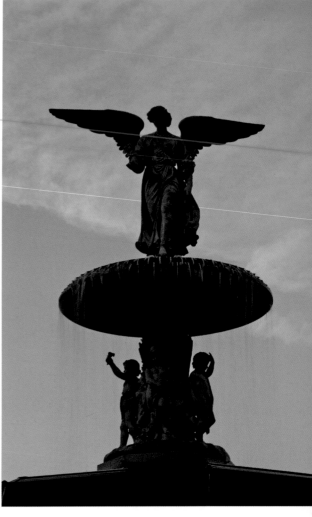

The statues of this decorative fountain were just the right accessories for a colorful sunset sky. The simple, strong, and distinctive forms were in the shade, so a meter reading off the sky worked fine—I simply pointed the camera upward, filled the viewfinder with the sky, locked in those settings, recomposed, and fired away. This reading resulted in what you see here: silhouetted subjects and nice color and detail in the sky.
→ Photo © Jim Miotke. 1/6 sec. at *f*/9, ISO 200, 24–70mm lens at 70mm

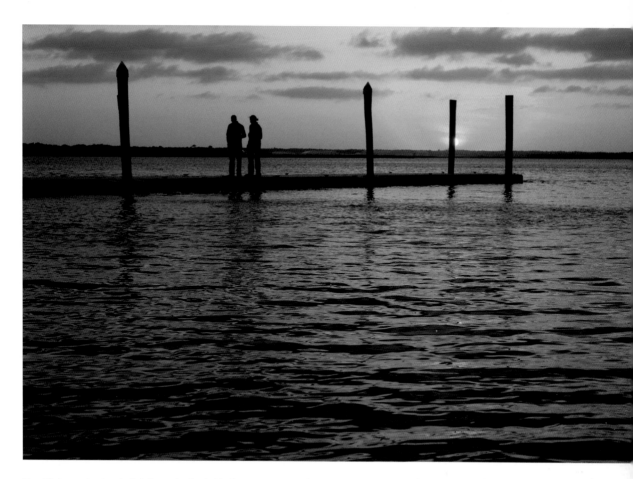

Beautiful sunset colors in the sky and reflected in the water attracted me to this scene. As with many sunsets and sunrises, silhouetted subjects can provide additional visual interest. I placed the sun behind one of the pilings to avoid a big area of brightness that might have drawn attention away from the scene's other features, such as the two people chatting and enjoying nature's light-and-color performance.

↑ Photo © Kerry Drager. 1/60 sec. at *f*/13, ISO 200, 50mm lens

Your camera is designed to provide accurate exposure readings of middle-toned subjects and scenes (green grass, medium-gray rocks, blue jeans, brown tree trunks, red jackets, or a rich blue sky). If the scene in your viewfinder is mostly light toned, the meter will try to darken it so the light areas are middle toned (hence, underexposure, as in the often-cited "gray snow"). Likewise, if your composition is dominated by darks, the camera will try to lighten up things so those darkened areas will go middle toned (too light, or overexposed).

There are several approaches to get the right exposure in tricky lighting. Here are some thoughts:

Meter the background for silhouettes

Here, the goal is to ensure that the background is metered correctly, while letting the shadowed foreground go dark. To do so, point the camera at the sky to the left or right of the sunset/sunrise sun (or away from the bright part of the sky if the sun is just below the horizon). This may mean pointing the camera upward and filling the viewfinder with the sky, temporarily zooming in tight with a telephoto lens, or switching to a spot-metering mode (which narrows the view so it covers just the designated area in the viewfinder). Take the meter reading. Set the exposure manually, or if you are in an autoexposure mode, press the exposure-lock button. Reframe your photo and shoot at those sky settings.

Meter the foreground for portraits

With backlighting, you will sometimes want your main shadowed subject to show color and detail—say, for a portrait. If you meter to lighten up the shadow area, the sunlit area in the background also will go lighter—likely becoming severely overexposed, or "blown out." That's OK, as long as your close subject fills much of the picture area. To get the right exposure, take a spot reading right off your subject's face, or simply move in temporarily and fill the viewfinder with the face and lock in those settings. Note: If you want a good front-to-back exposure, you'll need to use fill flash or a reflector (see chapter 5) to cast light on your close-up shadowed subject.

Check your results

Here's where you can take great advantage of the "digital advantage": After making some pictures, check your camera's playback. One back-of-the-camera feature, the histogram, takes an overall look at your picture by showing what's going on in terms of shadows as well as highlights and everything in between. The histogram's display shows darker shadows on the left, middle tones in the middle, and highlights on the right. But not every histogram shows an equal range of tones. Low-key scenes will be weighted toward the left, while high-key scenes will show more light areas than shadows. Here's a quick-and-easy check: the highlight warning mode. If your camera has this playback feature, be sure to activate it. This overexposure indicator makes the washed-out highlights (bright with no detail) show up as flashing or blinking—often referred to as "the blinkies." Then, if necessary, use exposure compensation to reduce the exposure—for example, starting at -1/3 or -2/3 to see if that stops the flashing; if not, reset to -1, take another picture, and check again. Yes, this is really trial-and-error, but that's because every scene is different! Keep in mind that some highlights don't need detail, such as the sun, lampposts at night, or sparkles on reflective surfaces.

Note: Many Roads Lead to Rome

There's an old saying in photography that goes something like this: "If you ask a half dozen photographers how they determined an exposure for a particular scene, you'll get a half dozen different answers." Throughout this book, we offer suggestions on how we might expose for a tricky lighting situation, but those are just ideas to get you started. Once you nail down the concept (e.g., why the camera might be fooled in a certain instance), you'll find that there are many valid ways to get to the same place—namely, exposure nirvana!

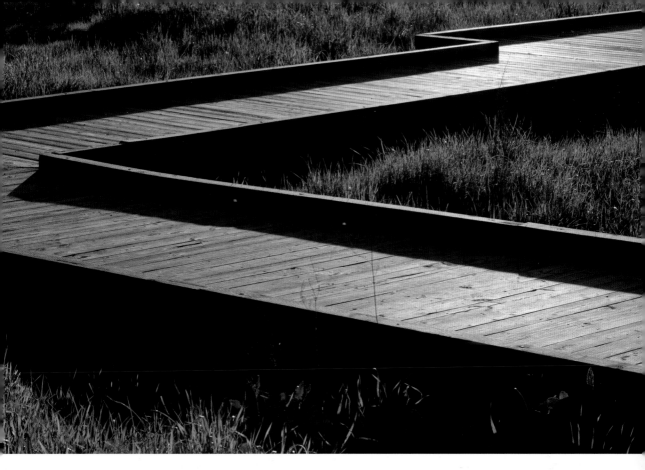

This pattern of boardwalks at a nature preserve comes alive when the sun is low in the sky, as this photo shows. A telephoto lens let me zero in on this zigzag pattern of lines. The low-angled sunlight—mostly backlighting but with the sun coming just slightly from the side, too—high-lighted the light-shadow pattern. To get the exposure, I could have pointed the camera to the sky, filled the frame with rich blue, and used those settings, or I could have switched to my DSLR's spot mode and metered on a sunlit part of the glowing backlit grasses—a middle tone. In either case, the idea is to use exposure lock to hold the settings, while recomposing the picture and shooting the scene. I used the spot method, and the exposure values all fell nicely into place, with the shaded areas going appropriately dark, the highlights staying bright, and the middle tones remaining right where they belong—in the middle. The result is what I wanted: a stark interplay of light and shadow.

↑ Photo © Kerry Drager. 1/60 sec. at *f*/16, ISO 200, 105mm lens

🔘 TIP: USE YOUR EXPOSURE INSURANCE POLICY

If you've taken some test images in a difficult metering situation and checked the histogram or highlight warnings but still can't figure out whether things are correct, then go with your camera's exposure safety net: autobracketing. With autobracketing, the camera shoots one image at the metered setting, then automatically makes additional images with both more and less exposure.

You can program your camera for the number of frames in each direction and the amount of difference between each exposure—for instance, you might choose two above and two below at one-stop intervals (i.e., +1 and +2, then −1 and −2). Sure, you'll end up with additional images, but you can delete the extras when you have had the chance to evaluate the results and choose the image that turned out best. Believe us when we say that it's far better to have too many images than to miss an awesome shot altogether.

SUNBURST EFFECTS

Usually, you won't want to include the sun in a picture, since it can overpower everything else in the frame. Plus, unless the sun is really low in the sky or diffused by fog or mist, you put your eyes at risk by viewing the big bright ball through the viewfinder. However, with a little maneuvering, you can include the sun for a dramatic effect.

Place the sun behind an object, mountain, or horizon so it's just peeking out, and you have the opportunity to create a dynamic sunburst in which starlike beams of light radiate outward. Incidentally, any other sharp and bright point of light, such as a street lamp, can show a sunburst, too.

The effect is most distinct with a wide-angle lens, since the sun shows up small in the frame (which enhances the sunburst's clarity), but even a normal (50mm) focal length can work as well. Here are some more tips:

- Stopping the lens down to a very small aperture (perhaps even your lens's highest *f* number) helps get the rays to radiate out from the sun.
- Using a small aperture and showing only a small amount of sun will reduce the amount of lens flare (spots of light reflections on the image) that usually results when the sun hits the glass.

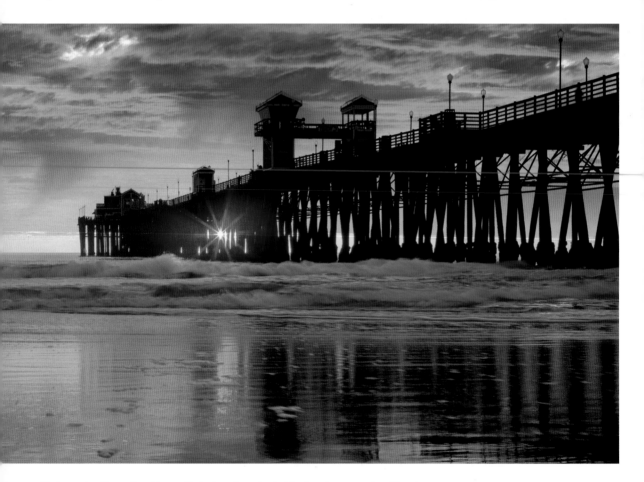

Photographer Donna Pagakis says that when she arrived at the beach one evening, "the sky was spectacular. The colors and reflections were so rich! I moved close to the pier, aligning myself to see the sun shining through the pier pylons. I stopped down to *f*/18, so that a star would form upon exposure." Along with the sunburst, the use of a small aperture and an accompanying low ISO produced a slow exposure that softened the surf.
↑ Photo © Donna Pagakis. 1/3 sec. at *f*/18, ISO 100, 50mm lens

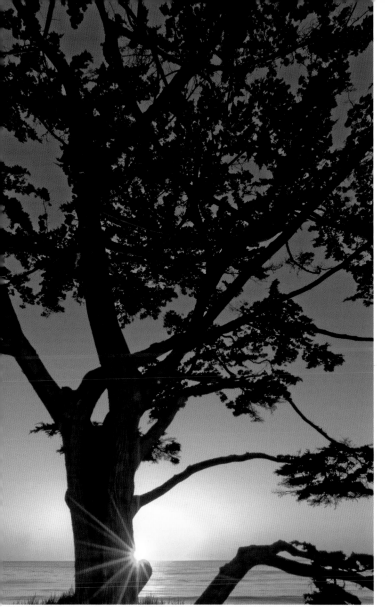

This distinctive tree made an eye-catching silhouette subject for a sunset scene at Carmel, along the California coast. I placed my tripod-mounted camera so the sun just peeked out from behind the tree trunk. My wide-angle lens's smallest aperture (*f*/22) helped enhance the sunburst effect. Also note that I used a vertical format and placed the horizon low in the frame to show a good amount of the silhouetted tree.
← Photo © Kerry Drager. 1/4 sec. at *f*/22, ISO 100, 12–24mm lens at 12mm

⬡ TIP: PREVIEW AND REVIEW

Depth of Field Preview—a feature found on many DSLR cameras—is most frequently used to see what will be in sharp focus in the final image. However, because the viewfinder darkens as the lens closes down to a small lens opening, DOF Preview also gives you a rough idea of how a sunburst or silhouette will appear in the final image.

Of course, after you take the picture, you can view the back of your camera to see if the shot came out the way you wanted it to. If not, reshoot. Let's say it again: Isn't digital photography great?

MIDDAY SUNLIGHT

While photographers should strive to get out in early or late day, that's not always possible. You may be passing through a place only at midday, when the sun is high overhead. Or sunlight may not strike a scene, such as the base of a canyon, until noon. You must shoot a special event when it's scheduled, and that may be midday. Fortunately, with creativity and care, you can create great photos even in midday sunlight. Legendary photographer Alfred Stieglitz (1864–1946) probably put it best: "Wherever there is light, one can photograph."

When selecting good subjects in midday, the soundest strategy is to think in terms of "suitable light." This means finding scenes in which the light brings out your subject's attributes, while avoiding scenes that are sure to be disappointing.

Unfortunately, some subjects just don't inspire at midday, no matter what you do. For people portraits, toplight (in which the sun shines down from above) creates unflattering shadows on the face. For landscapes, the overhead sun tends to flatten out contours, wash out colors, make distant views appear bland, and put light-and-dark contrast in all the wrong places. For forest scenes, the high contrast often results in an unsightly hodgepodge of glaring sunlight and murky shadow.

That said, here are some ways to make the most of midday light:

- Be on the lookout for translucent subjects that are backlit—such as flowers or leaves.
- Watch for objects that cast compelling shadows from the high sun.
- Focus on bold colors that will pop when lit by bright, direct sunlight.
- Be ready to shoot if you see puffy clouds in motion and shifting light. This can add depth and interest.
- For portraits, see if you can move your subjects into the soft light of open shade (covered in depth in chapter 4).

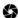 **TIP: BEWARE OF FLARE**

Lens flare occurs when sunlight strikes the front glass and causes light spots, colored hexagonal reflections, or light streaks to appear on the image. Flare can also cause a general washed-out or hazy look. You can actually see this in the viewfinder as you shoot, as well as afterward in the finished image. Occasionally it can be an artistic effect, but most times it's an annoyance.

A lens hood works most of the time for blocking the sun from the lens glass, but if the sun is barely outside the picture area, you may need to shade your lens with your hand or a hat to obstruct the sun. This is yet another worthwhile motivation to use a tripod whenever possible, since it's not easy to hold the camera steady with one hand while blocking out the sunlight with the other. Double-check the results on the back of the camera.

Note: If you can see even a portion of the sun as you are composing your picture, then it's impossible to eliminate the flare completely. Some unsightly spots can be cloned out in post-processing, though not all—another good reason to pay attention to flare during the shooting process. Avoid using more than one filter at a time, since extra glass can mean extra flare.

The nineteenth-century St. Augustine Lighthouse in Florida stands tall (165 feet) on the coast. I visited during midday and wasn't planning to take pictures, on account of the uninspiring light. However, I found the diagonal stripes very intriguing, and when I saw this lamppost, I knew I had my shot—a graphic-design pattern image with nice diagonal lines and a stark white-and-black look. I chose a telephoto lens to zero in on just part of the scene. A shallow depth of field—achieved with a wide aperture and telephoto focal length—helped isolate the sharp lamppost against the soft-focused lighthouse. I felt that the sections of plain blue sky added to the photo's overall pattern.
→ Photo © Kerry Drager. 1/2000 sec. at f/5.6, ISO 200, 105mm lens

These photos, shot in New York City's Central Park, show two ways to handle the midafternoon sunlight. For the wide-angle view (above), I chose colorful foliage for a close subject to frame the distant scene. I liked the cool-warm contrast between foreground and background. For the close-up shot (right), I pointed my camera downward—with a telephoto focal length—to show a small water-and-plant view with the wonderful sparkles created by the high-in-the-sky sun.

↑ Photo © Jim Miotke. 1/800 sec. at f/2.8, ISO 50, 24–70mm lens at 24mm
→ Photo © Jim Miotke. 1/400 sec. at f/7.1, ISO 50, 24–70mm lens at 70mm

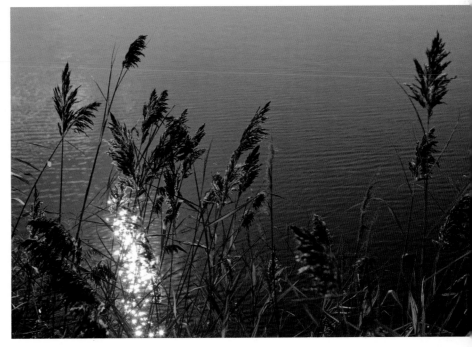

Like most special events, outdoor car shows take place in midday. When photographing custom cars and restored classics, I'm on the lookout for vivid colors, bold lines, shiny chrome, mirrored reflections, and, especially, artsy abstracts—close compositions that can work great in less-than-great lighting. Both of these photos were captured on a bright and sunny day. For the image at left, I decided to take advantage of the sun shining down from above to catch the very cool shadow, along with the reflection, lines, and rich red color. For the image above, I moved in very tight on a hot rod's chrome reflections, lines, and designs.

← Photo © Kerry Drager. 1/4 sec. at *f*/32, ISO 100, 105mm lens
↑ Photo © Kerry Drager. 1/8 sec. at *f*/19, ISO 100, 105mm lens

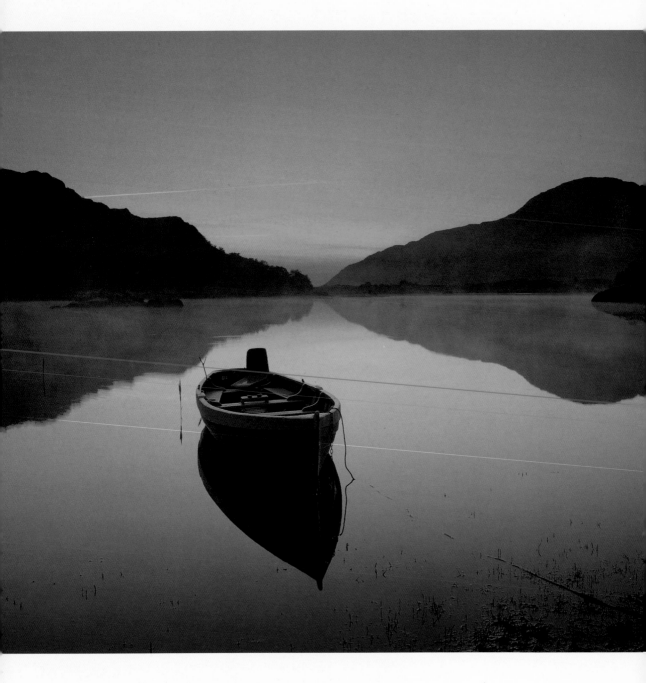

In this image, Deb Harder proves that twilight can occur at daybreak, too! She caught this wonderfully moody scene before sunrise at Lakes of Killarney in Ireland. A mirrorlike surface is one of the frequent attractions when shooting during the calm of dawn. Note the placement of the boat, to the right of center, angling slightly toward the left. Diagonals like this can add a touch of extra energy to a scene.

↑ Photo © Deb Harder/DRH Images LLC. 2/3 sec. at *f*/11, ISO 200, 24–70mm lens at 24mm

CHAPTER 3

LIGHT
AND COLOR

Natural light comes in a variety of colors, determined by the time of day, the weather, and the sky. But when observing light you must be on your visual toes, since the color of light isn't always obvious. While warm-toned light leaps out during an outrageous sunset, it's not so evident in less-dramatic situations. Plus, our eyes and minds adapt to the changing light and translate what's really there into what we are "programmed" to see.

The color of light is an important factor in a photo's mood and impact. Midday sunlight tends to be fairly neutral, while the light at the end of the day is much warmer and more dynamic. Cool light is typically found when it's cloudy, foggy, rainy, or snowy and also in the open shade under a blue sky. It's quite possible to come upon scenes in which the light is both cool and warm, and the effect is especially eye-catching and lively.

Once you get into the habit of noticing the various colors that light offers, your photography will take a jump in quality. The idea is to get started thinking about—and taking artistic advantage of—the color of light.

In this chapter, we explore how light affects color. We also take on the issue of white balance—what it is, how you can work with it, and why you may want to take your camera off automatic. Enjoy!

WHITE BALANCE

The color of light is managed in your digital camera with the setting called white balance (WB). Important as it is, WB is frequently misunderstood. There are so many WB presets, plus custom settings, that it's no wonder many digital photographers simply set WB on automatic and forget about fine-tuning. But a digital camera will render the scene the way it sees it—or, perhaps more accurately, the auto setting renders the scene that way it's programmed to record it. Auto white balance (AWB) is programmed to adjust for the white light. For example, in its quest to "balance" things out, AWB might strip the tones of an amber sunset or a pink sunrise. Or on a bluish day—with snow or fog—you may wish to retain the cool color cast (since cool suggests coldness), but AWB might warm up the light. Isn't it better if you make the decision yourself?

Photographers can use WB to take control of how the camera renders the colors of light. The concept behind WB is based on color temperature, with midday sunlight being "white light" and registering around, say, 5,500 degrees on the Kelvin scale.

Many photographers have found that they can get by with one setting most of the time and change WB only in specialty situations. We both set our camera on a daylight (sunlight) WB setting all day long, from dawn to dusk. We even use it at twilight, where the daylight setting captures the range of colors from the warm golden lighting of buildings to the bold blue of the sky. Once in a while—say, in the shade of a sunny day—we might switch off our "default" sunlight setting and go with a warmer setting (shade or cloudy) to tone down the blue. Or, if we're indoors working with available artificial light (no flash), we may switch to tungsten (incandescent). There are times when AWB has its place, too. It can be a valuable setting in situations with more than one light source, or if you're quickly moving back and forth between indoors and outdoors.

Of course, if you shoot in raw, you have the ability to easily tweak the WB in the digital darkroom. But getting WB right in the field has a triple advantage:

- It compels you to pay attention to the colors and qualities of light (an important aspect of photography mastery).
- You can see what you are getting at the time (and, if necessary, switch to another setting).
- You'll have one fewer task to do in postproduction.

By recognizing the nuances of color and light, and how white balance settings affect your camera's response to color, you can make more informed and creative decisions in the field, right at the time of shooting. Now, how cool—or hot—is that?

Light and shadow caught my eye one day in a Victorian-style inn in San Diego. In scenes like this—with a blend of natural window light and artificial (incandescent) light—there isn't a right or wrong way to interpret the scene. Sometimes with mixed lighting, auto WB can help, especially when shooting fast. But usually experimenting is the best approach. For this scene, I chose two interpretations that show radically different color palettes—warm (via daylight WB) and cool (via tungsten or incandescent WB).
↑ (top) Photo © Kerry Drager. 2/3 sec. at f/16, ISO 200, 105mm lens, daylight WB
↑ (bottom) Photo © Kerry Drager. 2/3 sec. at f/16, ISO 200, 105mm lens, tungsten WB

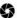 TIP: CONSIDER WHITE BALANCE OPTIONS

Some photographers prefer to change the camera's white balance to match the prevailing light. Here's a rundown of common presets:

- Cloudy warms up the light, which tends to have a cool tint on a cloud-filled day. Outdoor photographers sometimes shoot with this setting as a default, since they often like the added warmth for a great range of situations.
- Daylight (or sunlight) is our default standard, since we feel it most consistently reproduces the colors that entice us to take pictures in the first place.
- Flash helps warm up a bluish cast that can occur when using flash indoors. But when you're outside and are using flash to brighten a nearby foreground subject, go with a daylight setting.
- Fluorescent makes colors shot under fluorescent lights, which can produce a greenish tint, look more natural.
- Shade adds warmth to images shot in open shade on a sunny day, which frequently take on a blue cast.
- Tungsten (or incandescent) provides a more natural look to indoor scenes illuminated by most household-type lamps, which assume a yellow-orange tint when shot without a flash.

Remember, these are just presets. You may choose to analyze a scene and ignore these standard settings to reproduce it the way you wish. For instance, you might want to add extra blue to a twilight scene by switching to tungsten (incandescent). Or you may wish to retain the cool look in the shade of a sunny day by skipping the shade setting and going with daylight. Or at sunset, you may want to punch up the warm tones by switching to cloudy.

You can shoot a scene in various ways and study what you've captured on the back of your camera. Also, many models have a Live View feature that lets you preview the white balance options by toggling through the WB settings and watching the scene as it goes warmer or cooler.

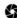 TIP: CUSTOMIZE THE WB

Sometimes you'll shoot a subject in which a precise color is crucial—as is often the case with commercial or studio shots. At other times, you simply can't get the look you want: Perhaps a scene is illuminated by multiple light sources with varying colors. This is where a camera's custom or preset manual white balance setting comes into play. Not all cameras perform in exactly the same way, so check your camera instruction booklet for the particulars. But basically, you will take a photo of a neutral tone with a white or gray card or a special WB tool, such as a translucent disc that temporarily fits over the lens. The camera then creates a custom WB that you may use for that specific lighting situation.

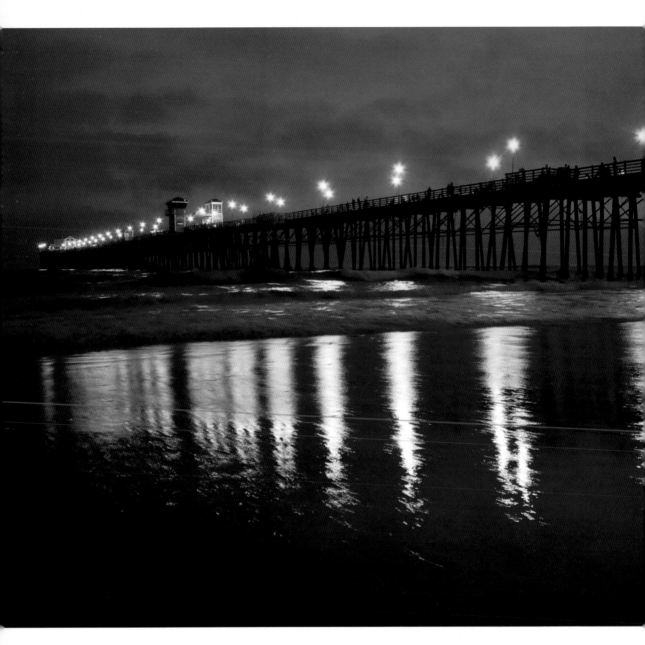

After the sun had set for the day at Oceanside, California, photographer Donna Pagakis waited for the twilight period and for the pier's lights to shine. She shot this coastal scene in raw mode with a daylight white balance. Later, in the digital darkroom, she changed the white balance to tungsten—as shown here—to render the scene with more blue. She titles this shot, aptly, "The Moody Blues."
↑ Photo © Donna Pagakis. 1/2 sec. at *f*/5.6, ISO 200, 18–55mm lens at 18mm

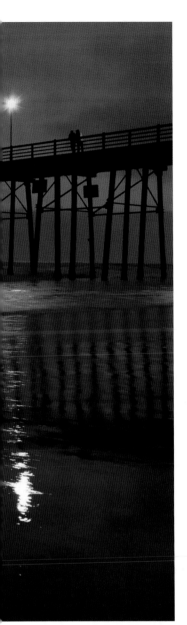

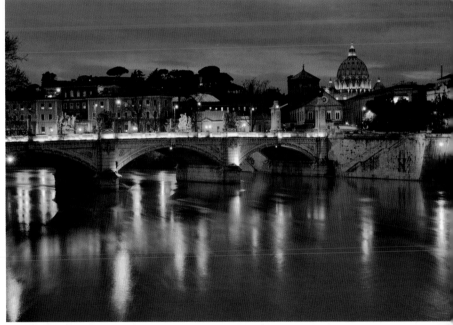

Twilight, with its beautiful blue sky, is photographer Deborah Sandidge's favorite time to photograph. For this reflection scene in Rome, the light was balanced between the twilight sky and the city lights for just a few minutes. "The water under the bridge seemed to soak up the most amazing reflections," Sandidge says, "creating a very painterly image. Long exposures at twilight paint the water with golden light, giving it an entirely different texture and color than during the day." As for white balance, she says, "A setting of automatic created a very cool look, while a sunny setting, which was used here, warmed things up a bit and made the scene more inviting."
↑ Photo © Deborah Sandidge. 6 seconds at f/11, ISO 100, 24–70mm lens at 32mm

Twilight is a special time to photograph cityscapes, such as this overview of the Seattle skyline that features the Space Needle (see page 96 for more about shooting at twilight). Working with white balance—either while shooting or later in postprocessing—gives you choices for portraying the scene. The color of light really is in the eye of the beholder. For this series, I shot the original image (top left) with a sunlight WB, which is my usual preference, and to my eye, it rendered things pretty much as I saw them. But that's not the only valid interpretation. In the raw conversion program, I made two other images, also shown here: one with a shade WB (lower left), which provides a warm tone, and another with tungsten (or incandescent) WB (above), which imparts more of a cool cast.

↖ Photo © Kerry Drager. 3 seconds at *f*/10, ISO 200, 70–300mm lens at 220mm, daylight WB
← Photo © Kerry Drager. 3 seconds at *f*/10, ISO 200, 70–300mm lens at 220mm, shade WB
↑ Photo © Kerry Drager. 3 seconds at *f*/10, ISO 200, 70–300mm lens at 220mm, tungsten WB

EARLY AND LATE DAY

Photographic rules don't get much clearer than this one: To take your photography from ordinary to extraordinary, make a habit of getting up early and staying out late. Is that clear, or what?

Have you ever heard the term "golden hours"? Those are the brief periods just after sunrise and right before sunset that can be pure magic. The pleasingly warm light casts a flattering glow on your subjects. Landscapes, seascapes, snowscapes, and city skylines just seem to look better when the sun is low in the sky. It's not just big scenics, either. This light adds drama to intimate views and people portraits too. Even normally drab subjects can turn into eye-catching photos.

Of course, many photographers typically shoot outside only between midmorning and midafternoon when the sun is high in the sky. As we discussed in chapter 2, it is certainly possible to get good images in midday. But if you limit your outdoor photography to only those times, you'll be disappointed more often than you're enthusiastic.

This scene covered quite a broad range of the cool-to-warm color palette, and that's what attracted my attention early one day. I combined a vertical format with a wide-angle focal length to show more of the sky while also including the strong diagonal line of the mast. In fact, the lines in this scene attracted me almost as much as the light and color!
→ Photo © Jim Miotke. 1/50 sec. at f/5, ISO 400, 24–70mm lens at 24mm

Things pick up in the "light as color" department when the sun is low on the horizon. For this sunset marina scene in the Caribbean, I sought a composition that emphasized both sun and subjects, and what better way than to have the setting sun showing through a boat's window? At the same time, I included a slice of the marina to convey a sense of place.
↓ Photo © Jim Miotke. 1/160 sec. at f/5, ISO 100, 70–300mm lens at 135mm

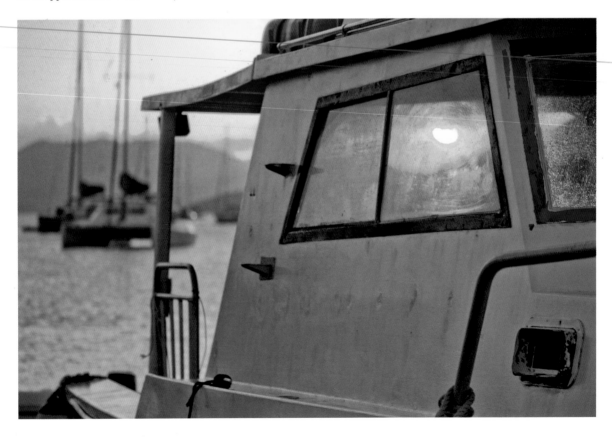

Photographer Susana Heide captured this photo of her son in the warm glow of the setting sun. Heide recalls: "I asked my son to throw on a non-distracting white shirt and he reluctantly came outside with me. The neighbors have some antique farm machines in the backyard, and they served as our setting. Of the dozen or so shots, this one turned out to be my favorite because of my son's relaxed, if a little bashful, pose."

↑ Photo © Susana Heide. 1/400 sec. at *f*/2.5, ISO 100, 50mm lens

Wandering around a nearby town one weekend day, I discovered this decorative door handle. The low sunlight of late day improved the color and added a shadow. I set up my tripod to obtain maximum sharpness with a steady camera and a small aperture to obtain a great depth of field. I felt that the diagonal composition, achieved by slanting the camera, added an extra jolt of visual energy.

→ Photo © Kerry Drager. 1 second at *f*/20, ISO 100, 105mm

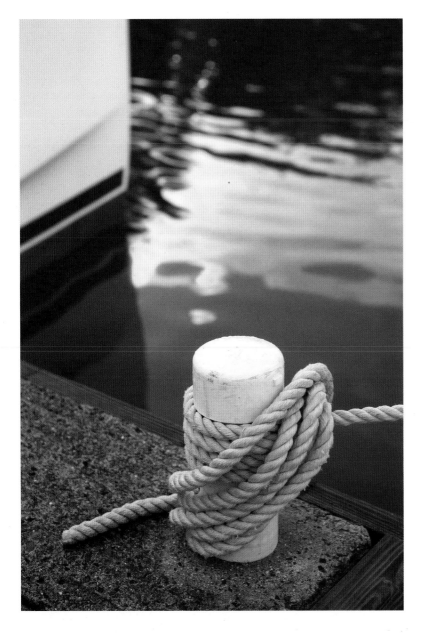

Marina scenes look awesome at any time of day. But in early morning, things just seem extra special, and that was certainly true on this day. I felt that the textures of the rope and the stark white post worked perfectly as a strong foreground subject against the bright and rippled water reflections.
← Photo © Jim Miotke. 1/25 sec. at *f*/5, ISO 400, 24–70mm lens at 70mm

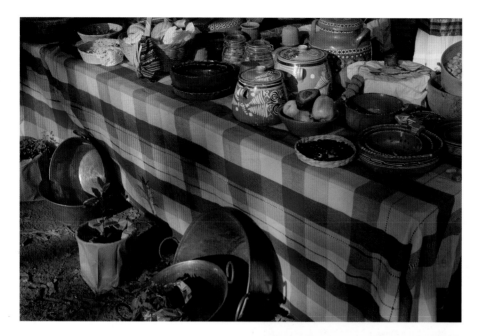

While attending a California Gold Rush living-history event, I was attracted by the beautiful early-morning light striking these old-time objects and the patterned fabric. With trees and period tents in between sun and subject, the result—in the image above—was slightly "busy" with a hodge-podge of light and shadow areas. Looking closer, however, I found a much simpler and, to my eye, stronger view. I zeroed in tight on a small slice of the big scene, catching the plant's shadow as the picture's main focal point while still showing the textures and colors of this wonderful period fabric.

↑ Photo © Kerry Drager. 1/500 sec. at *f*/10, ISO 400, 50mm lens
→ Photo © Kerry Drager. 1/250 sec. at *f*/11, ISO 400, 50mm lens

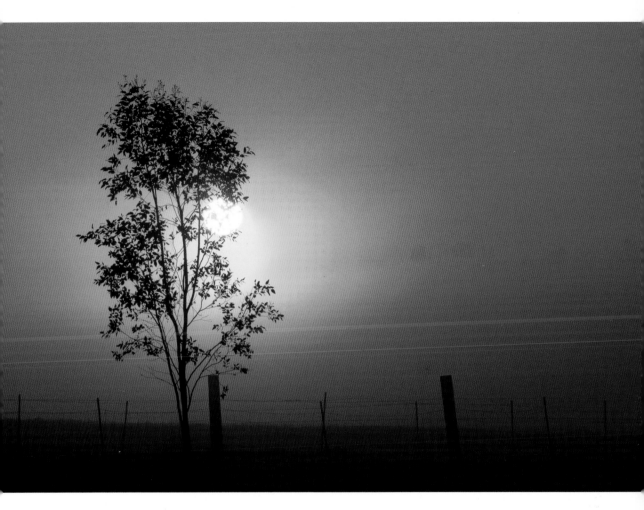

Weather conditions can transform light and color in wonderful ways! Early one winter morning, a beautiful sunrise coupled with fog sent me scurrying outside with camera and tripod. I rarely include the full sun in my photos unless it's obscured by objects or by mist. For this photo, I had both, and I carefully positioned the diffused low sun behind part of the tree. The silhouetted ranch fencing and the tree, along with the fog, added to the mood of the scene.

↑ Photo © Kerry Drager. 1/250 sec. at *f*/22, ISO 400, 70–300mm lens at 200mm

Get the most out of the scene. Experiment with different focal lengths—by zooming in and zooming out—and change to vertical and back to horizontal, to come up with a variety of renditions. That's what I did one evening in California's capital city of Sacramento. The low sun was catching the lines and angles of this office building with a warm glow, while the windows were reflecting the blue sky. A telephoto zoom let me isolate various design elements—pattern, symmetry, and repetition.

↑ Photo © Kerry Drager. 1/8 sec. at f/16, ISO 200, 80–200mm lens at 185mm

↗ Photo © Kerry Drager. 1/10 sec. at f/13, ISO 100, 300mm lens

→ Photo © Kerry Drager. 1/5 sec. at f/13, ISO 100, 80–200mm lens at 200mm

SUNRISE AND SUNSET

At sunrise and sunset, the world can be a remarkable place. When the light, color, and atmosphere all align perfectly and the sky explodes in a wild splash of color, getting out early and staying out late is well worth the sacrifice of a little missed sleep and a delayed meal.

But planning and preparation are major ingredients for sunrise and sunset success. There's no getting around it: Eye-catching light is fleeting. The sun moves fast and rises above or dips below the horizon in a matter of minutes.

While both sunrise and sunset offer quite a spectacle, there's a big difference in the lead-up to the drama. For example, one of the most exhilarating times in outdoor photography is to track and shoot the progression of light as it moves from afternoon to evening. In late day, you have time to check out the scenery and plan your compositional strategies in advance. Get there a few hours before the sun goes down and you can see where the shadows fall and consider potential silhouette subjects.

Not so at dawn. In the early darkness, you can't be sure how the landscape or cityscape will appear when the sun rises. Sometimes you can scout a potential sunrise spot the day before—even in midday—and try to imagine how it might look at sunrise. But that's not always possible. Things happen fast at sunup, and you just have to hope you are in the right spot. Otherwise, you'll need to do an urgent search—running around like crazy is another way to describe it—to find just the right place to shoot. Remember, the morning light gets worse as time passes. The peak of the morning light show lasts for perhaps just an hour after sunup, but that depends, since interesting clouds and sunlight could extend the drama.

Keep in mind that a colorful sky usually works best when the scene includes a good ground-based subject, too—to provide context (the storytelling element where you photographed the scene) or to provide a strong focal point or two for the composition. A silhouette subject might be the answer, or a pond, lake, or ocean for colorful reflections. So, planning and hoping for a great sky is just half the process; the other part is thinking about the foreground or a distant mountain, city skyline, ridgeline of trees, etc. to set against the sky.

Incidentally, it's always advisable to have a companion or two with you when shooting early or late. That's a good safety measure, and at the same time it's also more enjoyable to share the experience—both scouting and shooting— with others. Plus, you can trade tips and techniques along the way.

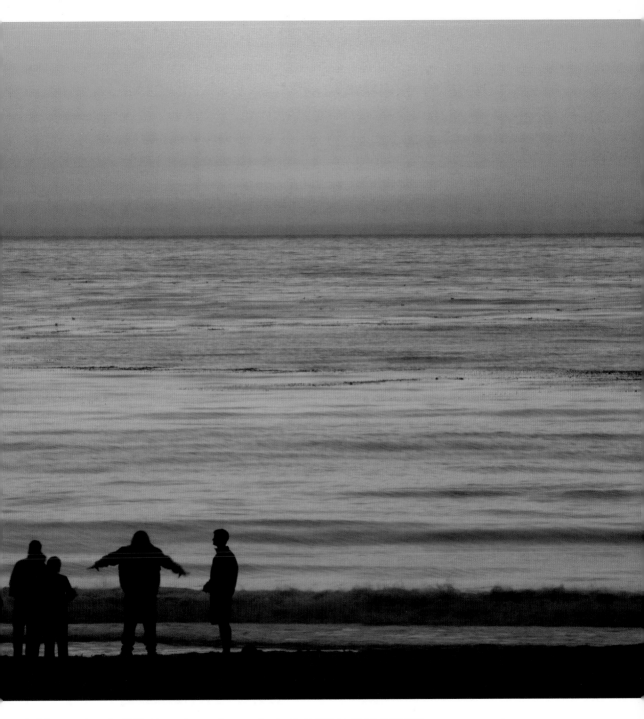

In this scene along the California coast, warm tones contrast with cool blues. At the same time, beachgoers provide an eye-grabbing diversion. Since I was facing the sunset sky, an exposure based on the background left foreground subjects in shadow and silhouette. Although relatively small in the scene, these dark, simple shapes stand out against the colorful ocean and sky.

↑ Photo © Kerry Drager. 1/60 sec. at f/11, ISO 100, 80–200mm lens at 135mm

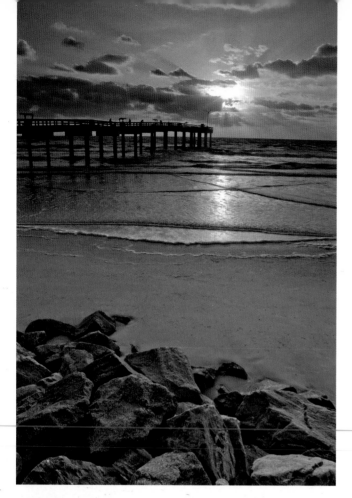

These two sunrise scenes have lots in common. Both were shot at St. Augustine Beach, Florida, during a scouting trip for a BetterPhoto workshop. But look at the differences. The colors definitely catch the eye, although the pictures were shot within minutes of each other. In Kerry's shot (below), the pre-sunrise scene mostly shows a bluish dawn tone, with warm colors starting to emerge. In Jim's shot (left), the whole post-sunup scene takes on a warm cast. That's the nature of light when things get crazy at sunrise! Also note the composition. Both images were captured with wide-angle lenses. In each case, the pier was incorporated into the compositions for visual interest and to provide strong leading lines that takes the viewer further into the scene.

← Photo © Jim Miotke. 1/4 sec. at *f*/22, ISO 100, 24–70mm lens at 27mm

↓ Photo © Kerry Drager. 1/6 sec. at *f*/16, ISO 200, 20mm lens

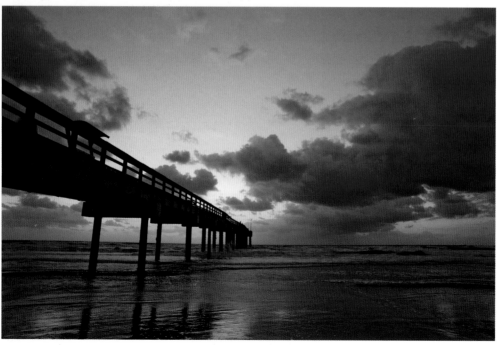

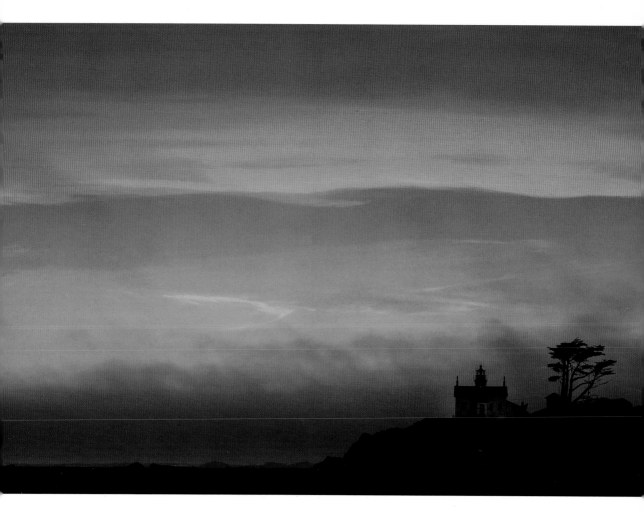

Factor in how much time you need to get up, get ready, and get to a spot. Know the weather forecast, and have all your gear packed up and ready to go—tripod, memory cards, extra battery, jacket, and flashlight. We always pack a snack, too. Well before dawn, you may not be in alert-enough shape to think of everything, so keep a checklist of your camera and personal gear, and check it twice before heading out the door.

On California's far north coast, the old Battery Point Lighthouse occupies a lonely perch outside Crescent City. For this scene, photographer Anne McKinnell felt that the lighthouse made a great focal point for a sunset shot. She says exposure was difficult "because I wanted just enough detail in the lighthouse so it would not be in complete darkness, but not so much light that the color was washed out of the sky. I metered for the lighthouse and then used –1 exposure compensation to ensure the photo retained its color. There was no added color saturation in postprocessing; it really did look like this!"

↑ Photo © Anne McKinnell. 1 1/3 seconds at *f*/22, ISO 100, 24–105mm lens at 50mm

It's hard to go wrong with a coastal landmark such as the historic Old Point Loma Lighthouse in San Diego! But as with any other subject, light matters. For this sunrise scene, I was attracted not only by the colorful sky—a beautiful mix of warm and cool tones—but also by the white walls taking on color. Note that for a series of images I started in the often-recommended way—with a wide-angle lens (right). Then I narrowed the view with a "normal" 50mm focal-length lens (below). I wrapped things up with a telephoto view (opposite). Note the telephoto perspective, which tends to "compress" the elements in a scene. In this telephoto shot—my favorite of the series—I love the strong graphic design: the lines of the picket fence, the windows, and, of course, the roof lines.

→ Photo © Jim Miotke. 1/40 sec. at *f*/8, ISO 400, 28–135mm lens at 33mm

↓ Photo © Jim Miotke. 1/60 sec. at *f*/8, ISO 400, 28–135mm lens at 50mm

→ (far right) Photo © Jim Miotke. 1/80 sec. at *f*/8, ISO 400, 28–135mm lens at 85mm

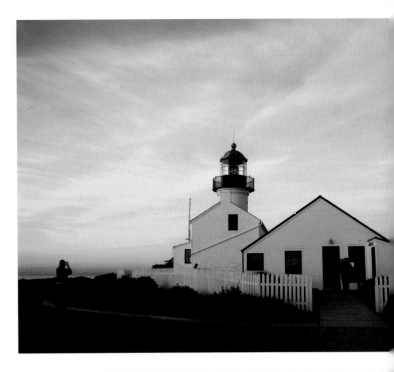

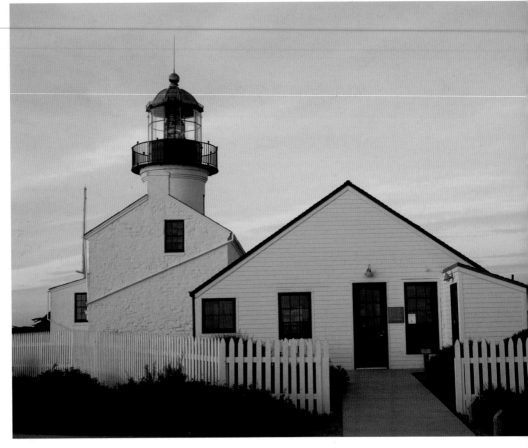

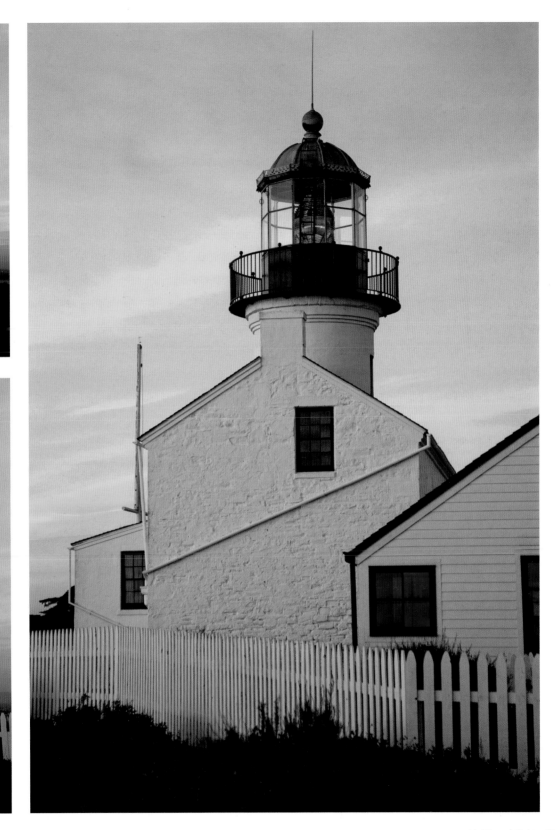

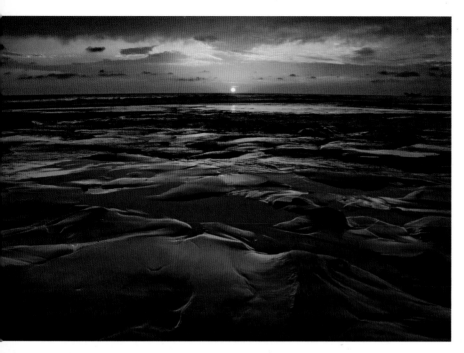

This has to be one of the more intriguing coastal scenes we've seen. The sunset colors and clouds are just splendid, but check out the wonderful foreground—emphasized by the use of a wide-angle focal length. Says photographer Donna Pagakis: "I captured this shot during a very unique situation. They were dredging sand from the harbor onto the beach at Oceanside, California. If you look closely, you can see the boat, on the horizon. I set up my tripod and began capturing images. I was so in the moment that I didn't realize I had sunk in the sand, much like quicksand!"

↑ Photo © Donna Pagakis. 1/100 sec. at *f*/7.1, ISO 200, 18–55mm lens at 18mm

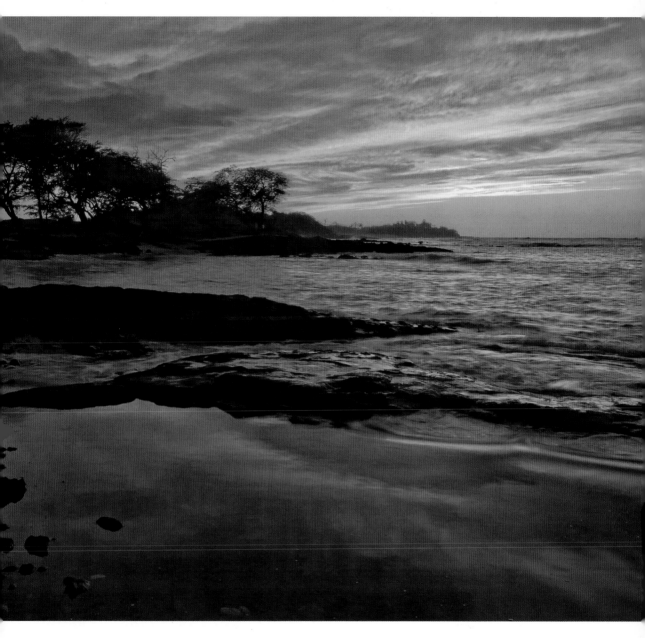

Clouds and colors came together in an eye-grabbing way during this sunset at Waikaloa, Hawaii. Pro photographer Kathleen T. Carr chose a wide-angle focal length not only to show the silhouetted trees and land forms but also to include the beautiful reflections in the close foreground. A small aperture ensured a deep depth of field, with everything sharp from near to far.

↑ Photo © Kathleen T. Carr. 1/4 sec. at *f*/22, ISO 100, 10–22mm lens at 22mm

TIP: EXPOSE CAREFULLY FOR A
SUNRISE OR SUNSET SKY

Most of the exposure rules you'll follow when
photographing backlight and silhouette scenes,
as discussed in chapter 2, apply to exposing
for a sunrise or sunset sky. Meter off a middle-
toned subsection of your scene—for example,
fill the viewfinder with a part of the sky away
from the sun—and note the readings. You can
then either use your Autoexposure Lock but-
ton (often abbreviated as *AE-L* or *AE Lock*) to
hold those settings or switch to manual mode
and dial in the readings you noted. Either way,
you're in business. Note, though, that every-
thing else in the frame between you and the
sky will be silhouetted, unless it's lightened up
by reflections or flash or if you're using an HDR
(High Dynamic Range) or grad-filter approach
(see chapter 5). Otherwise, beware of including
too much dark foreground.

When it comes to sunset photography, it pays to be ready for any
opportunity that presents itself. Late one day just down the street
from California's capitol, I had planned a wide-angle shot of the
colorful sky and the Sacramento River reflections. But I saw how
the low-in-the-sky sun was lighting up the Tower Bridge. I then
used my telephoto zoom to zero in tight on the graphic-design
pattern of warm light and intriguing shadows.
→ Photo © Kerry Drager. 1/40 sec. at *f*/22, ISO 200, 80–200mm
lens at 200mm

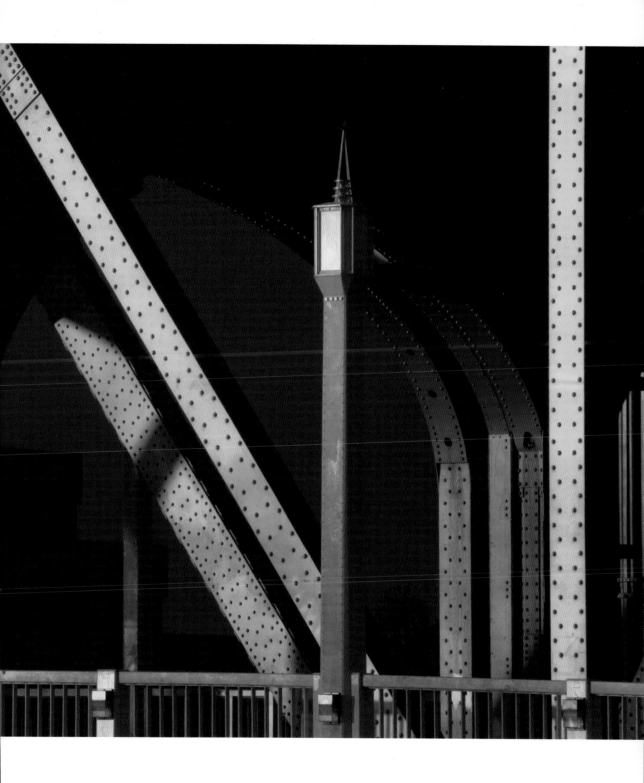

DUSK AND TWILIGHT

If you haven't photographed outdoor scenes at twilight before, you're in for a dazzling light-and-color adventure. The brief period between day and night provides a dynamic transition period for catching the edges of natural light.

Cityscapes come alive and look absolutely incredible at twilight. The twinkling city lights transform buildings and streets into dynamic mixtures of color. The sky turns an amazing blue, if not purple, and makes for a breathtaking background to the illuminated buildings. Add rain-slick streets or an adjacent body of water and the neon lights create wonderful reflections.

Other scenes look great at twilight, too—from villages to monuments—and they present rich details, from colorful car taillights to dazzling carnival rides. Landscapes take on a dreamlike look, and at the seaside, day's end can serve up shots of a soft-and-sensuous surf during long exposures in low light.

Also consider the other end of the day—dawn. Sure, that means getting out very early to catch the day's first light as it emerges from nighttime. But it's worth it, since dawn presents quite an impressive color performance.

As a very general rule, the best of the evening twilight occurs about fifteen to thirty minutes after sunset—dusk—when the colors glow, the sky turns an extraordinary shade of blue, and the light is balanced throughout the scene, from land to sky. Twilight lasts just minutes, however, since it's bumping right up against nighttime. Before the fast action begins, check different viewpoints, and try a few test shots to make sure you have the composition that pleases you. Then, when the drama hits its height, you'll be ready.

By the way, the finest twilight scenes don't always present themselves in the spot where the sun has just set. Look in the opposite direction to see some awesome light as well—in fact, frequently you'll witness light-balanced scenes in which land and sky take on similar exposure values.

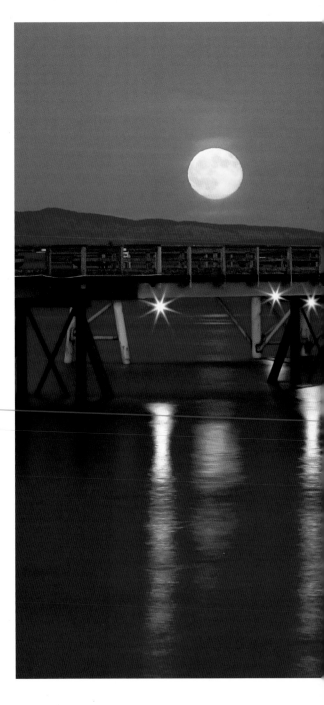

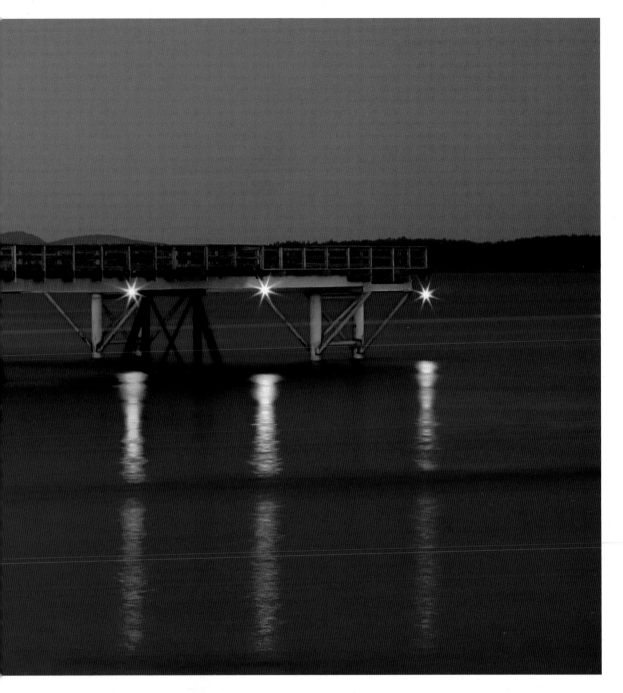

Photographer Anne McKinnell caught this intriguing pier-and-moon scene at twilight. She points out the value of planning and research, rather than relying on luck. "When the full moon rises just after sunset, and it is a clear day, it always has a lot of color," she points out. "There are a few Internet sites and programs to help you keep tabs on when this is going to happen and at what degree in the sky the moon will rise. I get out my nautical chart and decide what I want to be in the foreground and then figure out where on shore I have to stand to make the moon rise behind it." Note, too, that she used a small aperture (*f*/22), which turned the sharp points of pier lights into attention-grabbing "star" effects.

↑ Photo © **Anne McKinnell. 8 seconds at *f*/22, ISO 400, 24–105mm lens at 70mm**

I was hoping to photograph sunset and twilight one day in New York City, but things weren't looking good in the early evening. I was set up for a wide-angle composition that included the rocks in the near foreground, but with a scattering of clouds (left), the light was dull and lifeless. As often happens, it really pays to stick around, just in case. After a while, twilight came through, with the Brooklyn Bridge framing the Manhattan skyline. I also used a wide-angle lens for the image (below), but I pointed the camera upward to show more of the beautiful blue sky, though still including the colorful reflections below. This is what we mean by the "peak of twilight": rich, cool-blue sky contrasting with the beautiful warm city lights.

← Photo © Jim Miotke. 1 second at *f*/22, ISO 100, 24–70mm lens at 24mm

↓ Photo © Jim Miotke. 25 seconds at *f*/22, ISO 200, 24–70mm lens at 35mm

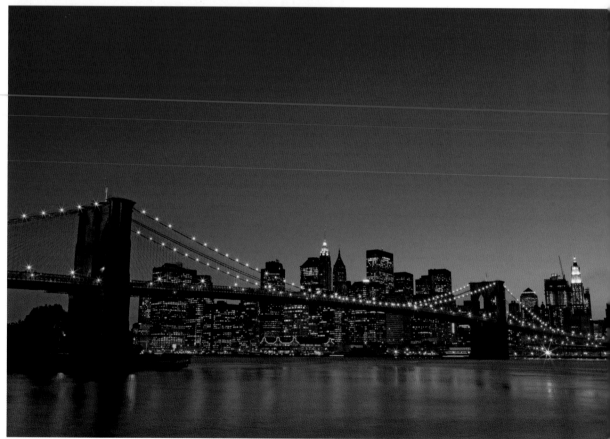

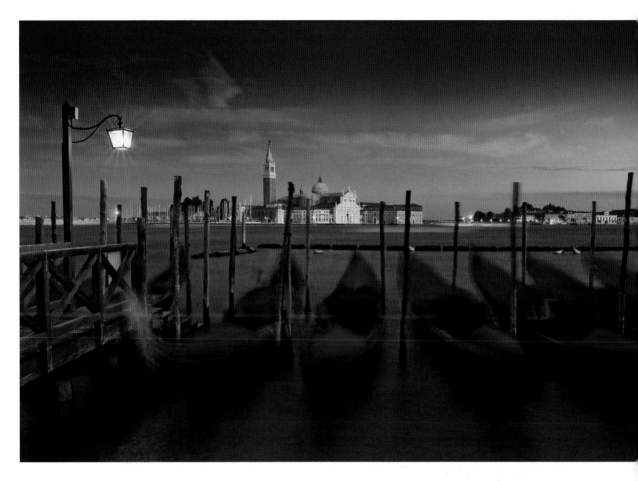

Photographer Deb Harder recorded this image of light, color, and motion in Venice during twilight. "The gondolas were moving like crazy," she recalls, "so instead of fighting circumstances and increasing my ISO, which would impact the quality of the image, I used a neutral-density filter to slow down the exposure for an artistic, painterly feel."

↑ Photo © Deb Harder/DRH Images LLC. 6 seconds at *f*/18, ISO 200, 24–70mm lens at 29mm

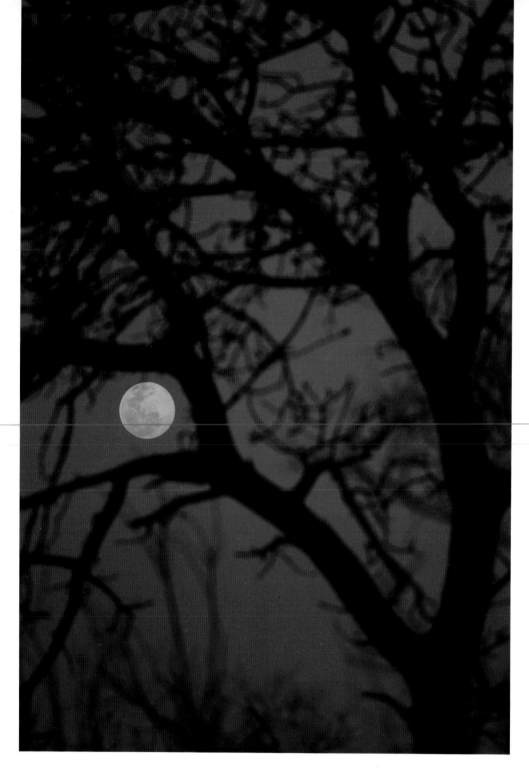

Photographer Simon Stafford shot this moonrise-and-twilight scene in Kruger National Park, South Africa. "Shooting while the last vestiges of daylight maintained some color in the sky," Stafford says, "and before the intensity of the moon had become too great, allowed the camera to record detail in both."
↑ Photo © Simon Stafford. 1/200 sec. at *f*/4, ISO 800, 200–400mm lens at 200mm

I captured this desert scene near Phoenix in the late stages of twilight, almost nighttime. The variety of colors—from the artificial lights—caught my eye and contrasted so beautifully with the backdrop of the lingering blue of twilight. The moon was an added bonus.
← Photo © Jim Miotke. 2 1/2 seconds at *f*/11, ISO 800, 24–70mm lens at 60mm

EXPOSING FOR TWILIGHT

Not all periods of twilight are alike. In early
twilight just after sunset, for example,
you may find a high land-versus-sky
lighting contrast, with the sky very bright
in contrast to the landscape. At the later
stage of twilight, or dusk, the rich blue sky
often matches the landscape (or cityscape)
in tonal or exposure value. When the entire
scene between land and sky is balanced,
then it's possible that an overall "point-
and-shoot" metering could work perfectly.
Otherwise, as with many exposure challenges,
it's a matter of taking a meter reading
off the sky (assuming the sky shows rich
color), using exposure lock to retain those
settings, and then recomposing and shooting.
But, as usual, another option is to check
your LCD monitor—highlight warning
or histogram—and if necessary adjust the
exposure compensation and reshoot.

 **TIP: USE A LOW ISO AT
TWILIGHT**

With low light, some photogra-
phers think they must rack up the
ISO to a high number. That's not
necessarily so! After all, you'll have
your trusty tripod to keep things
good and steady during long
exposures that can run many sec-
onds. Noise, incidentally, is most
noticeable in shadow areas, which
are common in twilight photos, so
it's all the more reason to go with
a low ISO if at all possible.

At twilight, sometimes getting the right exposure is surprisingly easy. Photographer Simon Stafford shot the Royal Palace in Phnom Penh, Cambodia, "when the level of ambient daylight had dropped to a point where it was about equal to the intensity of the artificial lights. I set the white balance to sunlight to ensure the artificial lights recorded with a very warm tone."
↑ Photo © Simon Stafford. 1/2 sec. at f/8, ISO 200, 12–24mm lens at 15mm

WATER REFLECTIONS

Reflections offer abundant opportunities for creating fascinating and beautiful mirrored images, as well as abstract pictures. They can be found anywhere, from rain puddles and small ponds to lakes and oceans.

Right off the bat, water reflections spark interesting design decisions. For instance, you can go for a full view that lets you record two elements for the price of one—the subject and its reflection. Or you can zero in tight on just the reflection itself. It's your artistic choice.

Besides composition, there are several other considerations to take into account. Windless conditions—most frequently found in the mornings—make for mirror-perfect images. But although the natural tendency is only to think of reflections for their looking-glass qualities, you also can make mild ripples work for you. With wind affecting the surface of the water, rich tones and bold patterns can turn into a kaleidoscope of colors.

Don't forget shutter speed when it comes to capturing water in motion, since your choice can affect the look of the scene. Fast speeds freeze the designs pretty much as you see them. For lake ripples, or stretches of a river or creek, slower speeds can create an artistic array of swirling colors—a brushstroke type of effect.

Lighting can make a difference, too. Look for a colorful subject near water, where the sun illuminates the scene directly and the water is in the shade. For example, if you are photographing fall foliage, find a spot where the trees and leaves are receiving direct light but where the water has slipped into the shadows. A situation like this can increase the intensity of color in the reflection.

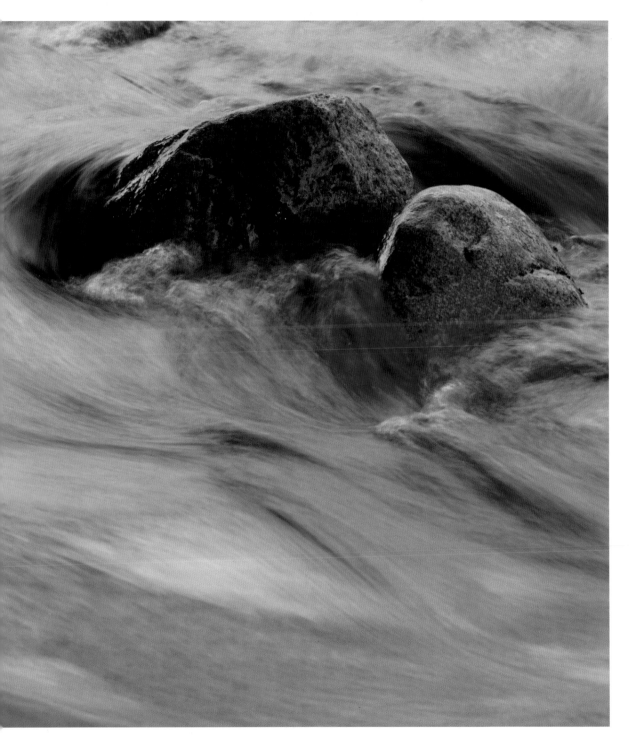

A tripod helped create this scene by making it possible to use a slow exposure to turn this river scene into a swirling blur of fall color. The water, by the way, was in shadow, but the nearby autumn foliage was in sunlight. The result was a photo that captured the beautiful reflections as a soft palette of color.

↑ Photo © Tony Sweet. 1/6 sec. at f/22, ISO 400, 70–200mm lens at 170mm

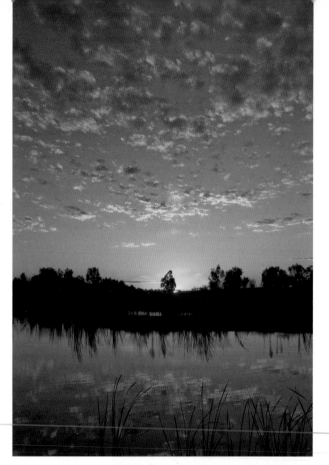

It's hard to beat a sunset sky coupled with water reflections. In this scene, next to my home, a wonderful design of clouds caught my attention one evening. There was just a minimal breeze that created small ripples in the water. A vertical format and wide-angle lens recorded a good expanse of the sky while also showing the reflections. I chose a camera position that added some extra visual interest with a stand of silhouetted grasses below.

← Photo © Kerry Drager. 1/15 sec. at *f*/16, ISO 100, 12–24mm lens at 24mm

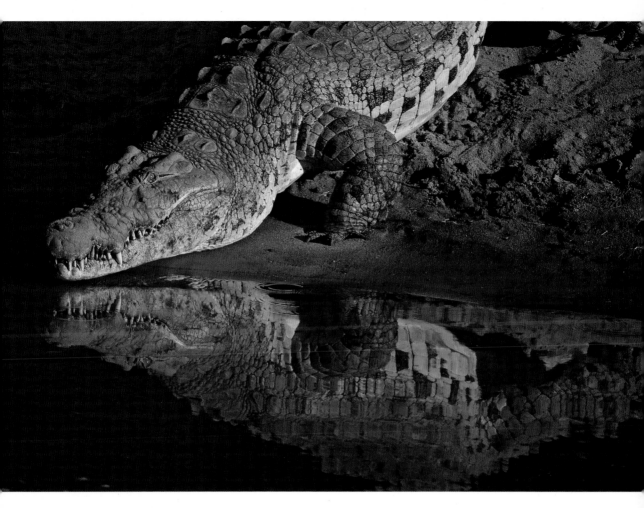

Photographer Renee Doyle captured this scene midmorning on the island of Burano, in the Venetian lagoon. "All the houses are painted a different color, and the patterns and the colors reflected in the canal appealed to me," she says. A telephoto lens allowed her to zoom in tight on the colors and designs. Note how the ripples in the water produce an abstract look.
← Photo © Renee Doyle. 1/500 sec. at *f*/9, ISO 200, 70–200mm lens at 150mm

Doug Steakley photographed this dramatic scene along a small riverbank in Serengeti National Park, Tanzania. "It was late afternoon, almost evening," Steakley says. "I anticipated the reflection as the crocodile slid into the water, and I got lucky."
↑ Photo © Doug Steakley. 1/640 sec. at *f*/5.6, ISO 320, 200–400mm lens with 2X teleconvertor at 550mm

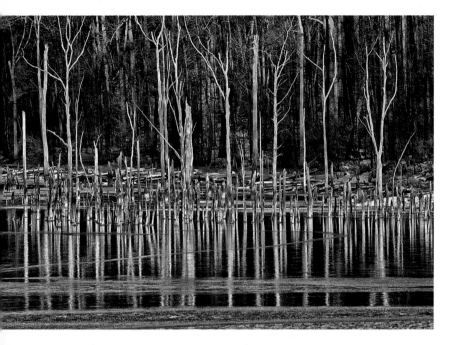

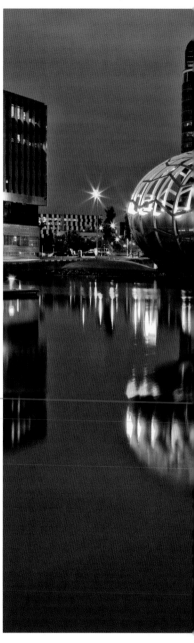

Stark tree trunks warmed by low sun in the late afternoon of a winter day caught the eye of photographer Deborah Lewinson. She used a long telephoto lens to zero in on just the design of the trees and the reflections.
↑ Photo © Deborah Lewinson. 1/180 sec. at f/11, ISO 200, 200–400mm lens at 300mm

 ASSIGNMENT: EXPERIMENT WITH REFLECTIONS

Let's give reflection photography a real creative workout. Find a reflection scene in a nearby pond, pool, stream, or lake, and then, depending on the conditions, mix things up with one or more of the following:

- If the water reflections are moving, vary the shutter speeds. Go slow, then go slower, then speed up.
- Change camera placement. Sometimes a low camera placement (close to water level) produces a striking reflected image, quite different from the typical eye-level view. When photographing colorful reflections, bend your knees and crouch down from time to time to see if this gives you a better composition.
- Vary the focal length. Start by going wide, then zoom in tighter and tighter with a telephoto. Experiment, review the resulting images, and reshoot!

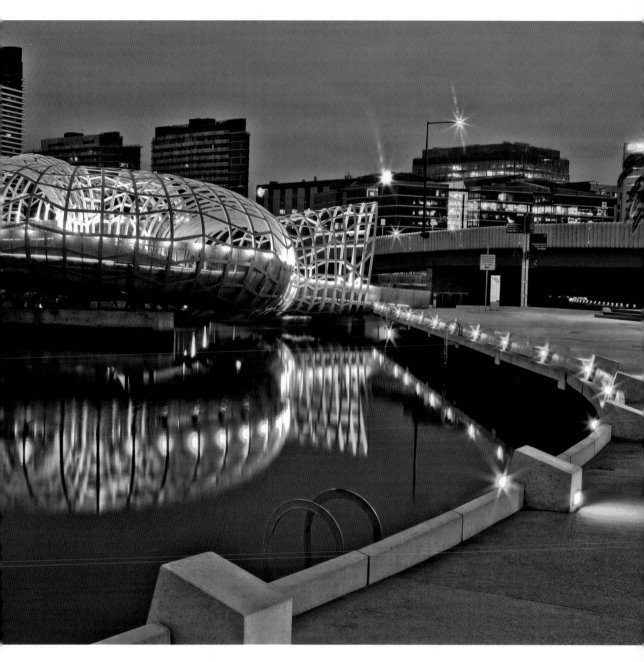

Photographer Renee Doyle has long appreciated the unique design and style of the Webb Bridge in Melbourne, Australia, and she photographed the lights and colors of this scene just after daybreak. To help even up the light, she used a graduated neutral-density filter (discussed further in chapter 5). Note the starbursts on the lights, enhanced by the use of a small aperture.

↑ Photo © Renee Doyle. 25 seconds at *f*/22, ISO 200, 24–70mm lens at 46mm

POLARIZING FILTER: BEYOND BLUE SKIES!

With a little imagination and skill, the use of a polarizing filter (also called simply a polarizer) can be a low-effort, high-impact method for controlling light and color. It can enhance a mood, contribute to your personal photographic style, and boost colors by reducing glare. But let's get something straight from the beginning. There's more than one type of polarizing filter on the market. The one you want is the circular polarizer. The other type—linear—can trip up a camera's autofocus system.

For outdoor shooters, the polarizing filter is a holdover from the film days (the effects of many other filters can now be duplicated with software in the digital darkroom). The polarizer—which attaches to the front of the lens—has long been known for its ability to deepen a pale blue sky. But a polarizer can do so much more than that. Most important, the circular polarizer can help tone down reflective surfaces such as glass, water, wet rocks, foliage, and painted objects.

Many outdoor photographers use the polarizer when it's overcast or just after a rain. Soft light is perfect for shooting water—waterfalls, streams, wet streets, etc.—and often a polarizer will give those images a boost by bringing out the natural colors. The polarizer also will cut the surface glare and let you see into small ponds, shallow streams, or tide pools.

If that weren't enough, the polarizer also can minimize atmospheric haze (thus increasing the clarity in distant views). And, since this filter is dark tinted (thus reducing the light that passes through it by about two stops), the polarizer can also help with creative slow-motion photography by providing a longer exposure (see chapter 6).

There are some things a polarizer can't do. It is at its peak effectiveness when used at a 90-degree angle to the light source—say, with the sun at your right or left. Don't bother trying a polarizer when you are facing the sun, or if the sun is at your back. Due to the 90-degree factor, beware when using a polarizer with a wide-angle lens to enliven a blue sky, since it could cause an unnatural variation from dark to light. If a reflective object consists of different angles, not all surfaces can be polarized at the same time. The solution is to rotate the polarizer's outer ring and see which orientation looks good to you.

> **TIP: DON'T FORGET TO TURN IT**
>
> The polarizing filter turns in its mount, and you must rotate the outer ring to see the possible effects. Then, when you hit the amount of polarization that you want, you shoot the scene at that precise orientation. If you do not see any effect whatso-ever as you rotate the polarizer, it's very likely that the scene is not a "polarizer scene"—i.e., you're not at an angle to the sun or the surface isn't actually reflective.

This wall shows the coastal ambiance of Seattle. Although it was a heavy overcast day, much of the red color was lost in the glare of the reflective surfaces. The addition of a polarizer not only made the colors richer but also reduced the distracting bright glare on the window, making it a more understated dark tone.

← Photo © Kerry Drager. 1/4 sec. at *f*/16, ISO 200, 70–300mm lens at 85mm
↓ Photo © Kerry Drager. 1 second at *f*/16, ISO 200, 105mm lens, polarizer

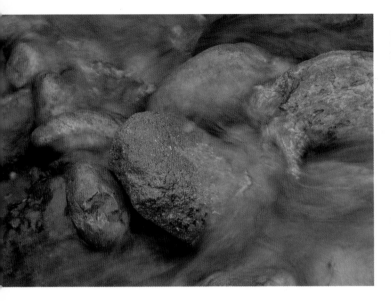

For this creek scene near my California country home, I wanted the soft light of overcast to prevent the sunlight-and-shadow contrast that often makes for harsh and unattractive photos of moving water. Water and wet rocks—and foliage, too—are surprisingly reflective, even under heavy cloud cover. In the shot at right, note how the polarizing filter greatly reduced the glare throughout the scene while also boosting the color. The use of a deep-tinted polarizer allowed for a much slower shutter speed, which further provided a sense of soft, flowing motion.

↑ Photo © Kerry Drager. 1/8 sec. at *f*/22, ISO 200, 105mm lens
→ Photo © Kerry Drager. 1/2 sec. at *f*/22, ISO 200, 105mm lens, polarizer

◉ TIP: STOW YOUR POLARIZER UNTIL YOU REALLY NEED IT

While it may be tempting to keep a polarizer on your lenses at all times, we wholeheartedly recommend against it. The polarizer is a specialty accessory, intended for the specific uses that we have outlined. It does cut the amount of light entering the lens, which can be a good thing (when you want a slower speed for creatively showing motion), but it can be a bad thing (such as when you need a faster shutter speed to stop subject motion or when you must handhold the camera). When you need a polarizer, attach it to your lens and be creative; otherwise, keep it safely stowed in your camera bag or photo pack.

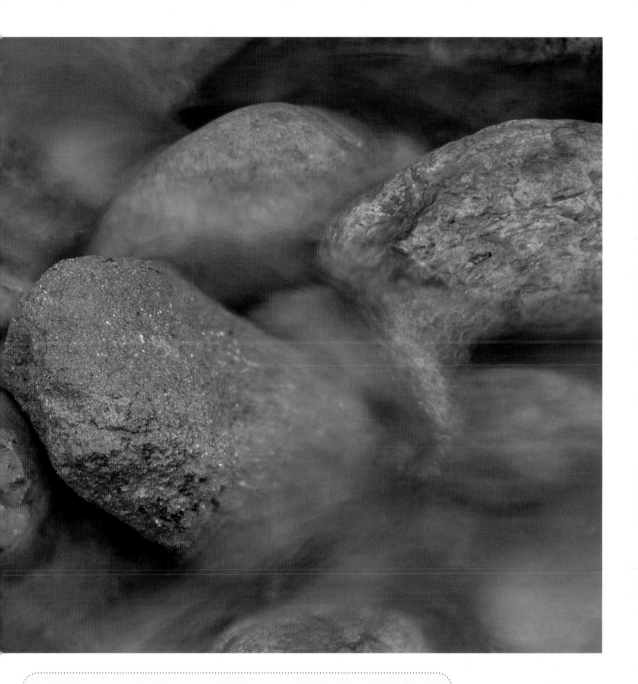

🔆 TIP: BEWARE OF VIGNETTING

The polarizer is thicker than other filters and, as a result, can cause vignetting (dark corners on your picture). This is especially an issue when stacking filters (using more than one at a time)—all the more so with the addition of a lens hood and when using a wide-angle lens. When in doubt, check the manufacturer's filter/hood specifications for your particular lens.

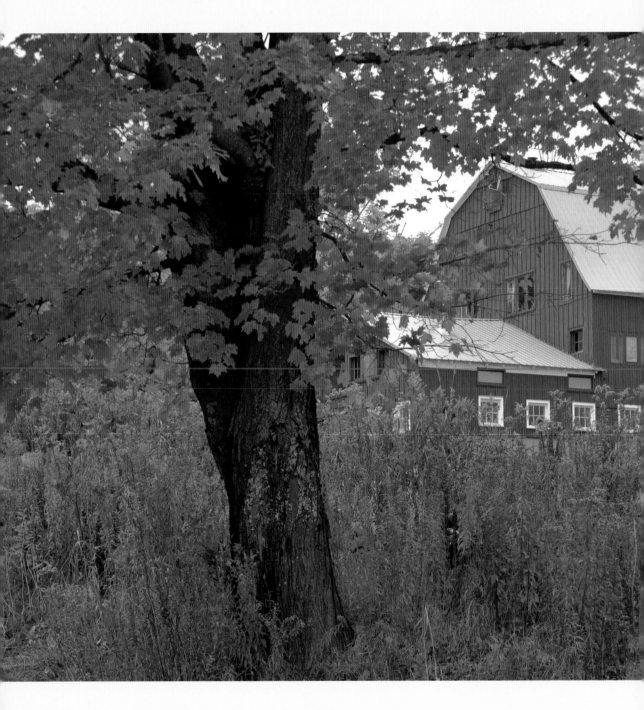

I thought this scene had "country color" written all over it! The cloud-filled sky acted just like a giant white umbrella to cast soft lighting. I composed the shot so the leaves mostly obscured the sky and key ingredients were in balance, with the tree trunk in the left foreground and the barn in the right background.

↑ Photo © Jim Miotke. 1/60 sec. at *f*/5.6, ISO 100, 28–50mm lens at 50mm

SOFT, MOODY, AND DRAMATIC LIGHT

Too often, outdoor shooters let bad weather get in their way. But we urge you to accept the notion that there is no such thing as bad weather when it comes to photography. While there's nothing quite like the cheerfulness of a beautiful blue sky, after venturing outside with your camera on a few days when the sun is not shining you'll find that images caught in soft overcast light or in dramatically "bad" weather can brighten your photographic horizons.

Making creative use of difficult conditions requires working the weather's edge—shooting on a white-sky day, getting out in the fog, photographing between storms, and catching inclement conditions from the safety of a protected area. Memorable scenes await photographers with an adventurous spirit. After all, dynamic light was behind the message of one of Ansel Adams's most famous quotes: "Sometimes I do get to places just when God's ready to have somebody click the shutter."

SOFT, OVERCAST LIGHT

Soft, pleasing light can enrich many colorful subjects. Overcast lighting often makes colors more vivid than direct sunlight and is more likely to reveal delicate details as well. Muted light offers minimal contrast, so scenes aren't marred by deep shadows and glaring highlights.

Studio owners spend tons of money duplicating the low-contrast light that outdoor photographers get for free from a cloud-filled sky. The soft, even illumination cast by a white sky is especially flattering for photographing people, and a thick cloud cover mimics the studio light produced with soft boxes and white umbrellas. The conditions are easy on the eyes and flattering for the face, and they eliminate unappealing facial shadows and your subject's impulse to squint in the sunlight.

The diffused sunlight of an all-white or all-gray sky is wonderful not only for photographing people but also flowers, pets, close-up subjects, waterfalls and streams, intimate landscapes, and colorful architectural details.

For photographer Peter K. Burian, lighting was just as important as great architecture during a trip to Dubai. He says, "It was a cloudy day, with no harsh highlights and no murky shadows—ideal for this type of scene." His camera's white balance was set for cloudy conditions to warm up things a bit, and the muted light eliminated the high contrast of deep shadows and intense brights. ↓ Photo © Peter K. Burian. 1/30 sec. at *f*/11, ISO 200, 18–70mm at 28mm

Photographer Anne McKinnell used a long telephoto lens to capture this tight portrait of a flamingo. The photo was taken indoors at a tropical garden that had beautiful soft light throughout. It was not necessary to use a flash.

↑ Photo © Anne McKinnell. 1/125 sec. at *f*/11, ISO 400, 300mm lens

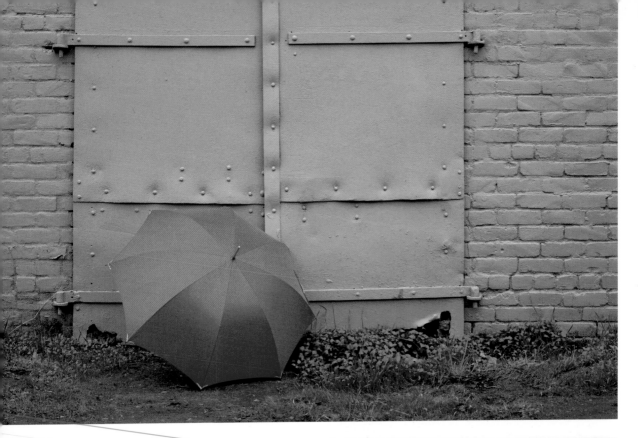

One cloud-filled day, I headed to a nearby town to find some scenes that would benefit from an extra burst of color. The brown wall and the green grass made a nice setting for the red umbrella shot (above). I then found an amazing blue wall on the side of a small shopping center. So I brought out my orange umbrella, which seemed made to order to contrast with the blue background. As I often do in these situations, I varied the composition and the format. The soft light from the solid overcast sky enhanced the colors and details.

↑ **Photo © Kerry Drager. 1/15 sec. at *f*/11, ISO 200, 50mm lens**
→ **Photo © Kerry Drager. 1/15 sec. at *f*/10, ISO 400, 50mm lens**

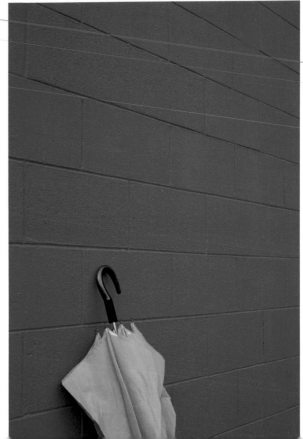

↑ Photo © Kerry Drager. 1/3 sec. at *f*/16, ISO 400, 50mm lens

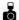 ASSIGNMENT: OVERCAST VERSUS SUN

For this exercise, you'll likely need at least two days—one sunny, one overcast. However, feel free to substitute another soothing-light situation—open shade, dawn, or dusk—for clouds. The idea is to shoot the same subject, person or object, in different types of lighting. For one image, catch your subject directly in midday sunlight. Then capture your subject in very even lighting. For extra credit, shoot your subject in the warm sunlight of very early or very late day.

🔆 TIP: BEWARE OF WHITE SKY

While an overcast sky filters the sun to create pleasing light, an image containing a big expanse of stark white or light gray, featureless sky will often be disappointing—the brightness can make everything else in the photo look dark in comparison. Here's the usual "rule": Skip grand-scale scenics that include boring (read: white or light gray) skies. Oh sure, there are exceptions to the no-sky rule, but not many. Either leave a white sky out completely, or severely reduce the amount of it.

With flower photography, light is just as important as the subject. Cloudy conditions—and no wind!—encouraged me to look for intense, precise colors during an early-morning shoot at San Diego's Balboa Park. I used a macro lens and then carefully set the focus to capture the razor-thin front-to-back sharpness range (depth of field) you get with an extreme close-up like this. I chose a vertical format to emphasize the vertical lines, curves, and curls.
↑ Photo © Jim Miotke. 2 seconds at f/14, ISO 100, 100mm macro lens

The soft light of bright overcast on a snowy day was ideal for recording intricate details and various colors. A close-up camera position and wide-angle lens allowed the inclusion of a slice of the snow-filled surroundings, and a tilt of the camera added a touch of visual energy to the composition.
→ Photo © Susan and Neil Silverman. 1/60 sec. at f/8, ISO 200, 20mm lens

During a BetterPhoto workshop, photographer Christopher J. Budny and his group hit the streets of New York City. "I wanted to capture one of the ubiquitous yellow taxis of Manhattan," Budny recalls. "Passing by a parked taxi, I noticed the reflections of moving taxis in the passenger window, with the car's dashboard visible inside. It was a gray, overcast day, which made the shooting easier, eliminating glaring highlights."

← Photo © Christopher J. Budny. 1/160 sec. at f/1.4, ISO 200, 50mm lens

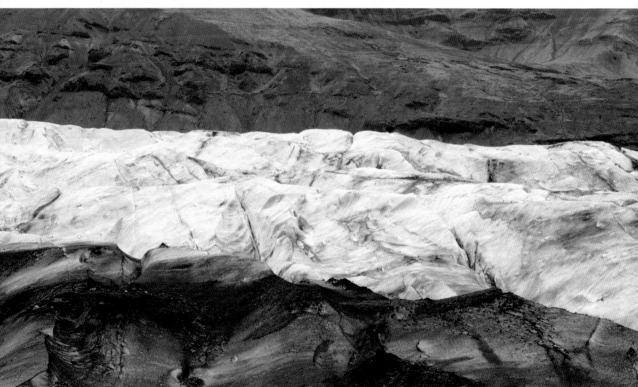

The multiple layers of this scene in Iceland captured nature photographer Tony Sweet's eye. The light was medium overcast, so he wanted to leave out the bright sky entirely, and with a telephoto zoom, he was able to show just the pattern of this landscape.

↑ Photo © Tony Sweet. 1/6 sec. at f/22, ISO 100, 70–200mm lens at 70mm

IN PRAISE OF SHADE

Open shade is a close "cousin" to overcast light. In fierce overhead sun, shade offers a diffused-light respite—an ideal solution when you wish to shoot portraits during a sunny midday. Look for the pleasing light under an overhang, on a covered porch, beneath the cover of a tree, in the shadows alongside a building, or just inside a door. As the two photos (below and right) show, a canvas awning can work as well. A good process is to place your subject just inside the edge of direct sunlight, where the shade is still relatively bright.

Background alert: As you compose a photo with a subject in shade, beware of any glaring hot spots. Distracting sunlight reflections can capture the viewer's eye and draw attention away from your main subject.

I wanted to create an environmental portrait of a "saloon girl" that showed a storytelling slice of the surroundings at a historical reenactment in California's Gold Rush Country. The "saloon" in this case was a big canvas tent with spacious doorways and windows that allowed natural light to stream through from all directions.
↓ Photo © Kerry Drager. 1/500 sec. at *f*/4, ISO 400, 50mm lens

I caught this "Gold Rush doctor" as he shared stories about 1800s medicine with a group of children. I chose a low camera angle, so that I could include the old tent's awning as a fairly plain background. I also liked the dappled patterns of very soft diffused sunlight.

↑ **Photo © Kerry Drager. 1/250 sec. at *f*/4, ISO 400, 50mm lens**

People aren't the only subjects that photograph well in the shade. This graphic design of this chain and gate caught the eye of photographer Ibarionex Perello. "The use of open shade provided me a good source of illumination," he says. Even in soft light, note how a light-toned, shiny subject such as this chain stands out against a dark background. The close-up composition helps emphasize the pattern.

← Photo © Ibarionex Perello. 1/80 sec. at *f*/5.6, ISO 400, 12–60mm lens at 60mm

ASSIGNMENT: SUNNY AND SHADY PORTRAITS

Here's a quick-and-easy exercise. All you need is to grab your camera and round up a willing friend or family member. Take at least two photos in different lighting. For one image, shoot in high contrast under a bright midday sky with the sun hitting your subject's face. For the other image, shoot in low contrast light—specifically, overcast or open shade. The results should be quite impressive.

I discovered these colorful chairs on a Florida porch in the cool shade of a warm, sunny morning. The color, line, and repetition seemed ideal for a close-up graphic-design image. I liked how the red popped out against the neutral background. I used a polarizing filter to reduce the glare on the reflective surface to pump up the color further.

↓ Photo © Kerry Drager. 1/15 sec. at *f*/11, ISO 200, 105mm lens

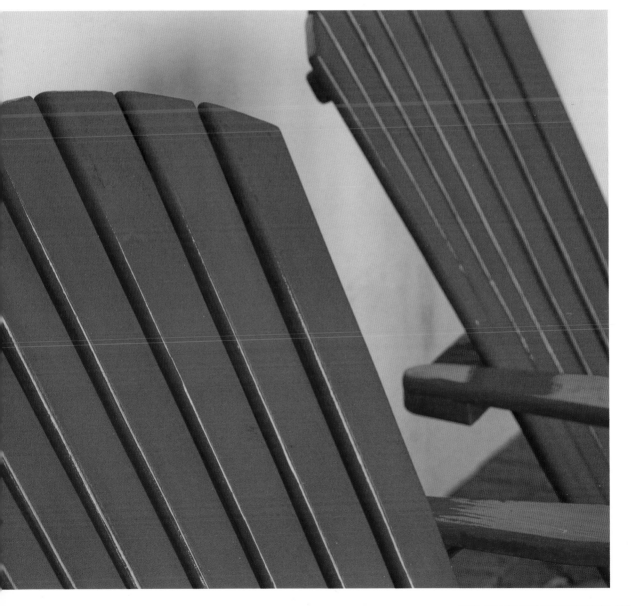

WEATHER DRAMA

Dramatic light is frequently the byproduct of dramatic weather. Your photographs will benefit greatly if you become weather-wise and work at the weather's edge. This doesn't mean trying to navigate a rain- or snowstorm. But it does mean being ready to dash out when the storm starts to break up and beams of light start to burst through the clouds in a dazzling way.

Watch for clouds casting shadows as they move across the landscape to provide depth, pattern, and texture. If all goes well, you'll be treated to stunning dancing light shot against a dark and imposing sky. Perhaps you'll see the sun-versus-storm ultimate: a rainbow.

When dynamic scenery and weather collide, the resulting images can be truly magnificent. Photographer Doug Steakley found these snow-covered oaks against a granite wall in Yosemite National Park, California. The combination of snow and low clouds hanging over the scene render things pretty much monochromatic— a black-and-white look in which whites, blacks, and grays dominate the beautifully moody scene.
→ Photo © Doug Steakley. 1/20 sec. at *f*/14, ISO 100, 28–70mm lens at 48mm

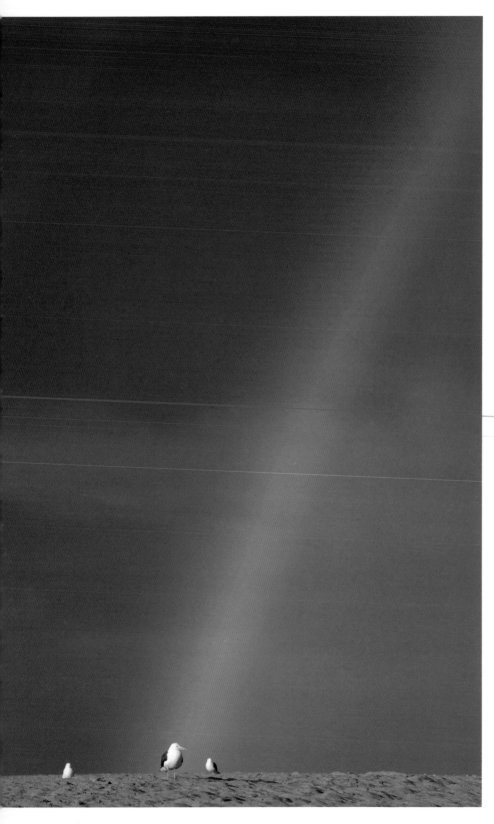

Many captivating landscapes owe their drama to a storm that is breaking up, with the sun emerging from the clouds. Ideally, you want an uncluttered background—particularly one that's dark, so the bright colors really show up. Such a combination of foreboding sky and intense sunlight can lead to a rainbow, just as it did one early morning along the California coast. Perspective really matters when it comes to rainbows. When I first saw this one, it was striking a bare stretch of beach. But by moving my camera position just a bit, I was able to place a seagull at the end of the rainbow.
← Photo © Kerry Drager. 1/1000 sec. at f/5.6, ISO 400, 80–200mm lens at 200mm

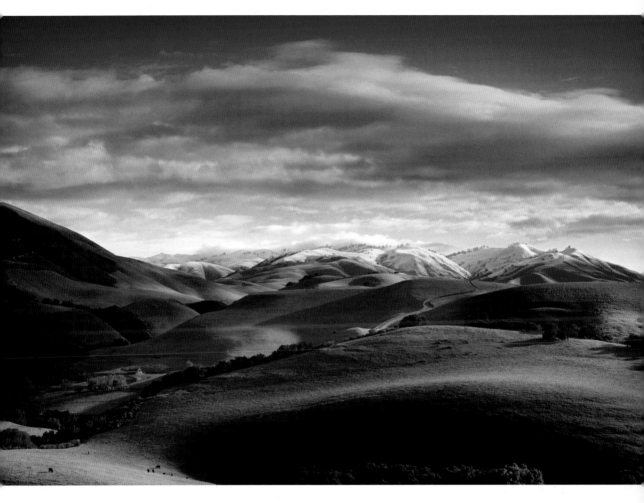

Photographer Doug Steakley was on the scene early one day in Carmel Valley, California, when a clearing storm served up great cloud formations, a dusting of snow on distant mountain peaks, and outstanding cloud shadows on the green, rolling hills.

↑ Photo © Doug Steakley. 1/30 sec. at *f*/13, ISO 100, 24–85mm lens at 42mm

⬤ TIP: TUNE IN TO THE WEATHER CHANNEL

Always check the latest weather forecast. Is the storm coming or going? Is there another storm on the way? Is there lightning in the forecast? The answers are critical for planning your shooting and safety strategy.

SNOW

For confirmed outdoor shooters, the out-of-doors is never out of season. Photographing winter's wonderland can be an especially exhilarating experience. Just consider the glistening vistas, frosty trees, simple shapes, moody scenes, fresh snow everywhere, and a myriad of subjects that are beautifully outlined in the "white stuff."

Of course, there's no denying that the cold requires some adjustments for comfort and safety. Plus, there's the most common question we hear in regards to winter photography: "How do you expose correctly for snow scenes?"

Exposing for white-dominated landscapes can wreak havoc on the camera's exposure system. That's because cameras are programmed to read midtones like green grass or blue sky and give good exposures. But if the scene is mostly white, the camera's meter tries to make it a midtone and, as a result, underexposes the image for "gray" snow.

One metering approach is to take an alternate reading on a midtone—often called "middle gray"—then shoot with those settings. To get that alternate reading, fill the frame with a midtone object in the same light as the main scene. The midtone object might be blue jeans, tree bark, sunny sky, red jacket, medium-brown wall, etc., and it needn't be in your scene, since it's only being used for exposure purposes. This approach is a substitute for the classic gray card (sold in camera stores) that you hold in front of your camera: You make sure the light hitting the card is the same as that falling on the scene, take a meter reading off the card, and shoot the scene with that reading. But these cards can be unwieldy and are easily misplaced, so using a midtoned part of the scene is often the best bet.

On a sunny day, your midtone subject should be in the sunlight (or it can be the blue sky). You might need to move closer or zoom in tighter—temporarily—to get the reading. Or you may have to use the camera's spot mode to read a small area from a distance. Then hold those settings (via manual mode, or, if using autoexposure, just press the AE lock button on the camera) and then fire away. By shooting with these settings—from the alternate midtone reading—the other tones in the scene will fall perfectly into place.

Another snow-exposure technique is to shoot just as you do normally. In an overall multipattern mode like

Evaluative or Matrix, the photo may turn out fine—almost certainly so, assuming your scene has an equal mix of white, dark, and midtoned areas. After all, not all winter compositions are filled with snow. There can be sky, buildings, people, etc., along with the white stuff, and with a range of tones, your camera may handle the scene perfectly.

Remember: When shooting stationary scenes that you can shoot again, you can evaluate things on the back of the camera, such as the histogram and highlight warnings. Then, if necessary, you can make adjustments and reshoot. Too dark? Too light? If so, fix the exposure by using the exposure compensation feature on the camera.

Fog and mist contributed to the dynamic ambiance of photographer Doug Steakley's shot of arching black oaks in Yosemite National Park, California. A black-and-white rendition added perfectly to the mood of this scene.
↑ Photo © Doug Steakley. 1/4 sec. *f*/14, ISO 200, 28–70mm lens at 40mm

Two seasons came together for this series by landscape photographer William Neill. He caught these oak trees, showing colorful leaves in a late-autumn snowstorm, near his home in California's Sierra Nevada. For the photo at left, he took the conventional approach and placed his camera on a tripod for sharp detail. For the other image, he used a slow shutter speed (1/4 sec.) and moved the camera to get a soft, muted, and downright intriguing look. For what he calls his "painting with light" photography, Neill will try all types of camera movement—up, down, sideways, even changing direction in the middle of a long exposure. He often takes a rapid series of photos and then checks his LCD monitor. "Based on what I see," he says, "I adjust shutter speed, focal length, or my camera position to refine the effect." (Note: We cover the "low light and slow shutter" theme in depth in chapter 6.)

← Photo © William Neill. 1/10 sec. *f*/11, ISO 100, 70–200mm lens at 185mm
→ Photo © William Neill. 1/4 sec. *f*/32, ISO 100, 70–200mm lens at 200mm

COLD CAMERA CARE

When shooting in cold climates, your photo gear needs a little tender loving care. For example:

- Don't breathe directly on any glass. Your breath could fog up your LCD monitor, viewfinder, or lenses.
- Avoid exposing your gear to sudden temperature changes. In extreme cases, doing so can create condensation inside the camera—definitely not a good thing. When heading indoors (or into a car) from the cold, keep your photo equipment zipped up tight in your camera bag or photo pack. Place it as far away as possible from the warmest spot. You might consider placing the gear in a transitional spot, such as a mudroom, enclosed porch, or garage first, and then moving it inside. The gear must adjust gradually to the inside air before you do any cleaning or organizing.
- Below-freezing temperatures can sap energy from camera batteries. Carry an extra battery (or two) in a protected inside pocket. When your camera battery starts to lose power, switch it out with the spare warm one.

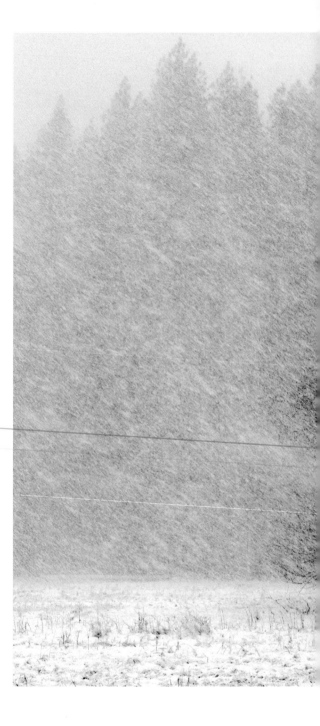

 TIP: KEEP YOURSELF WARM

Your cold-weather photography will only be successful if you're reasonably comfortable. So follow the usual stay-warm mantra and dress in layers and wear a hat. But don't forget your hands, since a frosty day can chill you all the way down to your shutter finger. While big, bulky mittens may keep your hands toasty, they fall short when it comes to handling a camera's intricacies. So for actual shooting, you need thinner gloves that are more flexible.

Some gloves are made especially for photographers or for other outdoor enthusiasts who need flexibility. These feature a surface that aids in gripping intricate objects, including cameras.

Of course, in really cold conditions, a thin pair won't be enough. We suggest wearing wool fingerless gloves over the lightweight pair for a little more warmth, then, between shots, slipping heavier gloves or mittens over your shooting pair.

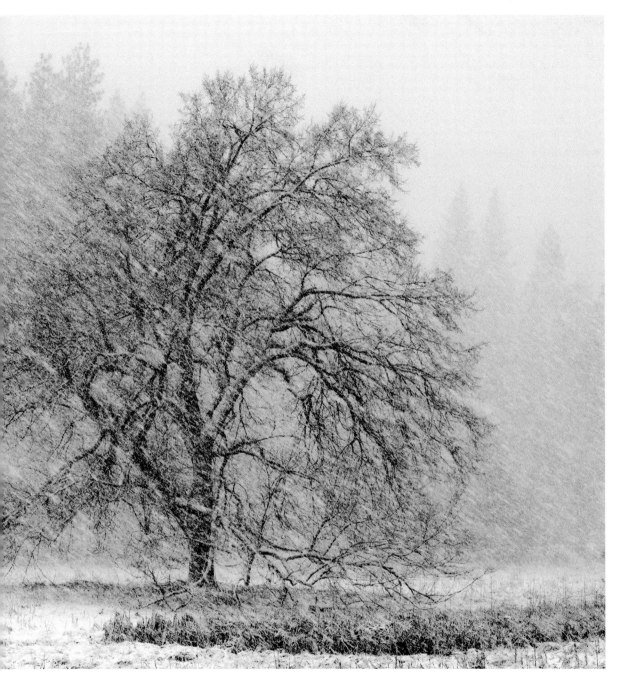

Soft forms and shades of gray and white highlight this photo by photographer Doug Steakley. For exposing a scene like this, you could spot-meter an area that's a middle gray (not dark, not light) and use those settings to shoot the scene. Multipattern metering (such as Matrix or Evaluative; see chapter 1) could work, too, but check your camera's histogram to make sure the scene doesn't go too dark (which often happens when whites or light tones dominate the scene).

↑ Photo © Doug Steakley. 1/60 sec. *f*/11, ISO 200, 28–70mm lens at 56mm

RAIN

Let's put it out there right now: Rainy-day photography doesn't sound very enticing. Yes, we know. We get it.

But wet weather creates wonderful opportunities for capturing innovative images. Yet, a rainy-day shoot doesn't have to be a miserable experience and will certainly expand your thinking when it comes to light, color, and weather.

On a rainy day, expect fresh images of gardens and people, and other scenes, too, especially with sparkling drops of water clinging to flowers, branches, and umbrellas. While pictures of pavement or asphalt rarely inspire when dry, they can take on a new feel from colorful reflections on rain puddles.

You and your gear really won't be getting drenched in a deluge, since you'll be waiting—comfortably dry indoors—for the storm to pass or for a break in the rain. Then get out there and have fun. But be sure to have a speedy escape plan for you and your equipment in the event of a cloudburst.

Pro photographer Deborah Sandidge loves the look of reflections on nighttime rain-soaked streets. "It creates a more expressive image than a photo taken during the day," she says. This image was captured in Florence. The scene had an extreme range of lighting—from shadow to light—so the camera couldn't capture (in a single exposure) all the information Sandidge wanted. To show more details and colors throughout the scene, she employed the High Dynamic Range (HDR) technique by shooting a number of bracketed images (the same composition but with different exposures) and combined them into the single well-exposed photo shown here. The three images used for this HDR shot had shutter speeds of 10 seconds, 2.5 seconds, and 1/6 sec., with the aperture remaining constant at f/16 to maintain the same depth of field. (Note: We cover HDR in depth in chapter 5.)
→ Photo © Deborah Sandidge. *f*/16, ISO 125, 24–70mm lens at 70mm

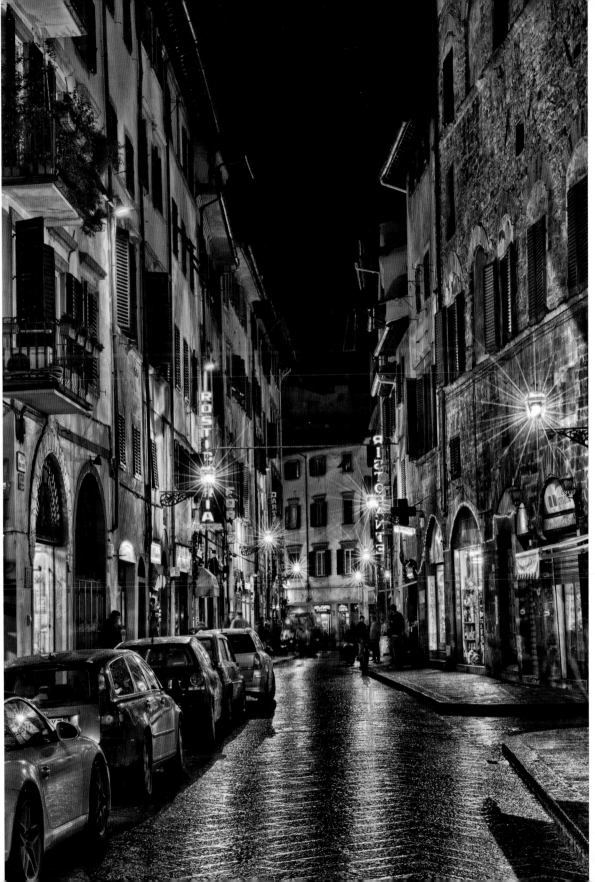

KEEP YOUR GEAR DRY

We don't recommend getting out in heavy rain or snowfall, but mild mist or a slight sprinkle? These conditions can be great for shooting, and here are some tips and tricks to help you take advantage of them:

- A lens hood is generally thought of in terms of keeping stray sunlight at bay to prevent flare, but it can also double to ward off drizzle or a light snowfall.
- An absorbent cloth will soak up drops of water on the camera body and the lens barrel.
- For errant raindrops on optical glass, keep a special lens-cleaning cloth handy.
- Use an umbrella, which helps keep the camera and lens dry—and the photographer, too! Unless you have an assistant to hold the umbrella, you'll likely need a tripod for the camera.
- Use a covering for your camera while shooting. We like an ordinary shower cap—the clear plastic kind with an elastic band—that can be stretched over the camera with a small- to medium-sized lens. Just be sure the shower cap doesn't cover the front (glass) of the lens. Also, check out a camera store for one of the commercial rain covers that are designed to fit cameras and long lenses. Practice putting on this rain "jacket" indoors, since doing so can be awkward the first few times.

The soft light of a rainy day adds freshness to any portrait scene. Here, the umbrella served a dual purpose: to keep the misty rain off my stepdaughter, Kristin, and to make a colorful backdrop. I was protected from the mist, too, while shooting with a telephoto lens from underneath an overhang. I did not need a flash or reflector, since the unaided natural light was just right for outdoor portraiture.
↑ Photo © Kerry Drager. 1/250 sec. at f/4.8, ISO 400, 105mm lens

Nature photographer William Neill specializes in intimate landscapes. He makes full use of the day, from dawn to dusk, and as this photo proves, he takes full advantage of the weather, too. For this small scene, he captured grasses and raindrops at Siesta Lake in Yosemite National Park, California. He shot this scene at midday on a cloudy-bright day, so he could use a fairly fast shutter speed to catch the circular ripples spreading out from the raindrops hitting the lake's surface. A telephoto focal length let him zero in on this tight and beautiful scene.

← Photo © William Neill. 1/90 sec. at f/16, ISO 200, 90mm lens

Old ranching and farming equipment and such assorted other castoffs as this red grille always seem to catch my eye. I captured this close-up view right after a rainstorm, moving in very tight to fill the picture frame with a graphic design of color, line, and pattern—plus raindrops. I like how the red jumps out against a discarded yellow grate.

↑ Photo © Kerry Drager. 1/13 sec. at f/9, ISO 200, 105mm lens

Soft, Moody, and Dramatic Light **139**

FOG

If you're a dedicated outdoor photographer, you'll want to rejoice—not complain—when the fog rolls in. Foggy conditions can reveal an atmospheric interplay of light and shape.

These misty times can have an ethereal, even dreamlike, quality—low in contrast, often light and airy, sometimes gray and moody, and frequently monochromatic—in which everything appears as black and white with silhouetted forms. The most common time of day for fog is in the morning, before the sun begins to burn off the mist. At times, you'll have an evocative scene with a rising sun and low fog that can be pure magic.

Composition is extra important when shooting in heavy fog. Generally, you'll want to get close to an interesting element in the foreground, making sure it can be clearly discerned through the fog. In a scene with front-to-back depth, this nearby object will stand out as other objects dissolve or even disappear mysteriously into the distance. In fact, for certain scenes, fog can serve a practical purpose, too, by simplifying the composition by blotting out distant distractions.

The photographic team of Susan and Neil Silverman captured this bicyclist in the bright natural light of a foggy morning. Note how the bright colors really pop in this photo—the effect of the muted lighting and placing the main subject close to the camera. At the same time, the wide-angle focal length includes a good chunk of the background, which fades into the misty distance.
→ Photo © Susan and Neil Silverman. 1/250 sec. at f/8, ISO 200, 14–24mm lens at 19mm

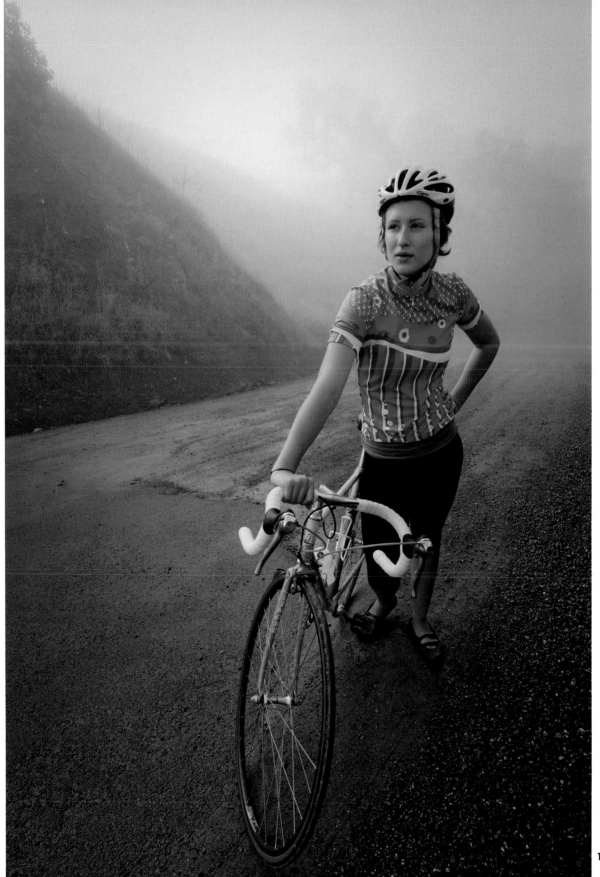

FOG EXPOSURE

Like snow, an expanse of bright fog can also fool a camera's meter into underexposure. However, since fog comes in all tonal densities, there isn't a one-size-fits-all formula for setting the exposure compensation. Fog is usually lighter than the camera's middle-tone target, so underexposure is often an issue. Check the back of your camera to verify the images. As with snow scenes, fog pictures may turn out too dark, so use exposure compensation to lighten things up.

But again, this shouldn't be a hard-and-fast rule. Fog has lots of room for artistic interpretation. While light and bright might be the way to go much of the time, a darker rendition translates into a moodier image. Exposing for fog provides one more example of how light, exposure, experimentation, and artistry go hand in hand.

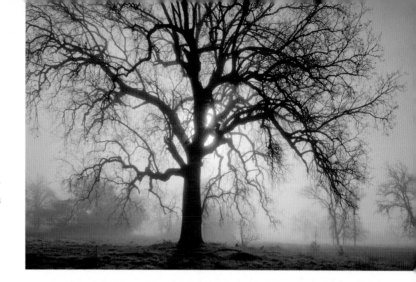

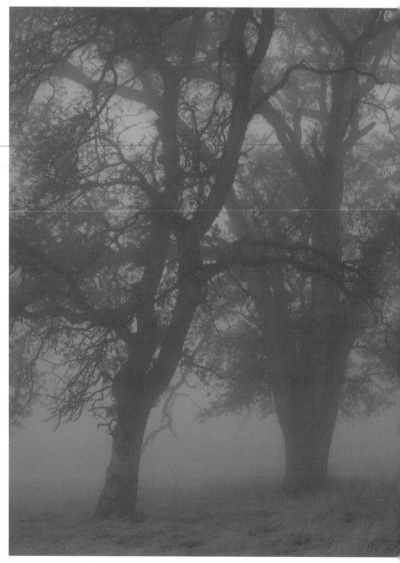

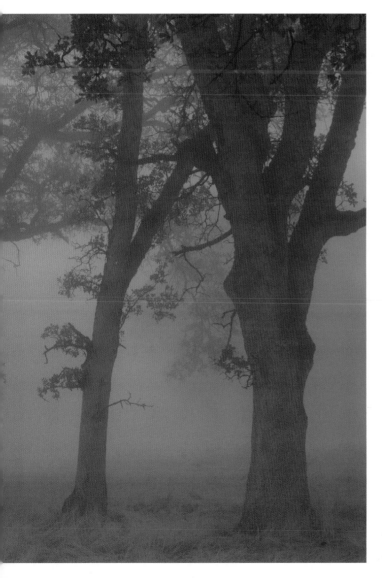

Foggy conditions come in all shapes and sizes, as you can see in these images from the Sierra Nevada foothills of California. Photographer William Neill shot them in the early morning on different days. In the photo at lower left, it's all soft light and soft tones, as Neill isolated a grouping of four oak trees that stand out against the foggy background. The look of this scene is decidedly moody and almost monochromatic, providing a wonderful sense of mystery. In the upper-left photo, the interplay of sun and fog catches the attention. Neill chose one oak tree to serve as the star of the show. He carefully placed the sun behind the tree—with just a bit of it peeking out from behind—while using a small aperture to create a small sunburst effect (see page 62).

↖ Photo © William Neill. 1/80 sec. at *f*/16, ISO 100, 24mm lens
← Photo © William Neill. 2/3 sec. at *f*/22, ISO 100, 50mm lens

Simon Stafford caught his teen daughter on a trampoline shortly after sunset. "To enhance the blue color," he says, "I set the camera's white balance to incandescent (tungsten), then put two speed lights (separate flash units) in small soft boxes positioned one above the other to give me a 2- x 4–foot light source to camera right, about 8 feet from the subject. The ambient exposure was reduced by –1EV to further saturate the sky color, and the flash output increased by +1EV to balance the exposure of the subject."

↑ Photo © Simon Stafford. 1/200 sec. at *f*/5.6, ISO 200, 24mm lens

CHAPTER 5

MODIFYING NATURAL LIGHT

We've spent four chapters extolling the visual virtues of natural light, and now we discuss ways to modify light to get the image you want. Flash, for one, isn't limited to making pictures at night but can be used successfully in daylight to solve lighting problems. A reflector acts just like it sounds—to reflect (or bounce) light onto a nearby shaded area. The graduated neutral-density filter has been a longtime choice of landscape photographers for evening up the light between a too-bright sky and a too-dark landscape.

In addition, we jump into a realm that entails recording multiple images—identical compositions but with different exposures—then combining them into a single well-exposed image. This approach is called High Dynamic Range (HDR).

Now let's proceed into the specific techniques, the nitty-gritty details, and the examples of how you can work with light, camera, and technique to get the photos you want.

FILL FLASH

Who says you can't use flash outdoors? Well, actually a lot of people say this, and a lot more people probably think it. It's not surprising, since flash is so closely tied to indoor shots of family gatherings, special occasions, and nighttime photos.

But here are some scenarios that may sound familiar:

- Unflattering facial shadows mar an outdoor portrait captured under a bright overhead sun.
- The awesome foreground of a landscape scene is lost in shadow while the bright sunlit background grabs the attention.
- A portrait subject under a shade tree appears dark (from the shadows) in contrast to a bright-sunlight background.

In each case, flash could have saved the shot. We're not talking about the harsh, overpowering "deer in the headlights" type of flash power. Definitely not! We're talking about fill flash, in which the light from the flash mixes with the existing light (also called ambient, or available, light) to illuminate a subject in a natural and unobtrusive way. This supplemental light can be accomplished with either built-in flash (which usually offers a fill flash mode) or external flash unit (a separate flash unit designed to work with a specific camera model and its exposure system).

With everything properly exposed—both the background and the flash-illuminated foreground—the whole photo is balanced, so neither looks too dark or too light. That's the point of fill flash—to make things appear natural-looking, so it isn't obvious you have blasted your close subject with artificial light.

Fill flash has other uses, too, that don't even involve fixing a contrast issue. Under a white or gray sky, you can add just a touch of additional light to create little sparkles or twinkles—also called catchlights—in a subject's eyes. Also, while overcast or shade delivers wonderfully even light, sometimes the colors appear muted—that's where a shot of extra light (via fill flash or a reflector to bounce light) can help make the colors pop.

Accessory flash units and most built-in flashes offer ways to control the desired amount of flash. These are especially important when you are trying to balance the light in a pleasing way. You might want enough light to fill in a deep shadow, or you might want only a dash of illumination, or something in between. The flash exposure

compensation feature allows you to adjust the flash output in one-third or half-stop increments usually up to plus/minus two or three stops. What's best? It depends on the circumstances, but with digital, it's easy to figure out! Just take the picture and then study it in playback. Adjust the flash compensation if necessary, then take another photo. Repeat the process until everything looks great.

Note: Your flash only affects subjects within its reach, not the scene's ambient or existing light. So, for example, if the background looks too dark or light, you can adjust it via your camera's exposure compensation (the same feature you use to adjust the exposure for non-flash images). That's different than *flash* exposure compensation, which only affects the flash output.

On an overcast day, the photography team of Susan and Neil Silverman captured this vineyard worker cutting grapes. To lighten up things, they used fill flash, but with a –1.7 flash exposure compensation to keep the burst of light subtle.
↑ Photo © Susan and Neil Silverman. 1/6 sec. at *f*/16, ISO 141, 18–200mm lens at 48mm

Outdoor portrait photography can be fun for both photographer and subject, as my model, Kim, seems to be demonstrating here. The light was perfect, soft from heavy overcast. I zeroed in tight with my telephoto lens, while fill flash brightened up things and added a small sparkle in the eyes. To get more of a natural-light look and avoid a harsh flash appearance, I dialed down the light by using –1 1/3 flash exposure compensation.

↑ Photo © Kerry Drager. 1/180 sec. at *f/8*, ISO 400, 105mm lens

High-noon sunlight was the photographic challenge for a parade in Ontario, Canada. The overhead sun cast deep shadows under the helmets (see the image top right, made without flash). To brighten up things, photographer Peter K. Burian used fill flash. He set the flash exposure compensation to –1 to ensure a subtle and natural result while still lightening up the shadows.

↗ Photo © Peter K. Burian. 1/100 sec. at *f/13*, ISO 100, 24–105mm lens at 45mm, no flash

→ Photo © Peter K. Burian. 1/100 sec. at *f/13*, ISO 100, 24–105mm lens at 45mm, fill flash used

The light in this location (under some trees) was mottled, casting both shadows and bright areas on the face of photographer Peter K. Burian's daughter. So he used fill flash to even out the lighting and achieve a more attractive effect.

← Photo © Peter K. Burian. 1/100 sec. at *f*/7.1, ISO 400, 105mm lens

A low camera position and a wide-angle lens produced an eye-popping look at this stretch of seascape at Carmel Point, California. Since everything in the scene is important, photographer Doug Steakley chose a small aperture to get as much sharpness as possible with deep depth of field. He also used a tripod to keep the camera steady. To brighten up the foreground, he used fill light, with his wife holding the off-camera flash. Then, with everything ready to go, Steakley says it was a matter of "waiting for the wave in the background to splash at the right moment."

→ Photo © Doug Steakley. 2/3 sec. at *f*/18, ISO 200, 12–24mm lens at 16mm

🔘 TIP: CONSIDER AN EXTERNAL ACCESSORY FLASH

A built-in flash works just fine for most shooting situations. But if you find yourself getting more interested in light and flash photography, we suggest investing in an accessory flash. This type of flash attaches to the hot-shoe port on your camera and provides extra flash power as well as flexibility and creative control over how light hits your subject.

A separate flash usually has a tilting head, so you can bounce light off a wall or ceiling for a softer quality of light. Plus, you have the option of placing the flash off-camera by using a sync cord or wireless technology. This off-camera capability lets you direct the flash from any angle, often resulting in more dramatic light by giving subjects extra dimension and texture.

In addition, you can use an accessory diffusion dome that attaches to the top of the flash and scatters (diffuses) the light. Some models of flash units come with a diffusion dome; otherwise, you can buy one as an aftermarket product. Diffusion domes snap on easily and come off quickly, too, when you need more power to toss light from a good distance.

REFLECTORS

In certain ways, the reflector does what fill flash does—helps brighten up a shaded area. As opposed to flash, a reflector lets you see the amount of additional light that's cast onto your subject right as you are shooting. By slightly turning the reflector, you can decrease or increase the light. It's a great way to fill shadows and create a much more evenly lit subject. A reflector, by the way, can be commercially made or homemade—in either case, it involves a reflective surface that directs light onto your subject.

When the light source illuminates one side of your subject more than the other—as in sidelighting (see page 44)—a light-versus-dark contrast occurs. At times, you may want this artsy effect. But if you want to minimize contrast, you can use a reflector, placed on the shadowed side of the subject (just outside the picture area), to bounce sunlight directly into the shadows.

The use of a reflector doesn't have to be an all-or-nothing affair. Sometimes you don't want to brighten things entirely. You can soften the shadow to retain much of the form and texture that sidelighting provides. It's up to you to choose how much, or how little, of an effect you want.

Reflectors aren't limited to portraits, as some of these photos prove. They can be a great asset when photographing flowers, still-life scenes, and small objects. And things don't have to involve bright sunlight, either. Even in overcast, it's possible for the lighting to be unequal, even if softly so. Likewise, the soft light flowing through a window—whether on an overcast day or from a north-facing window—may be pleasing on the window side but show slight shadows on the side facing the rest of the room.

And on a sunny midday, toplight—with the sun above—can show people with eyes lost in dark shadow. A great approach is to move the subject under a tree, an awning, or another place that offers open shade, and then use a

This photo certainly has "happy child" written all over it! Pro photographer Vik Orenstein captured this scene in the open shade of a sunny midday. A three-foot round white reflector was placed at the left and slightly in front of the girl to bounce additional light onto her—and creating nice catchlights in the eyes. With the telephoto and wide aperture, the beautiful outdoor setting with flowers is blurry, so the sharp subject stands out in contrast. Of course, the bright, colorful clothing also help separate subject from background.
↑ Photo © Vik Orenstein/Kidcapers Portraits. 1/250 sec. at f/5.3, ISO 640, 18–200mm lens at 105mm

reflector to bounce light back into the shadows. Note: Another solution is to use a diffuser (also called a diffusion disc or a scrim). Made of translucent material, the diffuser is positioned between the subject and the sun to help tone down the harsh light.

What type of reflector should you get? A commercially made reflector may be the best and easiest option. These are collapsible, so they pack up nice and small. They are often sold as two-sided, such as white and gold or white and silver. The most commonly used side, white, casts a neutral-color effect for natural-looking results. Silver is neutral, too, but just more intense, for extra reflecting power. Gold creates warmer tones for your subject. These store-bought models are usually circular and made of a special reflective fabric with a flexible spring frame that allows it to fold down to a small size.

You can go the do-it-yourself route, too, with just about any material that's reflective. Options include white foam core from a craft shop or office supply store, or a piece of white poster board from an art-supply store. Alternatives usually don't have the fold-up convenience of commercially sold photo reflectors.

Regardless of the type of reflector you use, you'll usually need another person to hold it. In some circumstances, you may be able to place it on a stand or lean it up against something. Other times, you might be able to hold the reflector yourself, if your camera is on a tripod. Then, by the use of a self-timer or wireless trigger, you can trip the camera's shutter. This works better with stationary objects than it does with people, since you won't be able to see through the viewfinder to catch your subject's best expression.

Most reflectors are white, to get a neutral color cast, but not always. This portrait of a worker was taken in midmorning, and the beautiful warm tone originates from the pleasing but soft sunlight filtering through the doorway. Photographers Susan and Neil Silverman warmed things up even more by using a gold reflector to bounce light onto the subject and his armload of lavender.
↑ Photo © Susan and Neil Silverman. 1/8 sec. at *f*/8, ISO 200, 24–70mm lens at 29mm

A reflector can be used for inanimate objects, too! This scene shows an old yet freshly painted milk can in late-afternoon sidelight. Note how in the photo at left, the opposite side of the can—away from the sun—is in deep shadow. The image below shows how the reflector is placed so the sunlight hits it directly. The reflective surface then bounces light into the shadows of the can. The image at right reveals more color and detail on the shadowed side. For portraits, you'll usually need an assistant to hold a reflector, but with close-ups, you can lean a reflector against a camera bag or another object (such as a small tripod, as shown here).

← Photo © Kerry Drager. 1/250 sec. at *f*/6.7, ISO 200, 70–300mm lens at 92mm, no reflector
↓ Photo © Kerry Drager. 1/250 sec. at *f*/6.7, ISO 200, 70–300mm lens at 75mm
→ Photo © Kerry Drager. 1/250 sec. at *f*/6.7, ISO 200, 70–300mm lens at 92mm, reflector used

Indirect sunlight from a north-facing window provided the primary illumination for this graphic-design image. Photographer Donna Rae Moratelli used a reflector to bounce light onto the side farthest from the window and create even light and a balanced exposure throughout this photo while helping to enhance the pattern of designs, curves, and textures.

← **Photo © Donna Rae Moratelli. 8 seconds at *f*/22, ISO 50, 50mm lens**

Kitchen objects work great for close-ups and window light. Photographer Donna Rae Moratelli captured this scene with ambient northern window light. To reduce the contrast from the directional window light, and also to add light, she used a silver reflector.

↓ **Photo © Donna Rae Moratelli. 2 seconds at *f*/22, ISO 100, 70–200mm lens at 172mm, with extension tube for close focusing**

That's coauthor Jim photographing BetterPhoto's husband/wife team Jay and Amy. This outdoor portrait setup shot shows several outdoor portraiture techniques. Note that a helper is holding a reflector to bounce light onto the subjects. This reflector has two sides—white (which is facing the subjects and is most commonly used) and silver (which is simply brighter, for the rare times when you need more reflected light power). While the reflector did the main job of adding light, Jim also used a hint of flash (softened by the addition of the white diffusion dome).
↑ Photo © Kerry Drager. 1/90 sec. at f/4.8, ISO 800, 105mm lens

When it comes to outdoor portraiture, great light is just as important as a great subject. But sometimes natural light needs a bit of help. Since the sunlight was bright, Susan and Neil Silverman used a diffuser (a translucent diffusion disc) that they placed between sun and subject, along with a gold reflector to bounce light into the shadow area.
→ Photo © Susan and Neil Silverman. 1/2000 sec. at f/2.8, ISO 400, 70-200mm lens at 125mm

GRAD FILTERS

The graduated neutral-density filter—popularly known as a "grad filter," or just a "grad"— is half clear and half tinted, with a graduated (blended) gray tone across the middle. It helps you even up a scene's contrast so your camera can register detail in both light and dark areas at the same time. Landscape photographers have long used grad filters, since scenics often have an extreme range of tones, and the sky is generally far brighter than the ground. If you were to shoot such a scene unaided, the resulting photo would show the sky as totally washed out or the landscape as way too dark and muddy-looking. You may use the grad filter in any scene in which there is a great range in tonal values and a relatively straight line separating the two.

Here's how a grad works: You position the filter so the deep-tinted part covers the bright sky and the clear part covers the shadowed landscape. The tinted half holds back the light (exposure) of a bright sky, while the clear half permits a dimly lit foreground to be exposed correctly. As a result, the overall exposures show much better detail and color.

Grad filters come in different strengths or densities, usually cutting the light by two or three stops. The most common grads are neutral, or shades of gray, so the scene's color doesn't change. But you can also buy grads in various other colors—say, a cool blue to enhance a blue sky or assorted warm tones to pump up a sunset sky.

Grads come in soft-edge and hard-edge varieties. A soft-edge grad blends the dark and light sides in a gentle gradation and is used for horizon scenes such as mountains, trees, or other uneven lines. The hard-edge type works well only in scenes with a fairly distinct edge between bright and dark areas, such as ocean horizons.

Especially for the hard-edge type, it's important to take care so the dividing line isn't obvious in the photo. Regardless of the filter style, it's advisable to double-check your LCD after taking the picture, to make sure the dividing line isn't showing up in the sky or in another distracting place. You can also try activating depth-of-field preview (assuming your DSLR camera has this handy function), since it may help you fine-tune the grad's placement while you compose the picture. Since DOF preview darkens the scene in the viewfinder (assuming you have the lens stopped down to a small aperture), it makes it easier to verify that the density transition is in the spot you want. Moving the filter up and down while viewing can be helpful as well.

⬡ TIP: GO FOR A RECTANGULAR GRAD

The round version of the grad filter screws into the front of the lens, just like most standard filters. But this limits your compositional options by forcing you to always put the horizon exactly in the center, whether you want it there or not.

We recommend the rectangular version. Since there's room for the filter to move up and down, you can show lots of sky or just a little. Special holders are available for grads, but many veteran grad users simply hold them in front of the lens (with camera on tripod).

This image shows examples of two types of graduated neutral-density filters. On the left is the soft-edge version, with a gentle gradation between the clear and dark areas. At the right is the "hard step" style, with an abrupt clear-to-dark split. The soft-edge filter holds back two stops of exposure, while the hard-edged filter shows a darker, three-stop density.

Here, much of Yosemite Valley is in complete darkness, but the sunset light is catching the peaks and the sky is still bright. Photographer Anne McKinnell used a graduated neutral-density filter to even out the exposure between the bright sky and the shadows. This shot also required a very small aperture, f/25, to ensure that both the foreground and background would be in focus with a deep depth of field.
→ Photo © Anne McKinnell. 4 seconds at f/25, ISO 100, 10–20mm lens at 14mm

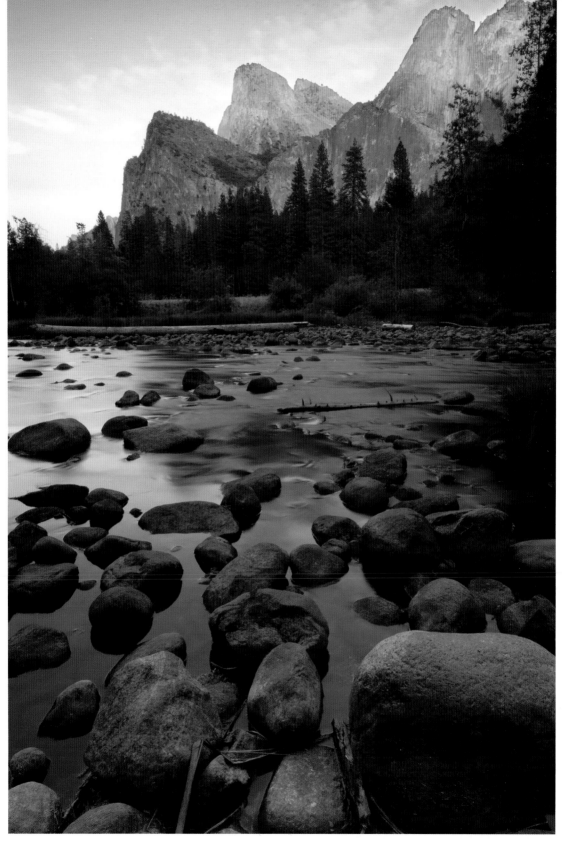

HIGH DYNAMIC RANGE

The High Dynamic Range (HDR) process is a very effective way to give you a natural-looking image from a high-contrast situation. In short, HDR helps to expand the camera's limited dynamic range, by providing good detail in both dark and bright areas. The process involves shooting several different exposures of the exact same scene, and then, in postprocessing (in the digital darkroom or, in more and more cases, the camera itself), combining them all into a single photo with well-exposed shadows, midtones, and highlights.

HDR takes the wide range of tonal values that we see in the real world and, via a series of exposures, merges them into an image that better matches what we saw at the time. With digital-darkroom software, you can also make decisions on how to present the final image—photorealistic, artistically edgy, or somewhere in between.

Here's how it works: You take a quick series of images that cover the range of exposure values in the scene. At one end, a photo shows the bright area with good color and detail (while the shadow areas appear appropriately dark). At the other end, the shadow areas are exposed correctly but the brights are washed out. Depending on how extreme the bright-to-shadow contrast is, you'll have one or more photos in between. These photos cover all of the important areas of the scene and are exposed correctly for each. You then merge, or "stack," them to create one well-exposed image.

You'll want to choose one *f*-stop and keep it there—this way the depth of field remains the same in each image (see page 34). This can be most easily done in Aperture Priority, so if you choose, say, *f*/8, then that *f*-stop will stay constant, while the camera automatically adjusts the shutter speed for each exposure. With the same *f*-stop, the range of sharpness from foreground to background (depth of field) stays the same.

Set your camera to the autobracketing mode (e.g., go with a one-stop change between shots), and set it for a continuous shooting mode, too. This way, all you need to do is press down on the shutter and fire off a rapid series. This technique works best when there is little or no motion going on in the photo, since anything moving will show up as blurred in the series of images.

So how many images do you shoot? That depends on just how extreme the exposure range is from the brightest highlights that you want to record in good detail to the deepest shadows that you want to be well-exposed. A good starting place is three to five images in intervals of plus one and minus one stop. For three photos, you might want to start with the camera's automatic meter reading (0), then go one below and one above. Or, for more, you may need to go with two above and two below (for a total of five shots), and so forth. The best way to get the precise number of exposures is by taking a meter reading on the brightest area and then on the darkest shadow area that you wish to show good detail, and then determine the number of stops separating the two.

For photographer Christopher J. Budny, this stairway scene at Washington, D.C.'s National Cathedral has long been an architectural favorite. But, he says, "all my attempts to shoot it over the years were never quite what I envisioned"—that is, until he shot the scene with the techniques displayed here: a wide-angle zoom lens and High Dynamic Range (HDR). For HDR, he shot this extreme-contrast scene with three bracketed exposures (at one-stop shutter speed intervals of 0.6, 1.3, and 2.5 seconds) while using a tripod and shutter remote. After combining the separate exposures to make the single exposure shown here, he desaturated the image for a monochromatic interpretation.
→ Photo © Christopher J. Budny. *f*/8, ISO 400, 10–22mm lens at 10mm

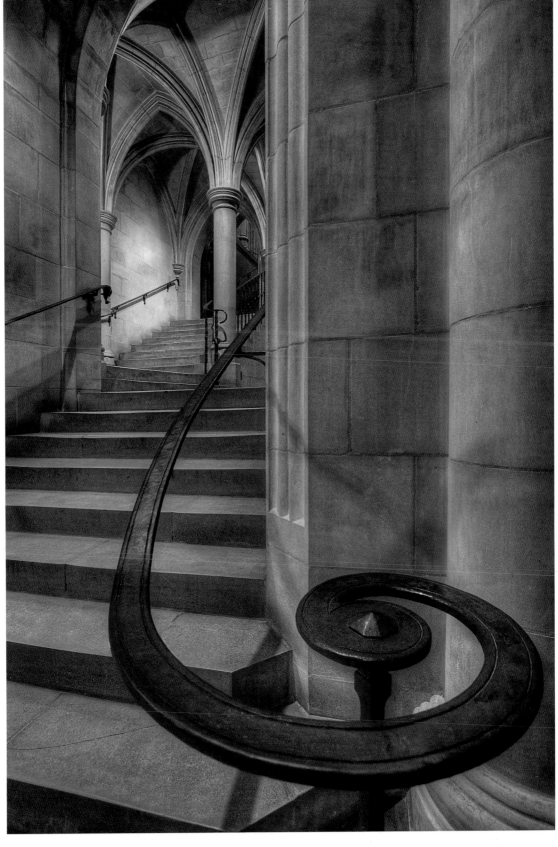

↑ Photo © Lewis Kemper. 1/100 sec. at *f*/22, ISO 100, 24–105mm lens at 24mm

↑ Photo © Lewis Kemper. 1/13 sec. at *f*/22, ISO 100, 24–105mm lens at 24mm

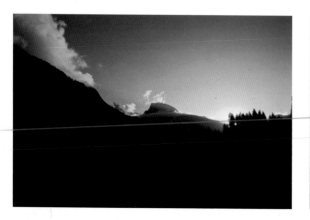

↑ Photo © Lewis Kemper. 1/50 sec. at *f*/22, ISO 100, 24–105mm lens at 24mm

↑ Photo © Lewis Kemper. 1/6 sec. at *f*/22, ISO 100, 24–105mm lens at 24mm

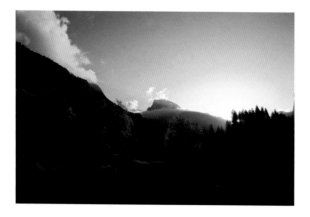

↑ Photo © Lewis Kemper. 1/25 sec. at *f*/22, ISO 100, 24–105mm lens at 24mm

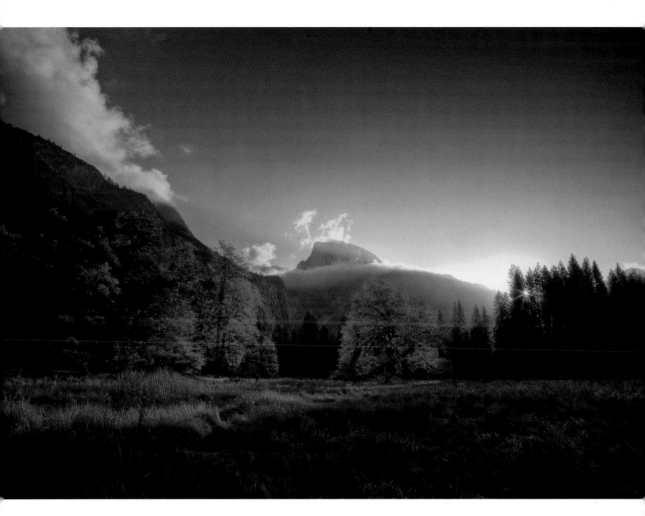

This backlit scene in Yosemite Valley, which shows the sun rising near Half Dome, has a high contrast from bright highlights to deep shadows. Photographer Lewis Kemper wanted to capture a good range of detail and color throughout the scene, so he went with an HDR approach—shooting a variety of exposures and then combining them into one well-exposed image. Note that he selected the *f*-stop first—a small aperture (*f*/22), to get good depth of field from front to back. Also, with the sun peeking out from behind the trees, the small lens opening helped create a sunburst effect. For the HDR approach, the *f*-stop usually remains constant to prevent blurring by keeping a constant sharpness (DOF) throughout the image. Then for each exposure, only the shutter speed changes—in this case, five images in one-stop increments, from 1/6 sec. through 1/100. The idea is that each important area in the photo—from bright to shadow, and tones in between—is captured with a good exposure. The final image reveals much more color and detail throughout the scene than any single exposure would.

↑ Photo © Lewis Kemper. *f*/22, ISO 100, 24–105mm lens at 24mm; this final photo was compiled from five images with shutter speeds ranging from 1/6 sec. to 1/100 sec.

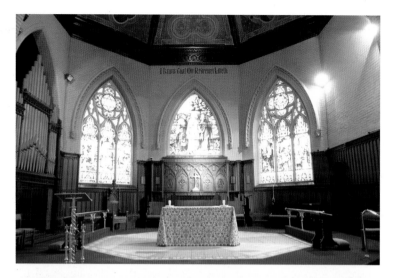

← Photo © Peter K. Burian. 1/15 sec. at *f*/2.8, ISO 800, 16–50mm lens at 21mm

← Photo © Peter K. Burian. 1/60 sec. at *f*/2.8, ISO 800, 16–50mm lens at 21mm

← Photo © Peter K. Burian. 1/250 sec. at *f*/2.8, ISO 800, 16–50mm lens at 21mm

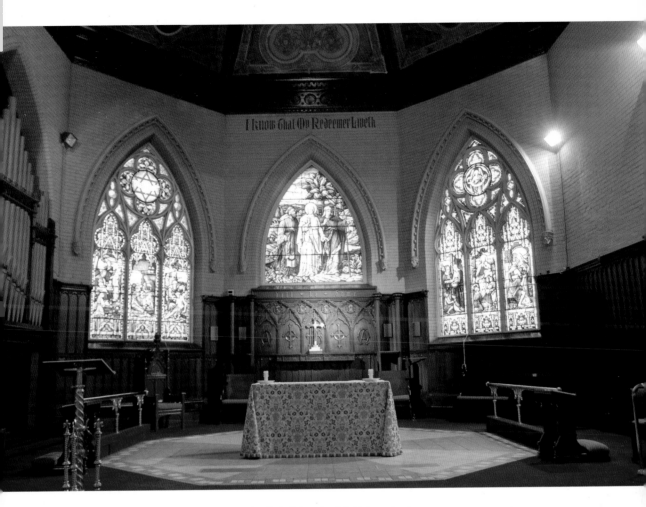

With the church's bright stained glass windows and the dimly lit interior, this high-contrast scene was ideal for an HDR treatment. Photographer Peter K. Burian shot one image (1/60 sec.) with a straightforward approach—"just a point-and-shoot photo, letting the meter do what it would." Then, with the aperture remaining the same (*f*/2.8), he shot two more bracketed photos: two stops more exposure (1/15 sec.) and two stops less exposure (1/250). He combined the three for the final image.

↑ Photo © Peter K. Burian. *f*/2.8, ISO 800, 16–50mm lens at 21mm; this final photo was compiled from three images with shutter speeds ranging from 1/15 to 1/250 sec.

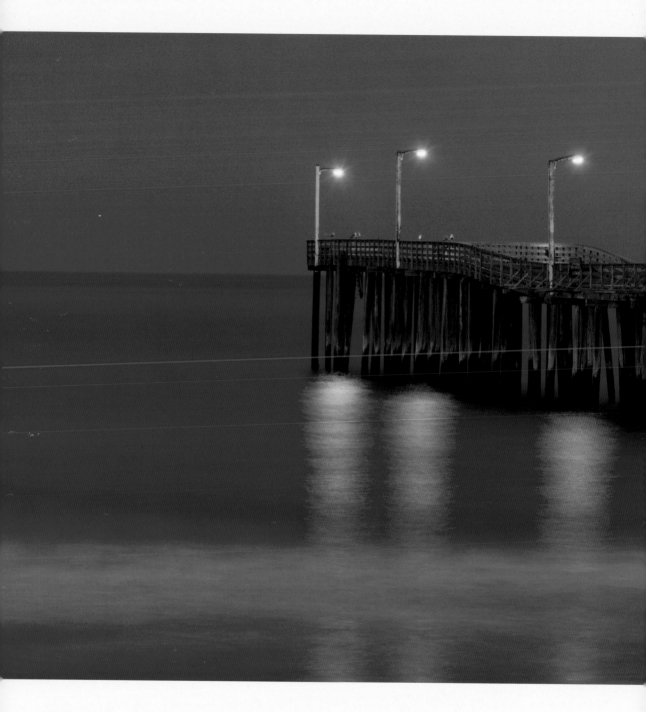

Twilight colors occur at dawn, too! Just as daybreak started to emerge along the California coast near the town of Cayucos one morning, I caught the blue colors interacting with the warm tones of the lights of a pier. The dim conditions, plus a small aperture and low ISO number, required a 20-second exposure that produced a soft, silky, and downright ethereal surf. A daylight white balance setting rendered the colors just as I saw them.

↑ Photo © Kerry Drager. 20 seconds at f/19, ISO 200, 70–300mm lens at 185mm

CHAPTER 6

GETTING CREATIVE WITH LIGHT

Now we explore such aspects of the world of light as slow motion, nighttime photography, moonlight, star trails, infrared photography, telling a story, light box as light source, and just plain having fun. OK, you may be asking, what do these topics have in common—aside from cool photos and hot techniques? They also all involve light as a key ingredient and reinforce concepts we've looked at previously in this book, and some dive into new territory and push the creative boundaries beyond the comfort zones of most photographers.

Now, let's continue our studies into light.

LOW LIGHT AND SLOW SHUTTER

The idea of conveying motion in a still photograph might seem like an oxymoron, but some impressive things start to happen when low light (at such times as dawn or dusk or in heavy overcast) allows you to use slow shutter speeds to imply movement. Adding a sense of movement is an artistic way to add energy to your imagery and also makes it possible to create some impressionistic interpretations with shapes, colors, and designs abstracted in many diverse ways.

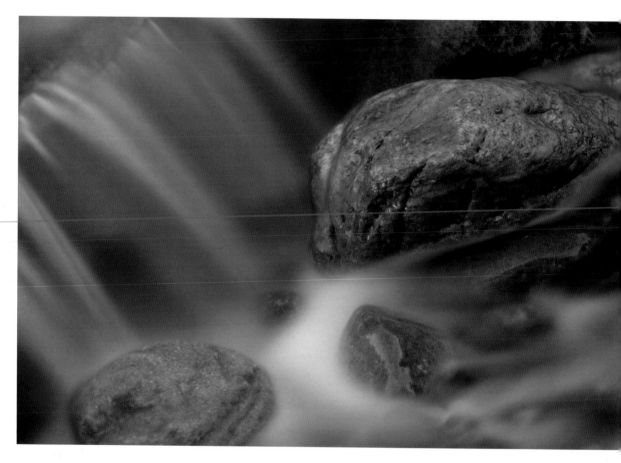

Beautiful things happen when light and composition come together, especially when it involves water in motion. A friend's waterfall fountain looked beautiful in the soft light after the sun went down. The colors resulted from a combination of the reflected blue sky and warm artificial lights, and were further enhanced by a polarizing filter that reduced the amount of glare on the water surface and wet rocks. I chose a Daylight white balance setting to render the colors pretty much as I saw them. The 30-second exposure turned the water into a velvety smooth flow.
↑ Photo © Kerry Drager. 30 seconds at *f*/16, ISO 200, 80–200 lens at 200mm

Thinking outside the box has many valuable applications in photography. For this eye-catching image of a costumed reveler at twilight during carnival in Venice, Jim Zuckerman used flash, a long exposure, and the intentional movement of the camera. Recalls Zuckerman: "The long exposure created the blur, because I purposely moved the camera during the exposure. I did not use a tripod. The flash created the frozen portion of the image." Incidentally, the slow shutter speed (2 1/2 seconds) also had another benefit: While the flash lit up the foreground, the long overall exposure kept the low-light background bright and colorful.
→ Photo © Jim Zuckerman. 2 1/2 seconds at *f*/22, ISO 100, 70–200mm lens at 105mm

Florida photographer Deborah Sandidge describes downtown Orlando, with its fascinating statues and interesting architecture, as a "happening place." She particularly loves shooting the colors of twilight. She captured the tight view of the "Four Elements" sculpture (by artist Tuan Nguyen) with a standard wide-angle (12–24mm zoom) and the more expansive view was shot with a fisheye—a lens, Sandidge says, that "creates a unique distortion that I find charming." While subjects are not actually in motion in these pictures, there's a lot of visual energy shown. The looking-upward perspective and the statue-versus-buildings create a strong dynamic feel.

↑ Photo © Deborah Sandidge. 25 seconds at *f*/16, ISO 200, 16mm fisheye lens
→ Photo © Deborah Sandidge. 13 seconds at *f*/11, ISO 200, 12–24mm lens at 20mm

STEADY CAMERA AND LONG EXPOSURE

With a long exposure and water in motion—rivers, streams, waterfalls, ocean surf, and even fountains—you can get the so-called cotton candy effect. That's the soft and silky smoothness of flowing motion. But other subjects can be turned into expressively flowing scenes as well—moving traffic, runners, bicyclists, a wind-blown field of grasses or wildflowers, an amusement ride at twilight, falling rain or snow, passing trains. While a slow shutter implies motion with your moving subject, stationary objects in the scene will record in crisp detail for a sharp-versus-blur contrast.

Long exposures don't just happen. Besides low light, set your camera for a low ISO number (such as 100 or 200) and a small aperture. Use a tripod to keep your camera rock solid.

The best shutter speeds for recording blurred movement depend on the speed at which your subject is moving, plus the distance between subject and camera. A starting point might be from 1/4 or 1/8 sec. down to a couple of seconds, or even longer.

For photographer Renee Doyle, two favorites are synonymous with London: a double-decker red bus and Big Ben. "I really wanted to capture these icons together," she says. "So I crouched down low and composed my shot and waited for a bus to whiz on by." The low light of sunrise permitted a slow shutter speed that recorded the moving bus as long streaks of color that take the eye right to Big Ben. Doyle kept things steady with a tripod and cable release.
↑ Photo © Renee Doyle. 2/3 sec. at *f*/14, ISO 320, 24–70mm lens at 24mm

A solid overcast day gave photographer Doug Steakley the opportunity to capture this small waterfall with a look of slow motion. Along with the low light, he chose a small aperture and a not-too-high ISO number to get a long exposure that created the silky stretch of water. The vertical format and the tight composition help make the water flow right through the scene.
→ Photo © Doug Steakley. 1/3 sec. at *f*/16, ISO 320, 28–70mm lens at 62mm

With camera secured firmly on a tripod, photographer Kathleen T. Carr used a multisecond shutter speed to portray the misty surf framed amid the silhouetted coastal rocks. She captured this ocean view at sunset at Manini Point, Hawaii.

→ **Photo © Kathleen T. Carr. 2 1/2 seconds at *f*/16, ISO 100, 18–55mm lens at 37mm**

PANNING THE CAMERA: MOVING SUBJECT

We have said a lot about the need to keep your camera steady. Well, let's drop that notion for now, since the steady-camera rule definitely does not apply to panning. Deliberately moving, or panning, your camera while following your subject results in a real feeling of motion. You'll capture a fairly sharp subject set against a streaked backdrop.

To achieve this effect, position yourself so the action moves across your field of vision—i.e., left to right, or vice versa. Start panning so you are moving the camera at the same speed as the subject that's in motion. As you do so, press the shutter smoothly. Try to avoid any jerky motions or sudden stopping, and be sure to continue panning the camera once you release the shutter.

Typical shutter speeds for panning are 1/8 sec. to 1/30 sec.—although a little slower or a little faster may be just the thing in certain circumstances. The subject's speed and the distance to the camera are among the determining factors.

With the overcast light, a small aperture, and a low ISO number, photographer Peter K. Burian used panning to turn skiing action on a cloudy day into a study of motion. He tracked his moving subject (panned the camera) with a slow exposure to get what you see here: a fairly sharp subject against a blurred background. With panning, says Burian, "it can take many attempts to get a photo that is just right as you learn to move the camera at exactly the same speed as the subject's motion." Note, too, how Burian placed the skier a little to the left—since he is heading toward the right, there is sufficient "breathing room" between subject and border.
→ Photo © Peter K. Burian. 1/25 sec. at *f*/16, ISO 50, 70–200mm lens at 110mm

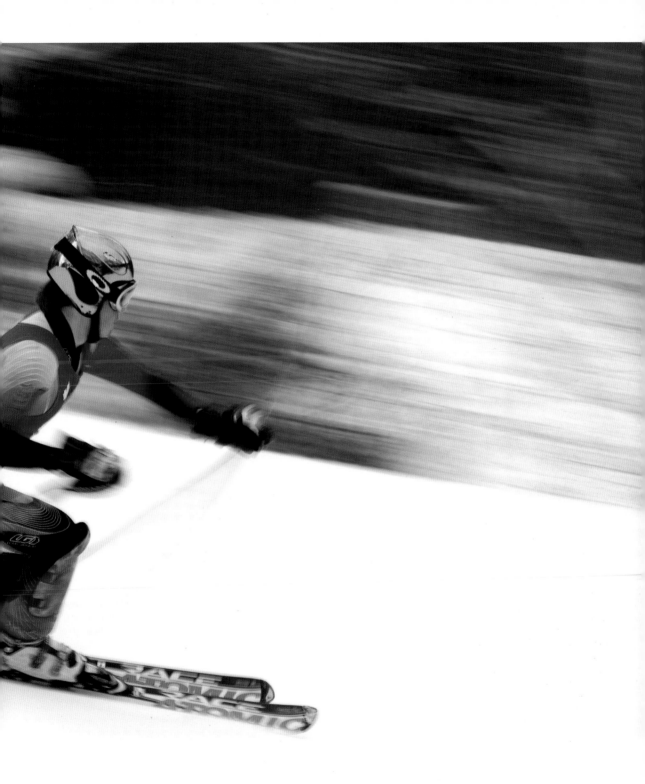

PANNING THE CAMERA: STATIC SUBJECT

With this camera approach, just about any stationary subject performs effectively: from gardens and flowers, to trees and meadows, to produce markets and fruit stands, from graffiti-painted walls to office towers. Keeping the shutter open for a long exposure lets you pan or twirl the camera in any motion you wish. The result is an artistic abstract of details and colors. Expect one-of-a-kind painterly images with nothing in sharp focus.

A speed of 1/15 sec. to 1 second is one place to start. But you can also paint with exposure when shutter speeds hit multiple seconds. Start panning before pressing the shutter button and continue moving after the picture is taken to ensure that the camera is in motion for the entire frame.

The results are often unpredictable, but that's part of the creative excitement. And you needn't worry if your early attempts fall short. With instant reviews of your work, you can tweak the various elements as necessary—the exposure time, for instance, or composition—to make sure you get what you want.

This scene had all I needed for a painterly rendition—colorful flowers and the low light of overcast. Then it was up to me to come up with the camera settings to get a slow shutter speed (1/4 sec.) by going with a low ISO number (50) and a very small aperture (f/32). Finally, I zoomed in tight with my telephoto to fill the frame with colors. Then I moved the camera while the shutter was open (starting the movement before clicking the shutter and continuing for a bit after it was closed). It took a number of attempts and checks of the LCD monitor before I came up with the photo I liked best.
→ Photo © Jim Miotke. 1/4 sec. at f/32, ISO 50, 70–300mm lens at 135mm

ZOOMING WITH YOUR CAMERA

For this special effect, zoom the lens while the shutter is open during a long exposure. The shutter speed must be slow enough so you have time to zoom—say, 1/4 sec. to a full second, or even longer.

Using a tripod will help you avoid extra camera movement when you are using a slow shutter speed. To further ensure smooth streaking without any herky-jerky movement, begin zooming before pressing the shutter button and keep on zooming after the shutter closes.

For these two photos—shot in Seattle at twilight on different days—I used the zooming technique to imply motion by zooming the lens with the shutter open during a long exposure. For the image at near right, I went one step further and tilted the camera for a diagonal composition and extra visual energy.
→ Photo © Jim Miotke. 1 1/3 seconds at *f*/5.6, ISO 400, 28–135mm lens at 100mm
→ (far top right) Photo © Jim Miotke. 2 1/2 seconds at *f*/5.6, ISO 100, 70–300mm lens at 185mm

Photographer Jim Zuckerman had an important aspect in mind when artistically using his zoom lens to capture this colorful image of a whirling dervish in Turkey. "The room where the performance was taking place had some construction materials in the background," he says, "and this was a way to eliminate the unattractive environment."
→ Photo © Jim Zuckerman. 1/4 sec. at *f*/4, ISO 500 24–105mm lens at 40mm

NIGHT PHOTOGRAPHY

The most overlooked time of the day for photography takes place long after the sun goes down. We've already talked about the visual value of twilight—in terms of the outstanding sky color—but nighttime offers striking images, too. Bright and colorful subjects jump out against a black backdrop.

In most cases, the trick to nighttime success is to consider the black sky as a design element—specifically, negative space. Too much black sky, however, can overwhelm the photo. But when the right amount of sky is incorporated into the composition, the photo can be a grand success, with the lights and colors popping out in a striking way. Of course, for tight shots of city lights, no sky at all may be the suitable choice.

When setting exposure, it's important to make sure the dark sky doesn't influence the meter; otherwise, the photo could appear washed out or overexposed as the camera tries to lighten up the night. At the same time, if the hottest and brightest city lights are influencing the meter, then underexposure could be the result if the camera registers the scene as being way too bright and tries to compensate by letting in less light. Spot-metering a middle tone on a bright building is one way to handle the metering. Then take the picture and double-check the image in playback mode (i.e., consult the histogram or highlight warning). You may wish to try autobracketing as well (see page 61).

As usual for any long exposure, you'll need a good tripod and a cable shutter release or self-timer. Go with a low ISO to reduce the possibility of noise, which is more obvious in darker areas of an image. A flashlight helps you see the camera controls better. Also, if you need to set the focus on a nearby dark spot, a flashlight can light up the area so the camera lens can pick it up. Other times you may want to illuminate a foreground subject. You can use flash, of course, but during a long nighttime exposure, some photographers use a technique known as "night painting" in which you move the flashlight's beam around your selected scene to expose the various objects as evenly as possible. Incidentally, in her image of star trails on page 187, photographer Anne McKinnell used a flashlight to brighten up the rocks in the foreground.

Stefania Barbier photographed the amazing La Sagrada Familia cathedral in Barcelona, Spain, shortly after twilight one evening. A meter reading that avoids the black areas and the brightest highlights will yield a good exposure in a scene like this.
← Photo © Stefania Barbier. **2 seconds at *f*/10, ISO 100, 24–70mm lens at 52mm**

Generally a tripod is recommended for low-light photography, but photographer Peter K. Burian found that using a tripod was impractical because of the crowds at a Chinese Lantern Festival in Toronto. Instead, he relied on image stabilization to get a blur-free image. With the almost equal bright-and-black tonal values, he found that the exposure was fairly straightforward for this situation—he just set the camera for overall metering.
← Photo © Peter K. Burian. **1/15 sec. at *f*/6.3, ISO 400, 24–105mm lens at 32mm**

MOONLIGHT PHOTOGRAPHY

The light of a full moon can transform the nighttime world into a magical place, illuminating subjects in remarkable ways. Look around on a moonlit night and you'll probably be enticed by a wealth of scenes to photograph. The trick is to get just the right exposure that will allow you to capture moonlight in all its surreal glory.

These two old churches in England make splendid subjects for night photography. They are pictured here under the light of a full moon. Without any other light source, the scenes take on an almost otherworldly look. Says pro photographer Simon Stafford: "For both images, I set the camera to a shutter speed of 30 seconds, as this is about the longest exposure that will retain stars as points of light rather than recording them as light trails. The ISO was limited to 800 to keep noise levels low, which left the aperture (a wide lens opening of f/4) as the variable to control exposure."

↑ Photo © Simon Stafford. 30 seconds at f/4, ISO 800, 24mm lens
→ Photo © Simon Stafford. 30 seconds at f/4, ISO 800, 24mm lens

STAR TRAILS

Few images in photography are more arresting than those of a night sky filled with curving streaks of star trails. What a visual treat. Planning is key. Some things you'll need: wide-angle lens, tripod, cable shutter release, flashlight, and fully charged battery for the long exposures. Says photographer Anne McKinnell about the image at right, "This is the most preparation I have ever put into one photograph. First I had to find a location away from any city lights. I wanted that spot to be a campground since I knew I would be there very late and I didn't want to be alone out in the wilderness. It had to face north and have some foreground interest. Then I had to go there on a clear, moonless night."

For photographer Deborah Sandidge, who shot the star-trails image below, Rocky Mountain National Park in Colorado offers mesmerizing open vistas, endless skies, and ever-changing scenery. "I've photographed in the park many times," she says, "but it's completely different at night. The landscape is transformed into something magical."

In this mountain scene, "I like the way the trees were isolated against the mountain range," recalls photographer Deborah Sandidge, "and I knew I had to photograph them with sweeping star trails." There are a number of options for capturing star trails, including a single long exposure. This image is the result of more than an hour's worth of stacked exposures, shot on a cold and clear night filled with stars, using her Nikon DSLR's interval timer. You can look for Polaris, the North Star, or just use a compass to locate north (or south) if you wish to shoot circular trails. "For consecutive exposures to create the star trails," says Sandidge, "I used the interval timer feature in my camera (a Nikon DSLR), which is set to record one exposure (30 seconds) every 33 seconds for as many shots as my battery will allow. Your camera may have this feature, or you can use an interval meter device."

↑ Photo © Deborah Sandidge. *f/5.6, ISO 1250, 24mm lens.* **About seventy separate shots (each 30 seconds long) were stacked in Photoshop Extended using Image Statistics.**

This picture actually started in the daytime when, says photographer Anne McKinnell, "I could see all my knobs and buttons, get a nice composition, and set the focus. I had researched on the Internet to determine what angle Polaris, the North Star, would be in the sky and then used my compass to try to get it in the frame so the image would show the stars circling. This is a 50-minute exposure. I used my flashlight to light the foreground rocks. I only had two chances to make this photograph. The first night I missed Polaris. This is from the second night."

↑ Photo © Anne McKinnell. 50 minutes at *f*/4, ISO 200, 10–22mm lens at 10mm

TELLING A STORY

Paul Gero, a former newspaper photographer, brings his wide-ranging photojournalism skills to the coverage of weddings, portraiture, and special events. His accompanying images—captured at different weddings—show a variety of subjects, light, viewpoints, and compositions. Unlike many indoor scenes in which the foreground subject is bright and background is dark, if not black, in Paul's images the light is balanced beautifully from front to back. High ISOs and large apertures allow a balance between the flash and ambient room light. Says Paul: "That's why these fast lenses (ones with a wide maximum aperture) are so valuable to me."

For this portrait of a bride and groom before their wedding ceremony, photographer Paul Gero bounced the flash "over my right shoulder to the wall on my right side to create a soft boxlike effect."
↑ Photo © Paul Gero. 1/60 sec. at *f*/2.2, ISO 1600, 35mm lens

Paul Gero caught this unique image of the bride and groom dancing at their wedding reception. He bounced the flash at an angle—off a wall behind him—to light the scene.
↗ Photo © Paul Gero. 1/80 sec. at *f*/1.8, ISO 1250, 35mm lens

Friends of the couple toast near the end of a wedding reception. Note the interesting light. Paul Gero pointed the flash downward to bounce the light off the floor. "I used my left hand and gently held it against the outer lip of the strobe to block any light spilling forward toward the subjects," says Gero. "I held it gently because I didn't want the flash to be unseated in the hot shoe. This is not a conventional technique, but it creates a unique low light and works well in some fun and festive situations."
→ Photo © Paul Gero. 1/50 sec. at *f*/2, ISO 1600, 35mm lens

To capture this floral arrangement, Paul Gero directed the flash toward the ceiling over his left shoulder. In these types of bounce situations, he says, "I will most commonly set the flash exposure compensation to plus one-third of a stop."

↑ Photo © Paul Gero. 1/80 sec. at *f*/1.8, ISO 1600, 85mm lens

INFRARED PHOTOGRAPHY

Beyond the usual wonderful world of color lies another
enchanting technique: infrared. You can create traditional
black-and-white infrared images or photos in infrared
with a little color. You can do so with a digital camera with
the use of an infrared filter or with an infrared-converted
camera. Either gives you a whole new way to take pictures
while broadening your photographic horizons.

These three photos (here and on the overleaf) were all captured with infrared-converted
cameras: Kathleen T. Carr's koi pond scene (above), the tree caught with a fisheye lens
by Deborah Sandidge, and the country lane captured by Tony Sweet.
↑ Photo © Kathleen T. Carr. 1/60 sec. at f/4.5, ISO 400, 18–55mm lens at 18mm
→ Photo © Deborah Sandidge. 1/80 sec. at f/11, ISO 100, 10.5mm fisheye lens

LIGHT BOX AS LIGHT SOURCE

The light box has helped photographers evaluate color slides and film negatives for years. For many photographers who have switched to digital, these once-indispensible pieces of equipment have slipped into the far reaches of closets or storage rooms. But photographers Linda Lester and Donna Rae Moratelli show how they put artistry to work with a light box as light source. With the color-corrected, light-adjusted illumination, these portable viewers offer indoor lighting alternatives for macro photography—capturing translucent subjects with controlled backlighting.

Backlighting doesn't have to involve big scenes and the sun, as photographer Linda Lester proves with this photo. These slices of kiwi, placed on a light box, create a colorful macro pattern.
↑ Photo © **Linda Lester. 1 second at** *f*/**29, ISO 100, 100mm macro lens**

For this shot, photographer Donna Rae Moratelli went beyond a light box and photogenic subject. First, she placed glycerin drops on the leaves. Then, she says, "I turned on one hot light in a studio soft box, which gave me top-right illumination and also highlighted the glycerin drops. I shot this image in a room with northern exposure, for soft window light above the subject and opposite the soft box. I also added a silver reflector to balance the exposure and illuminate all shadows."
→ Photo © **Donna Rae Moratelli. 2 1/2 seconds at** *f*/**25, ISO 100, 50mm macro lens**

HAVING FUN

The joy of photography always includes a fine subject—
from people and pets to intriguing shadows, statues, and
sculptures. But as many of these photos also show, excellent
timing comes in handy, too, to catch the decisive moment.
Of course, memorable photography always begins—and
ends—with memorable light!

Photographer Peter Burian's wife got into the act to create this imaginative picture
in Budapest. Burian often uses flash outdoors on "dark, cloudy overcast days to
add sparkle and contrast, and to enrich colors."
↑ Photo © Peter K. Burian. 1/80 sec. at *f*/5.6, ISO 400, 24–70mm lens at 50mm

Photographer Deb Harder's Boston terrier, Petey Beans, is the perfect model for this fanciful photo. Harder used window sidelight as the primary light source and a reflector to bounce light onto the shadow side. The main prop for this corporate "boardroom" scene is a leather chair. Harder says, "I waited until I got a very serious business expression from him."
↑ Photo © Deb Harder. 1/80 sec. at *f*/2.8, ISO 100, 17–55mm lens at 45mm

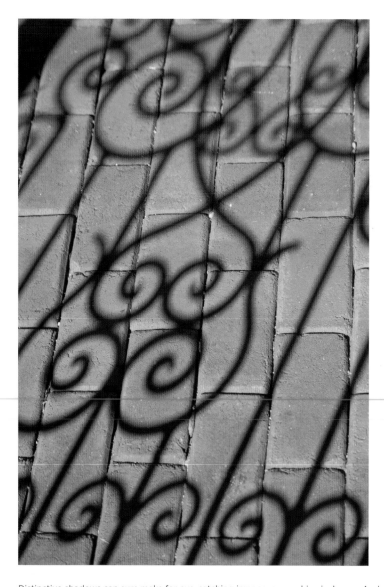

Distinctive shadows can sure make for eye-catching images, even whimsical ones. And when you receive help from a companion, you may even have a special one. I loved the look of these crisp shadows created in early-morning light by the decorative gates of a San Diego inn. For the first two photos, I worked only with graphic design. For the third image, I asked my wife, Denise, to create a shadow, and she came up with this awesome pose—making the shadow of her arm follow the pattern of the gate's shadow.

↑ Photo © Jim Miotke. 1/200 sec. at f/5.6, ISO 100, 70–300mm lens at 90mm

↗ Photo © Jim Miotke. 1/160 sec. at f/5.6, ISO 100, 70–300mm lens at 135mm

→ Photo © Jim Miotke. 1/200 sec. at f/5.6, ISO 100, 70–300mm lens at 90mm

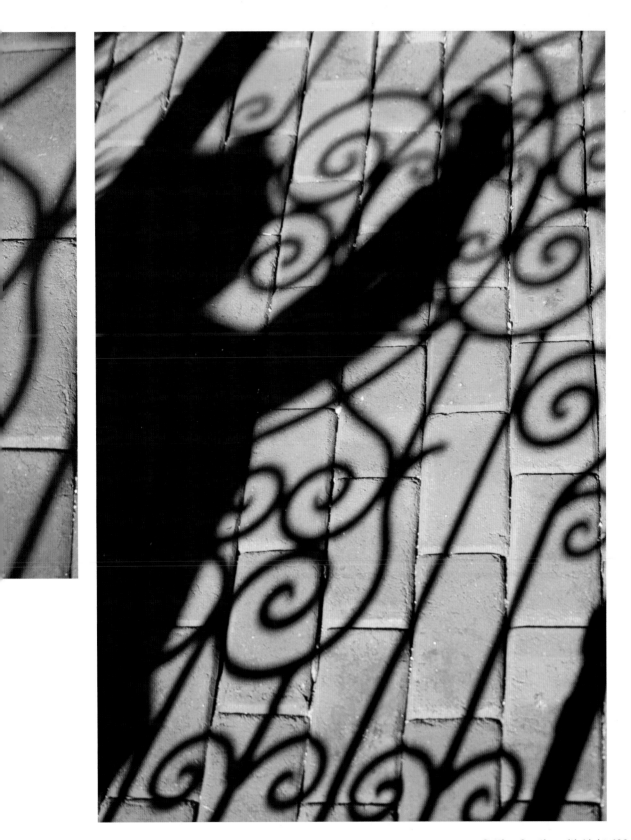

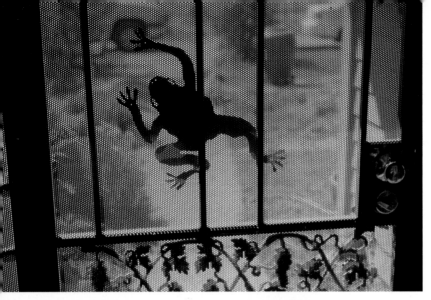

This metal frog sculpture adorns a screen door in my home. I thought it would be a good candidate for a silhouette (see photo top left), but the background is busy and full of distracting elements. However, while looking for photos around the house one sunny midday, I discovered the frog's eye-catching shadow on the tile floor.

↑ Photo © Kerry Drager. 1/125 sec. at *f*/5.6, ISO 200, 50mm lens
← Photo © Kerry Drager. 1/4 sec. at *f*/19, ISO 200, 105mm macro lens

In the late-day sunlight, just before sunset on a windy day, photographers Susan and Neil Silverman caught their model in a playful mood. A gold reflector enhanced the beautiful lighting.

→ Photo © Susan and Neil Silverman. 1/750 sec. at *f*/4, ISO 400, 70–200mm lens at 110mm

William Neill photographed dogwood trees along the Merced River on a spring day in Yosemite National Park. He liked the color version of the image, in which the dogwood blossoms are so sharp, since there was little wind, but he also liked another scene in which a broken branch dangled in the water. Many of the blossoms moved with the river, he says, and the thought of a more impressionistic effect intrigued him: A slow exposure "let the blossoms dance their dance and for the river to blur softly in the background." The result is a blend of sharpness and softness that shows in the horizontal version. "I feel that the black-and-white treatment adds to the delicate effect," adds Neill.

← Photo © William Neill. 1/3 sec. at *f*/32, ISO 200, 70–200mm lens at 135mm

↑ Photo © William Neill. 2 seconds at *f*/32, ISO 100, 70–200mm lens at 130mm

For photographer Vik Orenstein, great portrait subjects go hand in hand with a variety of lighting and compositions. For the flower garden image opposite, the subject is the star, thanks to the color contrast and the shallow depth of field (sharp subject against blurred backdrop, achieved with the use of a very wide aperture, f/1.8). For the other two images, the subject is close up in the frame. All of these pictures, by the way, take advantage of soft and pleasing light. The girl in the garden at right was photographed in partial shade in late morning. The girl smiling and wearing the crochet hat was shot in a small, isolated area of shade in the early evening. The sleeping baby was photographed through the bars of the crib (which created the vignette or darkened corners effect) in the nursery. With a skylight and windows, the baby was enveloped in pleasing natural light.

↓ Photo © Vik Orenstein. 1/200 sec. at f/5.6, ISO 800, 18–200mm lens at 170mm
↘ Photo © Vik Orenstein. 1/320 sec. at f/1.8, ISO 1600, 85mm lens

↑ Photo © Vik Orenstein. 1/5000 sec. at *f*/1.8, ISO 200, 50mm lens

For this last assignment, give some of the techniques in this chapter a try. Play with low light and slow motion. Use a tripod to keep things steady, or move the camera for an artsy effect. Get out at night and photograph the lights of buildings and cars. Shoot the stars on a clear and moonless night. Catch the landscape under a full moon. Consider infrared. Look for shadows.

Also plan some fun photo projects around the home. One possibility is to come up with eye-catching designs in paint. Check out the photo at left to see what you can achieve.

Mixing paints and photographing the abstract pattern of colors, swirls, and curls can be a very gratifying rainy-day project. I was inspired by the work of pro photographer Jim Zuckerman. Unless you already have a variety of paints available in the colors you want, buy some little jars (half pints) of sample paints sold at home improvement stores. Blend them together in a small plastic container, watch the designs come to life, and photograph the patterns that emerge. Make sure the camera's back is parallel to the surface, to help ensure side-to-side, corner-to-corner sharpness. If it's overcast but not raining, the soft lighting next to a window or on a porch is excellent. For this photo, I used my garage as a "studio" on a rainy day. Just inside the open door, the light was very pleasing, and a reflector helped even out the light. I also used a polarizing filter to tone down the glare on the shiny surface.

← Photo © Kerry Drager. 1/20 sec. at f/11, ISO 400, 105mm macro lens

It was in the shade of late day that I found this shiny car. The combination of the taillight's warm colors with the cool blue caught my eye, along with my shadowed reflection and some Florida palm trees—ideal for a close-up rendition. I also liked the diagonal flow from the reflections at the upper left extending downward to the taillight at the lower right.
← **Photo © Kerry Drager.**
1/4 sec. at *f*/5.6, ISO 200, 105mm lens

GLOSSARY OF PHOTOGRAPHIC TERMS

AF (autofocus) lock. A function that allows you to hold the focusing point while you move the camera to recompose your photo. AF lock also allows you to pre-focus on a fast-moving subject to help you catch the right moment when shooting action shots.

Aperture. The adjustable opening in the lens. Measured in *f*-stops, it controls how much light enters the camera.

Aperture Priority (AP) mode. This mode automatically calculates the shutter speed after you choose your preferred aperture setting (*f*-stop). Also see *AV*.

Autoexposure (AE). When the camera automatically sets the aperture and/or shutter speed to what it considers best for your particular lighting situation.

Autofocus (AF). When the camera focuses for you, as opposed to manual focus, when you have to set the focus yourself.

AV. Stands for aperture value. This is often used to signify the Aperture Priority mode.

Backlight. When the sun is in front of you, lighting your subject from behind.

Blinkies. You may be able to set up your camera so that you see overexposed highlights flash in the LCD monitor. This warning flashing is often referred to as the blinkies.

Blown out. When the highlights are completely white and washed-out, with no detail.

Camera shake. When the camera moves a little as you press down the shutter button, causing the picture to come out blurry. A faster shutter speed or a tripod are generally the cures.

Close-focusing distance. The minimum distance you can get to a subject before the lens can no longer focus properly.

Composition. Arrangement of everything in the photo.

Contrast. This can refer to color (e.g., bold vs. subdued or warm vs. cool) or lighting (i.e., the difference between the bright areas of a photo and the shadowed areas).

Cropping. Cutting off part of your composition, either by moving in closer to your subject when you're taking the picture or by trimming your finished photograph in post-processing.

Depth of field (DOF). The range of sharpness in a scene from front to back. Among the factors that influence depth of field are the choice of *f*-stop (larger apertures for less DOF, smaller apertures for more DOF) and focal length (i.e., wide-angle for greater DOF, such as a big landscape scene, and telephoto for less DOF, such as a portrait shot with a blurred background).

Diffuser. Also called a diffusion disc or a scrim, the diffuser involves a translucent fabric that (unlike a reflector) lets light pass through it. The diffuser is placed between a bright sun and the subject in order to soften the light.

DSLR. An acronym for *digital single-lens reflex*. A DSLR camera allows you to use interchangeable lenses. Digital SLRs feature sophisticated focus, exposure, and flash systems. Also, users of DSLRs look through the lens itself to see the scene, rather than through a separate window.

Exposure. The amount of light that is allowed to hit the sensor. Balance is key here. Too much light results in overexposed (too light) images; too little light results in underexposed (too dark) images.

Exposure compensation. A function found on many cameras that lets you adjust exposure levels to compensate for circumstances (very light or very dark) that might trick the camera meter. Note: Also see *Exposure Value*.

Exposure Value (EV). This refers to the camera meter's measurement of the light—specifically, all the combinations of *f*-stop and shutter speed that provide the same exposure. The exposure compensation mode, or EV control, lets you adjust the exposure when shooting with automatic metering.

***f*-stop or *f* number.** The *f*-stop numbers represent the size of the lens aperture. This, combined with shutter speed, serves to expose each photo with the correct amount of light.

Fast. A fast lens can be set to a very low *f*-stop number to allow more light to pass through. Fast lenses can come in handy when shooting sports, weddings, or other subjects where you need a fast shutter speed in low light.

Filter. A piece of glass placed in front of your lens to enhance light and/or colors, or to protect the more valuable lens glass. Also, in the world of digital imaging, filters are software functions that can be used for creative effects, for fixing lighting issues, and so on.

Fixed lens. Also called a fixed-focal-length or prime lens. This lens is permanently a wide-angle, telephoto, or something in between; it does not allow you to zoom in or out.

Focal plane. The point in your photo that is in focus (this includes everything that's at the same distance from your camera).

Focal length. A way to measure the magnifying power of a lens. A 50mm lens has a focal length of 50mm and sees things at roughly the same size as the unaided human eye sees them. A 400mm telephoto focal length is like looking through a pair of binoculars; things far away are greatly magnified. A 20mm wide-angle lens allows you to squeeze in an expansive vista.

Form. A shape with three-dimensional depth.

Format. Refers to digital file format. JPEG is the most commonly used, but capturing raw files (photos before they're processed into a file format) gives a digital photographer more flexibility and latitude when it comes to processing the photo later.

Frame. The view you see through your camera's viewfinder. Also, framing can refer to a compositional trick where you use an element within the composition, such as tree branches or a window, to frame another element in the shot.

Frontlight. When the sun is behind you and therefore lighting your subject from the front.

Glare. When light reflects off of a reflective surface, such as glass, water surface, wet rocks, and so on.

Glass. Another term for lenses.

Highlights. The extremely bright points in a scene.

In camera. Refers to doing a technique while shooting, to save yourself the time and hassle of having to later fix the image in a program like Photoshop.

ISO. With initials deriving from the International Organization of Standardization, ISO refers to how sensitive a camera sensor is to light. A fast ISO, such as 1600, will capture images more quickly and generally will provide sharper results when handholding the camera in dim conditions. An ISO of 50 to 200, on the other hand, is much slower, less sensitive, and works best in bright light or when combined with the use of a tripod. In most cases, when shutter speed isn't a factor, a low ISO is recommended to reduce the possibility of noise.

Landscape. Besides a grand outdoor scene, this term also refers to images shot in a horizontal orientation (as opposed to vertical, "portrait," images).

LCD. An acronym for *liquid crystal display*. The LCD is the monitor on a digital camera that allows you to review images immediately after shooting them and, in more and more cameras, is also used as "live view" for composing photos.

Light meter (or exposure meter). A device that measures the brightness in a scene to help the camera get the proper exposure. There are in-camera light meters, and some photographers use special handheld light meters, as well.

Long lens. See *Telephoto lens.*

Macro. Extreme close-up photography. A specialized macro lens or macro accessory (such as an extension tube) lets you focus far closer to a subject than a regular lens.

Manual focus. When you dictate what to focus on in your scene, as opposed to letting the camera automatically do the focusing.

mm. Millimeter. A unit of measure used when referring to either a lens (for example, a 100–400mm zoom lens) or to film formats (for example, 35mm film). Confusingly, though, millimeter also specifies the filter sizes on some lenses; for instance, you may have a 50mm normal lens that accepts 52mm filters.

Noise. An effect of grainlike texture in a photo. Colors often appear duller, and a grainlike texture can reduce clarity. A major cause is a high ISO.

Normal. A normal lens—in the neighborhood of 40mm to 50mm—sees things at about the same magnification level as the unaided human eye. Telephoto and wide-angle lenses, on the other hand, make things bigger or smaller than the human eye usually sees them.

Overexposure. When the sensor receives too much light and the picture looks bright.

Perspective. The way lines converge as they travel farther away from the eye. Also, the way objects in your photo relate to one another in size.

Point-and-shoot. A basic, automatic camera. The term *point-and-shoot* also refers to the "snapshooting" style of quick shooting.

Point of view. The place and position from which you shoot.

Polarizer. A filter you can attach to your lens to reduce glare and saturate colors or to make skies a deep blue.

Portrait. Along with a picture depicting a person or group of people, this term also represents images taken in a vertical orientation, when you turn your camera on end before shooting the picture.

Prefocusing. See *AF lock*.

Program mode (P). On some cameras, this represents the mode that automatically calculates both aperture and shutter speed.

Raw. A preprocessed image, larger but containing much more information than a JPEG format. See *Format*.

Rule of Thirds. A principle of composition used to add a sense of balance and uniqueness to photographs by the off-center placement of the picture's main subject.

Selective focusing. The art of limiting depth of field so that only your subject is in sharp focus.

Self-timer. A feature that delays the moment when the camera takes the picture. A self-timer allows you to get into the picture yourself and, for long exposures, can substitute for a cable release to help prevent the camera from being jarred by touching the shutter button.

Short lens. See *Wide-angle lens*.

Shutter. A mechanism that controls how much light is allowed to get into the camera.

Shutter button. The button you press to take the picture.

Shutter Priority mode. This mode automatically calculates aperture after you specify the shutter speed. Also see *Tv*.

Shutter speed. How long the shutter is left open, or how long the camera takes to make the picture.

SLR. See *DSLR*.

Soft. Refers to the parts of photographs that are slightly blurry. This can be good (say, when creatively using a shallow depth of field) or not so good (when areas of an image are out of focus but should be sharp). This term also describes the diffused, gentler kind of light of a bright, overcast day and can refer to subtly beautiful colors (as opposed to vibrant hues).

Telephoto lens. A lens that magnifies your subject, enabling you to shoot subjects that are very far away; varies depending on camera, but usually 60mm or above.

Tripod. Wise photographers often attach their camera to this three-legged stand to keep the camera steady while taking a picture, to make use of certain creative effects (such as a deep depth of field and to convey motion), and to fine-tune their compositions.

Tv. Stands for time value. This is often used to indicate a Shutter Priority mode.

Underexposure. When the sensor doesn't receive enough light and the picture looks too dark.

Viewpoint. See *Point of view*.

White balance. The camera function that controls the color of light.

Wide-angle lens. A lens that gives you a wide or sweeping view—usually under 35mm.

Wide open. Shooting at a lens's lowest *f*-stop number, such as *f*/2.8.

Zoom. A zoom lens provides more flexibility by allowing you to easily change the focal length (the amount of magnification) before you shoot.

Evening sunlight warmed up the texture and design of this old wall. I was also attracted by the black stairway and its shadow, which created some dynamic patterns, angles, and lines. A telephoto focal length let me fill up the picture with the design.
← Photo © Kerry Drager. 1/45 sec. at *f*/16, ISO 200, 70–300mm lens at 80mm

RESOURCES

BETTERPHOTO.COM

Even if Jim wasn't its founder and president, and Kerry wasn't a staffer and instructor, we would still vouch for this site as the best photography resource on the Web! BetterPhoto's mission is to help photographers feel free to be creative and improve their skills and have fun doing it. BetterPhoto, launched in 1996, offers a top-notch online digital photography school (in which students get direct feedback from top pros), plus photo contests, newsletters, websites and online galleries, and a variety of other resources for photographers.

SELECTED BIBLIOGRAPHY

McNally, Joe. *The Life Guide to Digital Photography.* Life Books, 2010. A longtime pro and former *Life* staff photographer provides great insights on light, composition, design, and exposure.

Miotke, Jim. *BetterPhoto Basics: The Absolute Beginner's Guide to Taking Photos Like the Pros.* Amphoto Books, 2010. The fundamentals are all here: exposure, composition, and light. You'll learn tips and tricks to improve your pictures right away, regardless of your camera.

Miotke, Jim. *The BetterPhoto Guide to Digital Photography.* Amphoto Books, 2005. This and the following titles in the BetterPhoto Guide series will help you raise your photography to the next artistic level.

Miotke, Jim. *The BetterPhoto Guide to Digital Nature Photography.* Amphoto Books, 2007.

Miotke, Jim. *The BetterPhoto Guide to Photographing Children.* Amphoto Books, 2008.

Miotke, Jim, and Drager, Kerry. *The BetterPhoto Guide to Creative Digital Photography.* Amphoto Books, 2011. Don't miss our first collaboration, which covers all you need to know for mastering composition, color, and design!

Patterson, Freeman. *Photography and the Art of Seeing.* Key Porter Books, 2004. This acclaimed book covers design, composition, light, and creative vision and includes Patterson's superb photography.

Perello, Ibarionex. *Chasing the Light.* New Riders, 2011. Ibarionex Perello shares his expert insights on pursuing and capturing great images using available light.

Peterson, Bryan. *Understanding Exposure.* Amphoto Books, 2010. This beautiful book, now in its third edition, covers all you need to know about exposure. There's also a chapter on flash and HDR.

Rowell, Galen. *Mountain Light.* Sierra Club Books. Rereleased in 2011 as a twenty-fifth-anniversary edition, this classic book includes many of Rowell's best photos, accompanied by his fascinating and enlightening essays on how he captured them.

Sheppard, Rob. *The Magic of Digital Landscape Photography.* Lark, 2010. In this comprehensive guide, the author discusses the techniques, gear, and vision necessary to shoot striking nature images.

Tharp, Brenda. *Creative Nature & Outdoor Photography, Revised Edition.* Amphoto Books, 2010. The author shares her creative vision in regards to visual design, color, light, and composition.

Zuckerman, Jim. *Pro Secrets to Dramatic Digital Photos.* Lark, 2011. This inspiring book by a top stock photographer provides many insights and techniques for capturing extraordinary images.

Very pleasant late-afternoon light helped emphasize this fall scene. I liked the way the strong, dark lines of the tree trunks contrasted with the bright autumn colors and used my telephoto to zoom in on the best parts of the scene.
← Photo © Jim Miotke. 1/320 sec. at f/5, ISO 400, 70–300mm lens at 150mm

MAGAZINES

Outdoor Photographer

www.outdoorphotographer.com

An outstanding magazine covering the art and technique of scenic, wildlife, and travel photography.

Shutterbug

www.shutterbug.com

A well-stocked, well-edited magazine of shooting tips, techniques, and reviews of equipment and software.

Digital Photo

www.dpmag.com

A fine publication filled with tips, reviews, techniques, and buyer's guides.

Petersen's Photographic Digital Photography Guide

www.photographic.com

A quarterly magazine that features great tutorials and great photography.

Popular Photography

www.popphoto.com

Lots of reviews and news on camera gear and software, plus tips on photography and the digital darkroom.

Digital Photo Pro

www.digitalphotopro.com

Beautifully produced magazine that focuses on trends, photographer profiles, and techniques.

Practical Photography

www.photoanswers.co.uk

A British publication with information, inspiration, and down-to-earth photographic advice.

CAMERA AND GEAR MANUFACTURERS

There are many quality manufacturers, far too many to list. Here are a few of our favorites.

Canon

www.canon.com

Note: Jim shoots with Canon DSLRs and lenses.

Nikon

www.nikonusa.com

Note: Kerry shoots with Nikon DSLRs and lenses.

Really Right Stuff

www.reallyrightstuff.com

An innovative designer of high-quality tripods, ball heads, and quick-release systems.

Lensbaby

www.lensbaby.com

Unique SLR camera lenses designed for creative selective focus.

Manfrotto

www.manfrotto.us

The manufacturer of a full line of excellent tripods that fit just about any budget.

Gitzo

www.gitzo.com

The maker of high-quality tripods that have long been the standard for many top pro shooters.

LowePro

www.lowepro.com

A manufacturer of fine camera bags and photo backpacks of all shapes, types, and sizes.

Think Tank Photo

www.thinktankphoto.com

The state-of-the-art maker of high-quality camera bags and photo backpacks.

CAMERA AND GEAR RETAILERS

There's nothing like a good camera shop for one-on-one service and for getting your hands on that cool new camera model you've been considering. It's ideal to purchase a tripod in a shop, too: Just pack up your heaviest camera/lens combination and see how it works on the tripod that catches your eye. On the other hand, there's nothing like the convenience of an online store, and thankfully there are many reputable outlets. Here are two that we like:

B&H Photo

www.bhphotovideo.com
The website of this retailer is huge, with just about everything you can imagine. B&H also operates a monster-sized superstore in New York City that you must see to believe.

Hunt's Photo & Video

www.huntsphotoandvideo.com
Besides a big online presence, this retailer also has a big brick-and-mortar store presence throughout much of New England.

PHOTO SOFTWARE

Adobe Photoshop and Lightroom

www.adobe.com
Also in Adobe's fine line of image-editing programs, there's Photoshop's wonderful cousin: Elements.

Nik Software

www.niksoftware.com
Established in 1995, Nik has become a leader in digital photographic filters and software technology.

CONTRIBUTING PHOTOGRAPHERS

The following members and instructors of BetterPhoto.com contributed many wonderful photos for this book. Jim and Kerry created the others.

Stefania Barbier, www.stefania-barbier.com

Christopher J. Budny, www.chrisbudny.com

Peter K. Burian, www.peterkburian.com

Kathleen T. Carr, www.kathleencarr.com

Renee Doyle, www.renee-doyle-photography.com

Paul Gero, www.paulfgero.com

Debra Harder, DRH Images LLC, www.drhimages.com

Susana Heide, www.betterphoto.com?susana

Lewis Kemper, www.lewiskemper.com

Linda Lester, www.lindadlester.com

Deborah Lewinson, www.newjerseyphotos.net

Anne McKinnell, www.betterphoto.com/?annemckinnell

Donna Rae Moratelli, www.donnaraephotography.com

William Neill, www.williamneill.com

Vik Orenstein, Kidcapers Portraits, www.vikorensteinphotography.com

Donna Pagakis, www.betterphoto.com?donna

Ibarionex Perello, www.thecandidframe.com

Deborah Sandidge, www.deborahsandidge.com

Rob Sheppard, www.natureandphotography.com

Susan and Neil Silverman, www.silvermansphotography.com

Simon Stafford, www.simonstafford.co.uk

Doug Steakley, www.douglassteakley.com

Tony Sweet, www.tonysweet.com

Jim Zuckerman, www.jimzuckerman.com

Photographer Susana Heide is always attracted to elements of design in ordinary objects. At times, the photographic urge strikes indoors, and she puts pleasing window light to creative use. For this scene, Heide says, "The strong lines and contrasting colors, as well as the texture of this knitted sweater, grabbed my attention. I placed it in natural diffused light to get a few shots."
← Photo © Susana Heide. 1/100 sec. at f/2.5, ISO 100, 50mm lens

The warm colors of a red chair and yellow leaves stood out in perfect overcast lighting one autumn day. I moved in close with my 50mm lens and found a composition that caught just part of the chair at an angle. I wanted to emphasize not only the red and yellow color contrast, but also the way the chair's diagonal lines contrasted with the circular stepping stones.

← Photo © Kerry Drager. 2/3 sec. at *f*/22, ISO 200, 50mm lens

INDEX

The wonderful golden light of sunrise lit up this stretch of Monterey Bay, California.
I shot the scene from a high viewpoint, pointing my camera downward and
zooming in tight with a telephoto lens. Because I wanted the photo to emphasize
the color and reflections, along with the rocks, I was careful to leave out the sun.
↑ Photo © Kerry Drager. 1/15 sec. at *f*/22, ISO 200, 80–200mm lens at 92mm